The Relationship Between Individual *and* Family *in the* Caribbean *Novel*

The
Relationship Between Individual *and* Family
in the Caribbean
Novel

KHURSHID
ATTAR

PARTRIDGE
A Penguin Random House Company

To order additional copies of this book, contact
Partridge India
000 800 10062 62
orders.india@partridgepublishing.com

www.partridgepublishing.com/india

To

My respected guide Dr. Mrs. Sunanda Chavan who taught me how to enjoy research and to my father who was the best teacher in English and to my mother, sisters and their family who always encourage me and support me.

Table of Contents

CHAPTER ONE

INTRODUCTION

The hybridity and heterogeneity of races and cultures as the inheritance of the colonial history accentuates the primacy of the problem of identity in relation to the Caribbean society. The political leaders, sociologists, thinkers, writers and critics have tried to clarify the nature of the particular problem, the nature of its causes, and the nature of an identity in the process of being shaped through the lived experience of centuries.

Eric Williams, the first Prime Minister of Trinidad, is one of the first to pinpoint the nature of the problem of identity for the West Indies. He contrasts the lack of identity of his own newly liberated people with those in other liberated countries in his statement that all these 'victims of imperialism have had decisive advantages over the West Indies. They had a language of their own, a culture of their own... we in the West Indies have nothing of our own.'[1]

Different factors contribute to the traumatic sense of lack of identity for the Caribbean society. The oppressive impact of the European/English culture is found to be the major factor that has led to such consequence. As George Lamming states, 'A foreign or absent Mother culture has always cradled,'[2] the judgement of the West Indians. V. S. Naipaul also emphasizes the alien identity syndrome in his comment, 'Living in a

borrowed culture, the West Indian, more than most, needs writers to tell him who he is and where he stands.'[3] Fernando Henriques thinks that the West Indians are 'unique amongst coloured nations of the Commonwealth in regarding England as a welcoming mother from whom they can draw sustenance.'[4]

The imperialist ideological strategy of English educational system prevented the emergence of identity for the Caribbean society as for example, Kenneth Ramchand explicates it. According to him, the aim of the system was 'to teach the mutual interest of the mother country [England] and her dependencies, the national basis of their connection, and the domestic and social duties of the coloured races.'[5] The sense of rootlessness of the West Indian is 'a spiritual inheritance from slavery,' according to L. E. Braithwaite, which gives rise to 'a definite feeling of having no past, of not really belonging... '.[6] For instance, Samuel Selvon is obsessed with the sense of rootlessness which he expresses thus- "Who the hell am I? and where do it fit into it, have I got roots, am I an Indian? Am I a Negro?"[7] The psychological and cultural fragmentation of the Caribbean society poses, according to Wilson Harris, the crucial question of 'How can one begin to reconcile the broken parts of such an enormous heritage especially when those broken parts appear very open like a grotesque series of adventures, volcanic in its precipitate effects as well as human in its vulnerable settlement?'[8]

The experience of centuries has, however, begun the process of the emergence of an identity that is distinctly Caribbean, according to the sociologists, thinkers, writers and critics. Nettleford, for instance, sees the process of emergence of an identity for the Caribbeans as 'a process of decolonization of self and society by the conscious demolition of old images and deliberate explosion of colonial myths about power, status and production process.'[9] Paule Marshall notes proudly how the West Indian writers are engaged in reconstructing 'our personality', and are in 'the process of recreating'[10] themselves. The purpose of Merle Hodge's fiction[11] is the establishment of cultural sovereignty, of the Caribbean nation. Derek Walcott celebrates not only 'The survival of culture but a creation of a culture that is people's own'.[12] According to Renu Juneja, 'The Caribbean culture and people are no longer becoming something from nothing; they have already crafted a Caribbean nationality and identity.'[13]

In spite of such valuable attempts to understand the nature of the problem of identity; clarify its causes; and ascertain the emergence of an identity as an on-going process, 'identity' - oriented approach suffers from certain basic limitations. It should be noted that the phenomenon of dispersal and migration, hybridity and ethnic ambiguity has become universal. It has accelerated the demand for change in the 'identity' - oriented approach as the basis for comprehending experience. Richard White argues, with reference to the Australian situation, 'a natural identity

is an invention... they are all intellectual constructs, neat, tidy, comprehensible - and necessarily false. They have all been artificially imposed.'[14] Susan Lok problematizes the concept of a pure identity, while Stuart Hall[15] questions the very need of identity. Diana Yeh discovers the absence of single or definitive identity in her study of six British-Chinese Artists in whom she finds 'a diversity of subjective positions and cultural identities.'[16] Gloria Cumper dismisses the notion of identity in her view that Jamaican can claim several "identities" because 'no person has a single identity.'[17] Even Renu Juneja expresses her dissatisfaction with the "identity" - approach because 'the terminology of identity tends to favour the psychological as against the cultural and the political, the two important battle grounds wherein the colonized resist and reform.'[18]

The identity - approach appears to be particularly inadequate for scanning the enigmatic nature of the Caribbean phenomenon. 'Identity' signifies 'cultural identity as a nation and a people similar to and different from others,' as Kay Schaffer puts it.[19] The ethnocentric, homogeneous and stable societies define identity in terms of difference. The understanding of Caribbean phenomenon necessitates the concept of identity to be understood in terms of sameness or togetherness rather than difference. In their situation, the struggle for identity is, in essence, a struggle for meaningful relatedness - for the sameness with others as human beings - within a society cursed with racial, cultural, economic and political stratification.

"Family" is the most valuable medium through which the stratified Caribbean persona struggles to fulfil its urge for meaningful relatedness. The racial history of dispossession of ancestral homes, denial of family life for plantation slaves and, later, for indentured labourers, gives special significance to the institution of family in the Caribbean social history. The problem of economic survival on behalf of the majority of the poor also contributes to the significance of family relationship, according to Furnando Henriques. His comparison between the Caribbean society and English society discloses that there is 'intensification of family relationships as a substitute for the individual's social and economic development. In English society ... there has been a steady decline in the emphasis of family as opportunities for advancement and social security increase.'[20] Frantz Fenon universalizes the significance of family in his remark that there is 'a close connection between the structure of family and the structure of the nation.'[21]

This work proposes to study the relationship between individual and family in the Caribbean Novel, as a valuable means for comprehending the Caribbean persona's struggle to realize the urge for meaningful relatedness. The relationship between the individual and family becomes a complex process of dynamic interaction, both positive and negative, in response to a variety of discriminatory forces in mutual conflict. These forces can be classified as follows -

i) *Racial* - The multiracial society of the West Indies, includes the whites, Negroes (blacks), the East Indians, the Chinese, the Jews, the Lebanese, the Syrians and the Creoles.

ii) *Economic* - The Caribbean society is economically divided into three classes. The highest class includes businessmen and administratives; the middle-class, people in service; and the working class, peasants and workers.

iii) *Social* - Colour discrimination proves to be the most important social factor which gives rise to colour hierarchy. It is the legacy of plantation slavery system. There was the common practice of the white Europeans plantation owners to take the concubines from among the better looking black female slaves. The female children of such union often became, in turn, the mistresses of the Europeans. Concubinage can thus be said to be the foundation of present colour-class grading system in the West Indies.

iv) *Cultural* - From cultural point of view, religion tends to discriminate groups of Caribbean society into Christians of various sects, people with black faiths, Hindus, Muslims, Jews, and others, as well as people of mixed faiths.

v) *Historical* - Caribbean society passes through three periods historically - Plantation slavery period, Colonial period, and Post-colonial period.

vi) *Regional* - The regional discrimination involves stratification into the rural and the urban. The rural population is, mainly, black and East Indian; it is backward and poor. The urban is, on the other hand, associated with the modern and the civilized.

vii) *Exile Experience* - The Caribbean persona regards exile as an essential Strategy for survival

In the Caribbean literary context, the concept of family oscillates between two poles of socially realistic family situation, and imaginatively enlarged vision of the world as a family,

In almost all fictive narratives, 'family' provides a strategic device to project the multi-dimensional reality of the Caribbean experience. The individual is located in the 'family' - a multiple of dynamic relationships in various roles such as –

i) Individual during the process of growth from childhood to maturity within the family.

ii) Individual as an adult member of the parents' family.

iii) Individual as the head of his own family.

iv) Individual as an exile, separated from his family.

v) Individual in search of surrogate family.

On the psychological level, family with its members and surroundings, is identified by the individual as his 'home' or 'house'.

Along with the individual family units projected in the Caribbean fiction, there is a collective unit of people in a village or community bound together intimately as members of a family. Caribbean writers exploit the potential of such bondedness of the people by presenting the image of a village or community as itself a family. Such family can be called 'a communal family' in which different small family units participate as its individual members.

On the metaphorical level, the Caribbean writers envision the future of mankind as a single world which is then seen as a timeless and spaceless family, and different nations with their different geographies and histories as its members.

The chapter division is as follows -

The second chapter specifies the contexts for the study of individual and family relationship in the Caribbean Novel. It explicates the psychological and sociological context in general, and the Caribbean sociological context in particular. Psychologists and sociologists think that family evokes love, care, physical and psychological nurturance, and protects an individual from the hostile world during the process of his growth from childhood to adulthood. The Caribbean family structure is

heritage of slavery. As the males were discouraged from assuming responsibility for wives and children, the plantation slavery system gave rise to mother-centred family which was to continue in a modified form even after the abolition of slavery.

The third chapter deals with the novels of the fifties. The group presents the individual and family relationship in complex colonial environment. Family offers emotional support for the individual to survive in the hostile environment. Edgar Mittelholzer's *A Morning at the Office* [1950] epitomizes an urban workplace family, whereas, Lamming's *In the Castle of My Skin* (1953) centralizes mother-son relationship within the framework of rural peasant community. Roger Mais's *Brother Man* (1954) deals with the man-woman relationship with reference to the urban slum community, whereas, Samuel Selvon's *The Lonely Londoners* (1956) narrativizes the sufferings of the emigrant black community struggling to survive as a surrogate communal family in a white society. Naipaul's *The Mystic Masseur* (1957) turns to Hindu family relationship.

The fourth chapter deals with the novels of the sixties. Naipaul's *A House for Mr. Biswas* (1961) treats the familial relationships of the hero as a metaphor for the Caribbean persona's struggle for liberation from the oppressive environment. Wilson Harris's *The Eye of the Scarecrow* [1965] projects the metaphysical vision of the womb as the origin of the humanity

beyond history and geography through the multilayered relationship between the families of the so-called friends L - and the Narrator. Michael Anthony's *The Year in San Fernando* (1965) offers insight into the contrastive nature of the mother-son relationship in two families - one rural and poor, another urban and rich, representative of two cultures. *Moses Ascending* (1965) is Samuel Selvon's narration of the black exile hero's hopelessly comic struggle to be meaningfully related to the white society through achievement of the economically superior position as a landlord. *Wide Sargasso Sea* (1966) of Jean Rhys is the tragic history of the exploitation of the ex-plantation white owner's family by the black community and the white emigrants.

The fifth chapter deals with the novels of the seventies. Merle Hodge's *Crick Crack, Monkey* (1970) examines the psychological growth of a girl child in two families, rural and urban, whereas, George Lamming's exile novel *Water with Berries* (1971), explores the familial relationships between the black and white community. Selvon's *Those Who Eat the Cascadura* (1972) depicts the hopeful possibilities of meaningful relatedness through the intense love-relationship between a white exile and an East Indian girl. Naipaul's *Guerrillas* (1975) psychologizes the pseudo liberation struggle of the black hero against the white economic imperialism through his relationship with a white woman.

The sixth chapter deals with the novels of the eighties. John Hearne's *The Sure Salvation* (1981) narrates the voyage of the illegal slave ship, to expose the human lust for economic power which dehumanizes the white and black crew members of the ship. Jamaica Kincaid's *Annie John* (1983) depicts the mother and daughter relationship psychoanalytically. Samuel Selvon's *Moses Migrating* (1983) is a farcical scrutiny of the Europeanized black emigrant psyche reduced to the condition of homelessness due to the inability to be meaningfully related either to the black or to the white community. Merle Collins's *Angel* (1987) magnifies the role of 'family' as a vital link in sustaining individuals as well as society. In *The Enigma of Arrival* (1987) Naipaul's creative perception of the various types of British families heals his sense of racial guilt for the colonizer - colonized relationship, as an exile in England.

The last chapter summarizes the conclusions which emerge from the detailed analysis of the relationship between individual and family in the Caribbean novels of four decades.

References

1. Eric Williams, *The Approach to Independence*, (Port of Spain : 1960), p. 45.

2. George Lamming, "Occasion for Speaking" in *The Pleasures of Exile*, (London, New York : Allison and Busby, 1960), p. 35.

3. Quoted in Kenneth Ramchand, "Introduction", in *The West Indian Novel and Its Background*, (London : Faber and Faber, 1970), p. 4.

4. Fernando Henriques, (Compl.), "Introduction to the West Indies", *The Journal of Commonwealth Literature*, No. 4, Dec., 1967, p. 51.

5. Kenneth Ramchand, "In the Castle of My Skin", in *The West Indian Novel and Its Background*, op. cit., p. 20.

6. L. E. Braithwaite, "Roots", *Bim*, Vol. x, No. 37, July - Dec. 1963, p. 10.

7. Peter Nazareth, "Interview with Sam Selvon", *World Literature Written in English*, Vol. 18, No. 2, 1974, p. 426.

8. Wilson Harris, "Tradition and the West Indian Novel", in *Tradition, the Writer and Society : Critical Essays*, (London, Port of Spain : New Beacon Publications, 1967), p. 31.

9. Rex Nettleford M., *Caribbean Cultural Identity : The Case of Jamaica*, (Jamaica : Herald Ltd., 1978), p. 181.

10. Leslie Ogundipe, "Recreating Ourselves All Over the World : Interview with Paule Marshall", *Matau*, 3.6, 1983, pp. 30-31.

11. Merle Hodge, "Challenges of the Struggle for Sovereignty : Changing the World versus Writing Stories", in *Caribbean Women Writers : Essays from the First International Conference*, (ed.), Solwyn R. Cudjoe, Wellesly M. A. (Calalou : Calalou and Publications, 1990).

12. Derek Walcott, "Antilles : Fragments of Epic Memory", *The New Republic*, Dec., 1992, p. 28.

13. Renu Juneja, *Caribbean Transactions : West Indian Culture in Literature*, (London, Basingstoke : Macmillan Education Ltd., 1996), p. 217.

14. Richard White, *Investing Australia : Images and Identity - 1688 - 1980*, (Sydney : Allen and Unwin, 1981), p. viii.

15. Stuart Hall and Paul Du Gay, (eds.), *Questions of Cultural Identity*, (London : Sage Publications, 1996).

16. Diana Yeh, "Ethnicities on the Move : British, Chinese Art Identity : Subjectivity, Politics and Beyond", *C. Q. Critical Quarterly*, vol. 42, no. 2, Summer 2000, p. 83.

17. Gloria Cumper, "Review : Mirror Mirror Identity : Race and Protest in Jamaica", *Caribbean Quarterly*, vol. 17, nos. 3 & 4., Sept.-Dec. 1971, pp. 144 - 145.

18. Renu Juneja, op. cit., p. 8.

19. Quoted in Ken Godwin, "Some Problems of National Identity", *The Literary Criterion*, Vol. xxx, Nos. 1 & 2, 1995, p. 1.

20. Fernando Henriques, "West Indian Family Organization", *Caribbean Quarterly*, Vol. 2, No. 1, n. d., p. 24.

21. Frantz Fenon, *Black Skin White Masks*, trans, Charles Lam Markmnn, (1952, rpt. New York : Grove Press, Inc. 1967), p. 147.

CHAPTER TWO

INDIVIDUAL AND FAMILY : SPECIFYING THE CONTEXTS

The study of individual and family relationship in the Caribbean novel requires two important contexts. They can be specified as follows -

A) Psychological and Sociological Context

B) The Caribbean Sociological Context

A) Psychological and Sociological Context

'Individual' and 'family', the important subjects of psychology and sociology respectively, contribute vitally to the understanding of the human condition. Psychologists like Erikson and others believe that human development results from changes that are derived from interactions among the biological, social and psychological dimensions across the life-span. In the 80's, the scope of the study is enlarged by integrating the development of individual with that of family. The integral approach explains the individual development within the context of the family. According to Jerry Bigner, the family is one of the most powerful and pervasive influences on an individual's development especially during infancy, childhood and adolescence.

Psychologists have decided the following mentioned phases of individual's growth from infancy to death by taking into consideration

the growth of an individual in a 'stable family' for their study. They have European model before them. European society is stable society culturally, socially, economically and politically.

The Phases of Individual's Development :

Infancy : Infancy is a period in the life span when an individual is between 2 weeks to 3 years of age.

Early Childhood : It is the time when children expand their knowledge of the world and develop an attitude of accomplishment.

Middle Childhood : This change begins at the age of 6 and continues upto an individual's twelfth birthday.

Adolescence : The period at 13 to 18 years of age has been recognized as adolescence.

Early Adulthood : It is regarded as the pinnacle of individual development. To be an adult means that one has arrived at a respected and competent station of life, that one has attained maturity.

Middle Adulthood : It takes place when people are between 45 and 65 years of age. It is called a transitional period.

Late Adulthood : It extends from age 65 or old age.

Dying and Death : Dying is the last developmental stage of life span. (Death can also occur at any point of life span).

In stable societies, 'marriage' is the foundation of a family structure. A marriage between a man and a woman is necessary, because marriage is a socially and legally sanctioned institute. Jerry J. Bigner states, 'It is generally agreed that the traditional foundation of family begins with the committed relationships of two adults. A legal marriage is necessarily one between two opposite - sex adults. Traditionally family implies an adult opposite-sex couple and their children sharing a physical residence and mutually agreed - upon goals for their relationship.'[1] After marriage a man and a woman are called husband and wife. Father gives this name to the children and children become legitimate members of the family and society. Society provides them certain kind of security. Hence, marriage is a sacred institution of a stable society. It is a vital part of the culture which expects certain kinds of rules, customs and regulations to be followed by the family. Ethics and morality patterns are strictly observed by this social legal system. Even families may develop specific rules governing the relationship between parents and children. These rules are derived from adults' beliefs who have acquired these beliefs from a number of different sources, such as, from their own parents, the teachers, their peer groups, books and magazine articles about family life. Structural anthropolist (Claude Levi - Strauss, in his book *Elementary Structure of Kinship* (1969) states that any social order is based on kinship system and "marriage" is the origin of kinship system. Further he argues that biological families are transformed into social organization through marriage.

The concept of family evokes love, caring, physical and psychological nurturance in setting the individual apart from the hostile world. Murdock[2], has identified four functions believed to be found in all families in all cultures - (1) reproduction of new members of society, (2) legitimizing sexual relations between adults, (3) reciprocal economic relations between the family group and the larger society, and (4) socialization of children for their future adult functioning in society. Thus family and society help individual to establish his identity which takes shape in trustworthy environment. Tufte and Meyerholf comment, 'The family... is located as the physical site for a vast ... range of human expression, the valid arena ... where equality of life is concerned. It is in the family that we find the opportunity, for psychologically bearable, non exploitative personal life.'[3] The structure of family varies from society to society. Family or the home is the place to regain a person's physical and psychic balance in order to be able to deal effectively with the outside environments. The basic functions of family are internalization of society's culture, and the structuring of the personality. The family's functions for society are inseparable from its functions for its individual members. The family provides the only opportunity to participate in a relationship where people are perceived and valued as whole persons.

Sociologists recognize different types of families. In their scheme of classification, a family is known as a primary group. A 'primary group' is one characterized by small size where intimate interactions among members take place.

Nuclear Family : It refers to two or more persons related by blood, marriage, or legal adoption.

An Extended family : When several nuclear families live together and function jointly as one group, they make up an extended family. Several generations that share a common ancestor may constitute an extended family. Such pattern is common among certain minority and ethnic groups.

After industrialization nuclear family is common and dominant family form which is mostly seen in urban areas. In peasant and rural society, extended family pattern is still going on. Large family support is typical of rural life. Sociologists state that in nuclear families there is greater male-female equality. When the extended family is the predominent form, the male assumes greater power which leads to complex relationships.

Single Parent Family : It is composed of one adult parent. One or more children under 18 years of age are headed by a man or a woman. Such families are mostly female-headed. A single parent family is created through one of three means 1) divorce, desertion or separation of the adults; 2) death of one adult; 3) having a child illegitimately. Most common is divorce, and generally mother gets custody of the children. Both men and women experience greater role strain. The major adjustment woman must make is add wage-earner responsibilities to parenting duties and man has to assume greater home management responsibilities. They become very

protective toward their children. Women become more authoritative in such families. By and large, life is very hard for single parent families.

Blended Family : It is a new term for step-family. These families include an adult couple and children of one or both of them from a previous marriage or relationship. This family type is based on the remarriage of at least one of the adult partners.

A Generational - Inverse Family : It is like extended family where adult children head the household and act in a custodial capacity toward their parents. The parents are dependent upon them for shelter and support.

Homosexual Family : Society does not sanction homosexual relationship through legal means such as marriage, but now, in United States of America, such marriages are sanctioned. It is actually a long-term commitment relationship. Such families may include children.

In all, the survival of an individual is dependent on how successfully families respond to social changes. The course of individual's life from birth to death involves many developmental changes. They evolve and lead to progress in an individual's life. As individuals experiences a life course, so do the families of which they are members. Families go through a family life-cycle, a course of development from the time of its establishment to its dissolution, as shown by a number of sociologists like Evelyn Duvall[4], Mattessich[5] and O' Rand.[6]

B) The Caribbean Sociological Context

The exceptional nature of the Caribbean political and social history foregrounds the need of understanding 'family' in the Caribbean sociological context.

The long period of slavery, introduced by European sugarcane field owners in West Indies, has greatly influenced the family pattern of Caribbean society. Slave trade flourished between 1482 to 1860. Export of African labour to the West Indies and Americas marked the greatest and most forceful and fateful migration in the history of man. Barbara Bush states : "Africans of both sexes were regarded as 'salves by nature' - childlike, primitive, idle and of a lower intelligence level than Europeans."[7]

On plantation, men and women were kept in separate barracks. They were regarded as chattels to be bought and sold and resold, and even mortgaged at the will of the masters. Their masters were Spanish, Dutch, French and British. Thus the slave was an 'economic asset', 'an animate tool' and a part of 'agricultural machinery'. Men were called 'field-hands' and women were called 'mammies'. They were never allowed to form any kind of unit. They did not have any security. Naturally, the domestic life and behaviour of the slaves was affected.

The owner would often encourage his female slaves to breed more children from a number of men. They were even offered prizes for this

achievement. Good looking girls were selected by owners or masters for their sexual satisfaction. Their masters were many and, mainly, white. Their union led to hierarchy of skin colour, George Lamming comments, 'Some masters did not think the female slaves unfit for bed and commanded them to have intercourse whenever they chose. Sometimes a slave's dexterity under the sheets might earn her status of a regular mistress.'[8] The least degree of what may be described as family life was permitted to the female slaves as a mother. She was responsible for the growth of the children till they joined slave force.

Crossing the Atlantic meant for the Negro a complete break with his traditional tribal type of society. Customs, social sentiments, and patterns of behaviour could survive only as ideas and in oral form. Marriage was not possible in plantation slavery. Masters often forgot to give a father's name to the child. Gerald R. Leslie states, 'Strong healthy males were used as studs and the formalities of marriage often were dispensed... fathers were sold or traded without their wives and children and vice-versa.'[9] Hence, the emphasis in the slave family was upon the mother-child relationship.

In 1834, the Emancipation Act was passed and slave-trade was legally abolished. From mid 19th century to mid 20th century, majority of the islands were occupied by United Kingdom, France and United States.

Colonial system aimed at perpetuation of the white rule through the introduction of 1) white man's language and education system, 2) new religion (Christianity), 3) a new capitalistic set-up, 4) a different administrative and political set-up, and 5) a different culture (European). Colonial forces influenced Caribbean family structure through imposition of British family model in the form of monogamous marriage and patriarchal nuclear family. There was a general tendency to be like the whites. Immigration for economic security was basically the outcome of the spiritual urge to go to the Mother country, or master's land.

Ex-slave society continued mother-centred family structure with slight modifications. The concept of family remained flexible. As Barbara Bush points out, 'complex family relationship existed between non-coresidential as well as co-residential kin.'[10] In some cases, 'family' was represented by fictive kin. Merle Hodge also explains how, 'almost all of us are socialized ... in a family framework which has nothing to do with the traditional nuclear family... children are shared here by a network of households.'[11]

The introduction of indentured labour system to meet the requirement of field labourers after abolition of slavery marks another crucial stage in the Caribbean social history. The European plantation owners bring the labourers on contract, mainly, from East India, China

and Lebanon in the second half of 19th century. It leads to further racial hybridization and flexibility of Caribbean family patterns. The East Indians, Chinese and Lebanese also were tempted, as Nettleford points out, to 'side with the symbols of power which are logically those associated with Europe.'[12] As a result, their family structure was gradually Europeanized.

The institutions of family and marriage are considered to be synonymous concepts in stable societies. The children from married relationship between males and females are accepted by society as 'legitimate'. But the life-experience of the Caribbean society utilizes the need of merging the concepts of legitimacy and illegitimacy. The tendency towards cohabitation without legal sanction of marriage has given rise to racial hybridization with 'an overwhelming majority of population being illegitimate'[13]. It is indirectly noted in the statements about the racial mixture in Caribbean society. M. G. Smith[14] refers, for example, to 'a deeply segmented aggregation of descendants of European masters, African slaves and in-between offspring of both' in his pluralistic interpretation of the society. Henriques, validates the phenomenon of illegitimacy through numerical evidence of the survey of the total number of mothers in Jamaica in 1942 out of which 'Approximately 34 per cent were listed as married, 54 per cent, as unmarried, and 12 per cent, as widowed or divorced.'[15]

The impact of white culture has encouraged the Caribbean society to offer ideological status of a moral value to legitimacy, although actual practice contradicts it. It often necessitates defensive strategies on the part of the members. For instance, Jamaica Kincaid confesses and, at the same time, justifies her illegitimacy of birth in her statement, 'I am illegitimate, I am ambiguous. In some way I actually claim the right to ambiguity, and the right to clarity.'[16]

In general, life-long monogamous conjugal relationships on the European model, and Hindu and Muslim polygamous marriages are found, but are not common, in Caribbean society. The most common pattern is that of cohabitation with two or more mates during a life-span. Henriques[17] bases his classification of Caribbean family structure on this basis. He finds four broad types of families. The first type of 'Christian Family', is the only form based on marriage. The second type of 'Faithful Concubinage' involves the man and the woman living together like husband and wife. The third type of 'Maternal or Grandmother Family' is the kind of family in which the grandmother or some female relative takes on the function of a father or a mother. The fourth type is 'the Keeper Family'. It refers to the man and the woman living together in a temporary union. The four types may exist either independently or in various combinations.

Caribbean family pattern is not like Negro or Indian family pattern. Negroes were sold as slaves to private masters. They got comparatively more human treatment. They were allowed to maintain their family structure as their 'right' by their white masters and their relationship with them was affectionate. Skarga Poweski generalizes, 'Since slavery was chiefly a personal and household relationship after the rise of feudalism and serfdom, it seems safe to assume that both the best and the worst conditions were to be found under private masters.'[18] Zinn and Eitzen also state that 'slave society developed with its distinctive African-American family and kinship networks'[19] as their population increased. Indian family, on the other hand, is homogeneous. It has distinct racial identity and has a history of stable culture. Their family pattern remains patriarchal where mother is passive housewife. Caribbean family is exactly opposite of them. They are not allowed to have family. There is hybridization of all races, and their family pattern is matrilineal. Mother is wage earner, not by choice but by compulsion. Caribbean mothers are independent, assertive, able to fight with the environment alone. She learns to protect herself because in the period of plantation slavery her man failed to, or could not, protect her from rape.

Throughout Caribbean history there has been schisms within ethics, social class, culture, religious and sexual parameters, leading to the lack social cohesion. The absence of social solidarity has had comprehensive

implications of the identity. Experience of exile teaches them the importance of 'home'. For them 'home' means home, homeland, village, country, and place where they could feel their 'self'.

References

1. Jerry J. Bigner, *Individual and Family Development* (New Jersy : Prentice Hall, Englewood Cliffs, 1994, first published 1983), p. 72.

2. G. P. Murdock, *Social Structure*, (New York : Macmillan, 1949).

3. Eds. Virginia Tufte and Barbara Myerchoffs, *Changing Images of the Family*, (New Haven : York University Press, 1979), pp. 17-18.

4. E. Duvall, *Marriage and Family Development*, (Philadelphia : Lippincott, 1977).

5. P. Mattessich and R. Hill, "Life Cycle and Family Development", in M. Sussman and S. Steinmetz (eds.), *Handbook of Marriage and the Family*, (New York : Plenum, 1987).

6. A. M. O' Rand and M. L. Krecker, "Concepts of the Life Cycle, Their History, Meanings, and Use in the Social Sciences", *Annual Review of Sociology*, 16 (1990).

7. Barbara Bush, *Slave Women in Caribbean Society : 1650 - 1838*, (Kingston : Heinemann Publishers, London : Indiana Uni. Press 1990), p. 12.

8. George Lamming, *The Pleasures of Exile*, (London, Allison and Busby, 1984), p. 12.

9. Gerald R. Leslie, *The Family in Social Context*, (London : Oxford Uni. Press, 1976), p. 314.

10. Barbara Bush, op. cit., p. 86.

11. Katheleen Balutensky, "We are all activists : Interview with Merle Hodge", *Callalo*, 12.4, (Fall 1989), p. 655.

12. Rex. M. Nettleford, *Caribbean Cultural Identity, The Case of Jamaica : An Essay in Cultural Dynamics*, (Jamaica : Institute of Jamaica, 1978), p. 4.

13. M. G. Smith, "Caribbean Cultures", in *Encyclopaedia Britannica*, Vol. 3, (Berkeley, 1965), p. 904.

14. ----------------, *The Plural Society in the British West Indies*, op. cit.

15. Fernando Henriques, "West Indian Family Organization" reprinted in *Caribbean Quarterly*, Vol. 2, No. 1, n.d p. 19.

16. Kay Bennetti, "An Interview with Jamaica Kincaid", *The Missouri Review*, 1512 (1992), p. 129.

17. Fernando Henriques, op. cit., pp. 16-24.

18. Skarga Poweski, "Slavery", in *Encyclopaedia of the Social Sciences*, Vol. 13-14, ed. Edwin R. A. Sellagmann, (New York : The Macmillan Company, first ed. 1934, this ed. 1963), p. 79.

19. Maxine Baca Zinn and D. Stanley Eitzen, *Diversity in Families*, (Harper Collins College Publishers, 1996), p. 54.

CHAPTER THREE

THE NOVELS OF THE FIFTIES

The novels of the fifties evidence that individual family relationship offers an important device for structuring the Caribbean persona's struggle for meaningful relatedness in the complex colonial environment. The novels included in this group are as follows :-

1. Edgar Mittelholtzer's

 A Morning at the Office (1950)

2. George Lamming's

 In the Castle of My Skin (1953)

3. Roger Mais's

 Brother Man (1954)

4. Samuel Selvon's

 The Lonely Londoners (1956)

5. V. S. Naipaul's

 The Mystic Masseur (1957)

(1) *A Morning at the Office* (1950)

Edgar Mittelholzer, born in 1909, lived in a small Guyanese coastal town of New Amsterdam doing odd jobs for customs, checking drums of petrol, even acting as cinema inspector. His novel, *Corentyne Thunder* (1938)

was followed by *A Morning at the Office* (1950) set in Trinidad after his stay in Trinidad between 1941 and 1948. He finally settled in England. There existed an ambivalent relationship between him and his father, who resented the boy because of his dark complexion, but who, at the same time, loved him. Mittelholzer seemed to have admired his grandfather whose eccentric and non-conformist pattern of living appealed to him. In *Kaywana* triology he portrayed Dutch family and its Guianization from 1611 to 1953. Then he published *The Life and Death of Sylvia* (1953). He explored all the genres of literature. His hopeless love affair led to his suicide on May 6, 1965 in England.

A Morning at the Office [1] narrates the routine of the office in Port-of-Spain, Trinidad, which is meant for the transactions of Essential Products Ltd. of Roalk's Hardware and Cycle Depot, one brief morning between four minutes to seven and lunch time. The routine of the office with its colonial, urban, educated middle class milieu, becomes a microcosm for the West Indian Society. Michael Gilkes rightly points out, 'The daily lives of all the characters are shown burdened with a past that is responsible for the frustrations and prejudices that create racial snobbery, resentment and lack of self respect--- within the narrow confines of office and island...'[2] Entrenched in body's need for survival in economic terms ---the individuals in Mittelholzer's novel are hectically engaged in the strategies of superiority-inferiority as defence mechanisms.

The familial interrelationships in the workplace family of the office are offered in the following perspectives -

I) The racial perspective

II) The economic oerspective

III) The social perspective

IV) The psychological perspective

As members of the workplace family, with Mr. Murrain the Englishman as the head, they clash and compromise; indulge in the antagonism; and celebrate the victory as perpetrators of humiliations while being themselves the victims of the same. It leads to their inner sense of frustration for the failure to be related positively as human beings on the level of equality.

Mittelholzer's recognition of the skin as the origin of the hierarchy activates his choice of characters and their families. For individuals, as members of society, the colour of skin, and the economic status is the heritage of family. Hence, the outline of the relationship of the characters with their families becomes vital for the novelist's projection of Caribbean society.

I) The Racial Perspective

Horace Xavier, nineteen, a negro and brown, is an office boy living with his mother. Mary Barker, a negro sweeper has two sons - Richard and

Peter - both of whom are illegitimate. Richard's father, Boysie Lamb, lived with her for two years and deserted her for another woman. Peter's father, Jasan David, has been faithful to her for eleven years. He has left his wife Roxane, with two children on charge of infedility. Miss Henery Kathleen, coloured, is the accounts typist. Her parents are Anglo-catholic. Her complexion is nearly white. Mrs. Hinckson is the manager's secretary and a chief stenographer, she is coloured, middle-class woman. Mr.Jagbir, the East Indian, is assistant accountant. Laura Laballe, the switch-board operator, is Portuguese. She is illegitimate, and also has illegitimate child from an American soldier. Olga Yen Tip, a Chinese, is the chief clerk's stenotypist who cannot speak Chinese. Rafael Lopez, a Spanish creole, is a junior accountant. Eustace Benson, the chief clerk, coloured and three-parts negro with negroid features, is illegitimate. Mr. Reynolds William is coloured, Grenada born and salesman of the company. Patrick Lorry, coloured, is customs clerk. His mother is a mixture of negro, East Indian and white. His parental great-grandfather was a Scottishman. Miss. Bisnauth, an East Indian, is manager's assistant stenotypist. Her parents were coolies at sugar estate and cannot speak Hindustani. Michael Gilkes comments, 'The 'Office' itself is a microcosm of the West Indies, whose formal pattern of racial and social degree is reflected in the way the multiracial staff is organized.'[3]

II) The Economic Perspective

The body's need of survival in economic terms offers another important dimension for the relationship with characters, with their families in the novel. Xavier's mother tries to give him good education. She is a cook and thinks that one day he will be a chief accountant or a doctor or a politician, which heightens his belief in himself. He joins night school, reads Shakespeare and good novels like *Tale of Two Cities*. Mary Barker is determined to send her son, Peter, to school until he is at least sixteen. She and Jason David have two roomed cottage but, without money, Jason always feels insecure and desires to possess an unlimited amount of money. Edward Murrain, now a chief accountant, has left England for Trinidad for a good job opportunity. He draws 360/- dollars salary per month but it is not enough to keep his status as a member of the master class in Port of Spain. Mr. Jagbir, draws 120/- dollars per month. Yet he is always under tension that Mr. Murrain will dismiss him. He impresses everyone in the office to retain his job. He is forty and always fears instability. He has worked on the sugar plantation as coolie in his childhood. The memories of humiliation obsess him- 'Never a day had his white superiors forgotten to make him know his place'.(p.32) Even in his present job he has to tolerate all kinds of humiliation from whites as well as blacks. Laura Laballe's parents were once rich but now they are poor. Her father, Mr. Karl Laballe leaves her when she begins to earn. She has to retain her job so she keeps good relationship with her staff members.

Olga Yen Tip's grandparents were imported Chinese labourers. Her father's extravagancy and generosity made them poor. Poverty brought early death of her parents. She is not invited to the functions at the Chinese consulate. Her father was unsuccessful businessman. Mrs. Hinckson, although she belongs to higher middle-class, depends on her stenotyping due to her husband's early death. She has got a son. Economic dependency is against her pride.

To guaranty economic stability, individuals are compelled into corrupt practices because everybody wants to avoid the degradation of poverty. Mr. Benson adopts corrupt practice to become rich. With Mr. Milan he has made private arrangement to get money. They sell gas in half charge to their friends when the full amount is paid by Tucurapo company. Mr. Benson is expert in handling all the secret transaction by checking and passing all the gasoline accounts.

The fear of instability constantly haunts all the members of the office. The racial heterogeneity and stratification of the family background generates tensions for the individuals in the office. They convert their economic anger into jealousy, hatred, rivalry and attitude of antagonism. The pride in the complexion becomes one of their survival tactics. They all undergo colonial tensions and reflect society's attitudes about colour, class and money. Horace Xavier is happy that he is privileged by Mr.Murrain to open the office; that the key of the office is in his possession;

and feels that it is an upward step in his career. 'He felt triumphant and proud of himself....if gave him a sense of consolidation, made him feel he could now reckon himself beyond any doubt a member of the firm's office staff - a member who mattered.'(p.5) He is so proud of his given position that it makes him reluctant to speak with negress, Mary Barker, a mere sweeper - a menial . He has now desk of his own that means he is a person who is counted. Both of them are black but now it is position that matters. He hates Mr. Jagbir, an East Indian, who belongs to coolie class below his race. He never misses a chance to let him down. As a superior to him Mr. Jagbir wants that Xavier should wish him good morning. The boy answers, 'If you were the king it was your place to tell me morning when you come in and find me here'. (p.22) Insult is the only means to maintain the distinct identity. Mary Barker uses the same tact. She is proud of the race; East Indian like Jagbir is below her race. She calls them 'cheap coolies' and is reluctant to call him 'Mr.' On the other hand, Mr.Jagbir thinks that he is superior to Xavier and Mary because he is assistant accountant, the post of respect. He tries to satisfy Mr. Murrain and Mrs. Hinckson. He eulogizes them. He has a wife and children and does not want to lose his job. He is sincere in his work but nobody forgets to insult him.

Laura Laballe feels the same entrapment like Mr. Jagbir. She is Portuguese, but not considered as white. Her father Karl Laballe, a French

creole, was rejected by his father because he married a Portuguese girl, Teresa, i.e., Laura's mother. She tries to keep amiable relationship with staff members without involving herself in their personal or social matters. To keep aloof, is another strategy of survival which she adopts.

III)The Social Perspective

Everard Murrain, who does not know anything about the accounts, is the chief accountant and assistant manager. As an Englishman he thinks,'.....he had every right to be idle. The company had put him here, in reality, to superintend these people - not simply to work along with them. They were a subject people, and he was an Englishman in a colony dominated by the British Crown'.(p.37) As a boss, in every matter, in colour and position, he thinks that it is right not to grant two weeks' leave to Miss Henery. He is obsessed with the white man's need of defending his image as the master in colonial Trinidad. He is compelled to pretend richness. His wife, Caroline, does that by giving cocktail parties and bringing things on hire purchase. When his wife asks for the money he leaves unsigned check at home. He criticizes Mr. Sidney Whitman, a good friend of his class, for keeping company of the coloured people. Status-conscious Murrain feels unsafe in Port-of -Spain, because he and Mr. Walley and the people like him are in minority in Trinidad. They are victims of humiliation by the subordinate colonials who exploit every safe opportunity for the purpose. Mrs. Hinckson expresses her anger about white people . 'These English

people must be put in their places. They've got to remember that this island belongs to us who were born here'.(p.153) When the procession of Dock workers passes by their office, shouting slogans against white ruler, coloured staff members openly support the labourers by attacking whites with word abuse. But Murrain has to conceal hid mood of depression and irritation. When Miss Henery insults him, he cannot tolerate it. His head whirls, 'Mr. Murrain experienced a discomfiture which, in its intensity, frightened him. It was a psychopathic discomfiture, he felt,.....the trapped in skin shudder'.(p.37) He sometimes earnestly wants to go home to England.

Miss Henery, the coloured middle class is conscious of her background of gentility and social superiority. For her, East Indian and Chinese elements belong to low class. She is mulatto. Kenneth Ramchand comments, 'Connected with the mulatto desire to be White, is mulatto hypersensitivity about Black kins folk.'[4] She considers herself equal to the whites in breeding and general culture. 'Her pride forbade her addressing a white man as "Sir".'(p.45) She ignores Mr. Jagbir and Mr. Murrain's authority. When Mr.Murrain rejects her leave application by saying that for her ancestors such a luxury as leave was entirely unheard of , on that she retorts, "Which of my ancestors ? Some were white. Could you be referring by any chance to the English ones who were made slaves from childhood in the factories of your nineteeth- century industrial England?" (p.99) Her sense of superiority is gratified when she insults

him. Mrs. Hinckson, Mr. Benson, Olga Yen Tip approve her conduct with Murrain and his wife. Henery is aware of her lawful right of two weeks' leave. She is ready to leave the job and is sure that she will get another. She is jealous about the privileges, whites enjoy, in spite of their little talent. Rafael Lopez has many coloured friends and he respects them. They belong to coloured upper-middle-class, but he cannot bring them home because his parents' strong prejudices against them. He plays cricket. Raffy Lopez and "century" is synonymous throughout the British West Indies.

Eustace Benson dislikes negroes and hates whites. He never forgets that he is a chief clerk. He does not want to help Mary Barker when she wants to find her lost note. His illegitimacy constantly gives the feeling of guilt. His mother has to hire her body to good class-coloured people to make both ends meet. She cannot tell him who his father was. She died when he was seven and is raised by his grandmother who taunts him for his impure blood. When once he stole sixpence, his grandmother screamed at him, "You can't help stealing. It's de bad blood what your mother put in you. It must come out one day." (p.167) So 'pure blood' is his rival. His 'niggerness' is intolerable to him and is compensates it by his efficiency, by learning shorthand and typing. But he knows that socially he will never get far, that his black skin will always hold him back. He takes revenge against his social inferiority by calling Mrs. Murrain 'a bitch.'

Patrick Lorry's European mouth, grey-green eyes and red complexion give him admission in Raider's club. He mixes with coloured people but his parents do not allow black people in the house as his father is a civil servant and mother a cousin of the Telbs, one of the best coloured families. Mrs.Hinckson, also like Miss. Henery, cannot tolerate the presence of liar Jagbir and Mr. Murrain. She neglects them. In fact, they are all trapped-in-skin, scared that their complexion will negate the chances of better opportunity. In order to secure their (false) pride they take help of insult strategies. It becomes the only way of survival. Their anger, frustration is human. The money based value of status obstructs healthy relationship even within a race. Their antagonistic behaviour with each other exhibits that kind of mentality. Their unnecessary pride holds them back. The Graingers, the wealthy cousins of Olga Yen Tip, offer their financial help to her, but she and her aunt reject it ,"I'd prefer to die dis minute," Miss Yen Tip often told her friends, "dan accept a cent from dose people." (p.208)

IV)The Psychological Perspective

Mittlelholzer introduces the story of 'Jen'in the novel as an allegorical definition of the West Indian crisis of identity. Jen indicates frustration and the fear of loneliness. The West Indian's sense of loneliness and frustration is due to racial and class prejudices, misjudgments, disbelief in one another and lack of respect for essential human dignity. The longings

and complexities are created by the sexual urge and hampered by the subtle class structure. The tale of Jen structures such each and every relationships in the novel. W. M. J. Howard comments,'...Virtually every character is fascinated by or has previously come to terms with an attraction which developed slowly and then was frustrated by a situation beyond his or her control.'[5]

Each character faces conflict on the psychological level as a sexual being. In case of each, the man-woman relationship is restricted to sexual level. It fails to achieve the depth of love. Horace's sexual attraction for 29 years old Mrs. Hinckson as a 19 years old boy is expressed through his act of writing a love verse to her by selecting a paragraph from *As You Like It*, replacing Rosalind's name to Nanette. This romantic adventure sends him into a transitory excitement. It is transformed into a source of fear, jealousy, anger and frustration. Miss Henery is infactuated by her cousin's husband, Gerard Beaton, who is active Presbyterian believer of marriage sacrament. Her obsession is purely sexual. She is ready to take any risk to enjoy sex with him. Mrs. Hinckson found her husband an unsatisfactory sex partner, and refuses a number of intellectuals after his death because she desires a man who is at once intelligent and a masculine animal. 'She lacked the libido of a nymphomaniac, but she had a strong sexual streak.' (p.110) She inclines towards Horace and respects his passion, but knows their relationship is impossible. She is infactuated by Mr. Waley, an

Englishman. Patrick Lorry is boastful of attracting girls of all classes and races. He is mildly interested in Mrs.Hinckson only because she refuses his advances. Lopez is sexually starved because of his cricket. Mr. Reynolds is homosexual. A man with green beret gives him unendurable ecstatic pleasure in dream. W. M. J. Howard comments, '...not only the normal relationships which exist between man and woman are frustrated by difference, distinction, economy or the crisis of war but one also finds the deviation from normal longings in the case of Mr. Reynolds..'[6]

In spite of the blockages due to class and race stratification, the body's urge for sexual contact and love relationship offers the only opportunity to overcome the man-made barriers. Mittelholzer reveals how the sexual urge is, on the subtler level, the healthy human urge for relatedness. Mittelholzer believes in the essential dignity of man as a man. He is optimistic that the human need to understand each other will conquer racial prejudices. Mr. Murrain is haunted by the sense of importance in West Indian environment; Miss Henery is conscious of her prettiness; and knows that Marrian likes her. Nobody misjudges Horace. Mrs. Hinckson does accept his sincerity and his struggle to rise high. Reynolds is always ready to help others without least racial prejudice. Even the hateful East Indian like Jagbir helps Mary Barker to find her five dollars which she feared to have been lost.

The protagonist through whom Mittelholzer projects his vision of ideal human relationship, is Miss Edna Bisnauth and Arthur Lamby. Miss Bisnauth wants to become independent and self-reliant. She joins the present service eventhough she comes from wealthy background. She is a poetess. Her pity for Horace provides a genuine inspiration for a poem in her. Her staff has no complaint about her. She loves her parents. Both of them are compassionate people. Her mother helped the people of war, and father helped many by giving financial help. They are East Indians, cannot speak Hindustani; and have adopted European living style. They were coolies at sugar estate but strongly feel that an East Indian should marry an East Indian. Miss Bisnauth finds the Jen fairy tale supposed to be written by her lover Arthur, to offer consolation during her bouts of depression. Once he says to her, " do you realize I have English, French, German, Chinese and negro blood in me? I'm a regular U. N. Council". "Then we must have thousands of U. N. Council in West Indies," she had laughed.'(p.77) In spite of all odds, she decides to marry Arthur. The novelist believes, as is reported through Arthur's views on culture and nationalism, that 'If the West Indies was to evolve a culture individually West Indian it could only come out of the whole hotch-potch of racial and national elements.....it could not spring only from the negro.' (p.242)

The social realism in the novels of Mittelholtzer encourages Stephanos Stephanides to compare him as a novelist with Wilson Harris.

He thinks that 'Mittelholtzer consolidates the negative legacy of his characters' story or history and shows no possibility for change.'[7] However, *A Morning at the Office* closes on an optimistic note. Horace asserts his sense of dignity through his acts of protest; very boldly he declares that he is the writer of the love verse, and leaves job not submitting himself to humiliations. Mrs. Hinckson accepts Lorry's invitation, Miss Henery overcomes her sense of hatred. She accepts Mr.Murrain's lift in his car.

The novel succeeds in telescoping reality of the tremendous multiracial complexity. The unity of place, time and action in design of the novel, evidence Mittelholzer's skill. He assimilates multilayered West Indian community into a single plot. His characters are all individuals with all natural human urges. Arthur has solution over all discriminating factors that 'West Indians should remember that they were first of all citizens of the world and only secondly West Indians.'(p.242) The staff members of the office form a multiracial family, which points to the dream of a global village.

References

1. Edgar Mittleholzer, *A Morning at the Office* (London : Hienemann, 1950).

 (All quotations cited are taken from this edition).

2. Kenneth Ramchand, *The West Indian Novel and its Background*, (London : Faber and Faber, 1970), p. 44.

3. Ibid, p. 104.

4. Ibid, p. 44.

5. W. M. J. Howard, "Edgar Mittelholzer's Tragic Vision," *Caribbean Quarterly*, Vol. 16, No. 4, Dec. 1970, p. 20.

6. Ibid, p. 20.

7. Stephanas Stephanides, 'Victory over Time in the Kali Puja and in Wilson Harris's 'The Far Journey of Oudin', in *The Literate Imagination: Essays on the Novels of Wilson Harris*, ed. Michael Gilkes, (London and Basingstoke : Macmillan Caribbean, 1989), p. 130.

(2) *In the Castle of My Skin* (1953)

George Lamming was born in Barbados, one of the Caribbean islands, in 1927. His mother who 'fathered him' was a woman of strong character. He left Barbados at the age of 18 to teach in Trinidad college. Frank Collymore, his teacher, put at his disposal his extensive library which was the beginning of his new life. He migrated to London where he experienced the policy of discrimination of the British people. He expresses his traumatic experiences as an emigrant in his collection of essays *The Pleasures of Exile* (1960). He received 'Maugham Award' in 1957. His novels include *In the Castle of My Skin* (1953), *The Emigrants* (1954), *Of Age and Innocence* (1958), *Season of Adventure* (1960), *Water with Berries* (1971) and *Natives of My Person* (1972). His centre of operation is London, and this perhaps has added to the feeling of alienation in some of his work. His imagination is deep and moving but, at times, bizarre and violent.

The historical situation of colonization aggravates the struggle between urge for food and shelter and mind's urge for meaningful survival with the human core. The problem of economic survival leaves the colonized society helpless victims in the hands of the colonizers, ruthlessly engaged in the strategies for perpetuation of their economic and political power. *In the Castle of My Skin*[1] is a daring experiment of Lamming in autobiographical-childhood fiction where the story of G's/the hero's

growth from childhood to early adulthood is historically recreated to visualize the colonial society's evolution from self-ignorance to self knowledge- a crucial stage in every colonial history.

Two major kinds of family relationship are introduced in the novel.

I) Mother - son relationship

II) Communal family relationship

Lamming exploits the device of individual and family relationship to decode the complexities of the colonial economics and politics. The history of G's growth from childhood to early adulthood accentuates the relationship between G and his mother, while the history of the village focuses the communal family relationships between the white landlord and the rural community, as well as, between the members of the community.

I) Mother - Son Relationship : G and His Mother

Mother-son relationship passes through three stages along with the process of child's growth towards maturity-

i) Childhood

ii) Boyhood (school life)

iii) Early adulthood

i) Childhood

G's growth from childhood to early adulthood is a jealously guided and supervised process by his mother from the stage of symbiotic unity of the child with the mother to the stage of maturity at which the adult persona is empowered with the creative stamina to encounter the hostile and oppressive colonial environment. As a child of nine years, G experiences symbiotic unity with his mother. He lives in Barbados, which is 'Little England,' the colony of the whites, with Mr. Creighton as the head of the village. He is an illegitimate son who lives in the 'impermanent' house, which is turned into 'home' by his mother. G's mother is of strong mind, hard task master who maintains her family through hard labour.

The economic dimension dominates the mother's attitude to her son. She does not disclose to him her parents' slave past. When she was young, her parents went to Panama, and she was left to grow by herself without any family support. Even G agrees, 'My birth began with an almost total absence of family relations.' (p.12) She is poor, both wage-earner and nurturer. To make her son economically stable she has only one solution, i.e., education. She is vigilant and anxious for G's future. She wants to inculcate good habits in him. When G stops at the corner where people gamble, she flogs him and scolds, 'An' I talk to the boy about that corner he won't hear... I don't say you musn't have friends, but

that corner is no good for you.' (p.113) and she reminds him how much money she is spending on giving him extra tutions, and warns him against wasting her labour. She establishes her authority over him and underlines his responsibility of fulfilling her expectations about him. Her emphasis on the vitality of money in life excludes any opportunity of getting money through corrupt means. She tells him, "I think stealin' at any time is wrong,"(p.270)

G's mother is not only his mother but a guide and a teacher too. G's relationship with her is respectful and affectionate. He waits naked for her order after she bathes him. Mary Donnelly rightly comments, 'G lives in a state of pre-Oedipal unity with his mother.... like a foetus is dependent upon his mother for everything.'[2] He takes education under her strict supervision. If he fails to follow her orders she flogs him; but he never loses respect for her. When Bob, G's friend, and G exchange feelings over their mothers' flogging,

> 'Bob said....whatever she do to me I won't ever hit her back.'
> 'You ain't to do that,' I (G) said.
> 'They say you'll cursed if you hit a mother.'
> 'And she don't hit me for purpose. She does it' cause she's God-fearing, she always say that Bible say. "Spare not the rod and spoil the child." And it is only that she don't want to spoil me.'

'That's what mine says too.' I said '(p.21-22)

G finds his mother loving and caring but when she performs the role of a father, she is terrible. G learns survival tactics under her guidance taking education is foremost of them. He understands mother's emotions, her labour, her care. G says,' I had often seen her angry or frustrated and in tears, but there were other states of emotion. She experienced for which tears were simply inadequate..... she would become filled with an overwhelming ambition for her child'(p.18) G feels compassion for mother.

ii) Boyhood (school life)

As G grows, his sense of unity with the mother is substituted by his awareness of his separate existence from her. It is the phase of his 'individuation.' Still supervised, guided and economically supported by his mother, G is gradually exposed, as he grows, to the world of school, on the one hand, and to the village world around him, on the other. The world of school receives G, first as a student of primary school, and then, as a student of high school. His mother dictates his course of growth. The education given in the Groddeck's Boy school is planned by the colonial masters which is based on religious fantasy and myth so as to prevent powerfully their sense of identity. Sandra Paquet comments,'... the school functions to perpetuate ignorance, confusion, and destructive cultural dependence on the mother country (England) among its pupils'.[3] Boys

have fun time. They have secret life. G, along with his friends takes care not to be seen by the mother. He enjoys swimming in the sea, catching crabs, turning pin into blade on railway track, and secret visit to Mr. Creighton's house. There, G observes different complexions of Trumper, Bob and Boy Blue, dark, brown and brown black, and finds that nobody likes the idea of being black. G's exposure to the world of his village gives him opportunity to aquaint himself with the beliefs and superstitions of the community. The story of Bambi shows how Bambi and his family lived happily until European culture sabotages their faiths.

G goes to private tutions to get the scholarship for high school education. Mother does extra work. She constantly reminds him how much money she spends on him,'.....an' if you have no mind, then there is no use my tryn'. All my labour will simply go into Maxwell pond. The mind is the man.' (p.113) He wins the scholarship. He grows independently on the school ground and its premises. Still he obeys his mother. He concentrates on his studies as his mother has prepared him to fight for survival by giving him education.

iii) Early Adulthood

G witnesses the crucial period of the journey of the villagers from the illusion of Mr. Slime as saviour of his own people to the disillusionment of Mr. Slime as their most cruel betrayer. He observes Mr. Slime's growth

from school teacher to the leader of labour union of the shipping company, as the founder member of friendly society and the Penny Bank. He cheats innocent and ignorant village community by kindling the false dream of the ownership of land. G then comprehends the feudal system of overseer, police, teachers and Mr. Creighton. Even Pa and Ma, the most respected, oldest couple of Barbados becomes the victim of the change. The strike of shipping company takes place in town but the village remains unmoved. Afraid to grasp the change, they remain in their houses still believing the benevolence of Mr. Slime and Mr. Creighton.

G's exposure on two levels, at school and the village world, reveals the limitations of his mother, her little understanding of political changes. He completes the education and is offered a job of a teacher at Trinidad. That is the most enjoyable event for his mother. She prepares special Barbadian dishes 'Cuckoo' and 'Flying fish'. She talks continuously, and teaches him the values of their distinct culture though he has been learning them from his childhood. He reads diary when his mother talks to him. She reminds him, "Tis all I ask that you show me the right an' proper respect that a chil' should have for a mother----I had no easy time bringing you up Remember me an' you won't ever forget your respect for anybody else.'(p.265) Respect the human body is the Caribbean culture, she imbibes on his mind. She gives him Bible to remain decent physically and morally. G is thankful to her that she has given him the sense of identity, made him

ready to accept the challenges of the hostile environment. Trumper who comes to visit him from America, gives him political vision, the knowledge of Slime's betrayal. G departs from Barbados by taking Pa's, his godfathers, blessings and advice to go deep into the matter, learn your 'self' mother's love, and Trumper's political vision of 'my people'. Respect the castle of the skin is the advice Pa and his mother have given to him.

The variety of signified circles of meaning emanate from the mother - son relationship. G's family i.e. his mother, not only trains him in the strategies for economic survival but even empowers him with the core identity, the self-confidence to encounter the outside environment. The mother - son relationship also concretesizes the historical moment at which the colonial society chiscle out of its suffering, its future leaders. G's mother is, to use Alice Walker's phrase 'Walking history of our community.'[4]

Of course G's mother suffers from basic limitions as a colonial mother in training her boy. She is religious and fatalist. For her 'flood' is God's wish. She is resigned to the status quo position as Mr. Creighton, she thinks, will handle all the matters of the village. 'Acceptance' is all for her and as for all in the village. G comments, 'Miss Foster, My mother, Bob's mother. It seemed they were three pieces in a pattern which remained constant.'(p.24)

The adult persona G, recreating his childhood experience, regrets that the content of education cut him away from his roots. Sandra P. Paquet comments, 'G's mother's middle-class aspirations put a distance between him and the village'.[5] Education was an ideological strategy of the colonizers who alienate the younger generation from their own geography, history and culture. But for the alienation of G, G's mother may not be held responsible for G's sense of alienation. As a colonial mother, the only panacea for the economic predicament left available by the colonizers to the colonized was education. In spite of the malevolent content of education availability of its very available leads to the development of G's intellectual capacity to dignose the malady of colonialism as an adult.

G's mother reacts to Pa's going to alms house as an earthquake, but it does not reveal any awareness of the possible insecurity due to the similar fate reserved for herself. She is unable to understand Trumper's vision either. Whatever she does within her capacity is enough for G to define his environment and his role in it. He is armed by his mother with creative stamina to experiment with an alternative definition of 'my people', which may include both the whites and the blacks ... those sections of humanity free from exploiter-exploited relationship.

II) Communal Family Relationship

G's family is itself situated within the framework of communal family of Mr. Creighton's village. The village is almost an extended family with

three generations - the eldest generation of Pa and Ma, the elder generation of men and women, and younger generation of the boys. They all live in feudal society. Ngugi Wa Thiong'o comments, 'At the head of the Estate is Creighton, whose house appropriately stands on a hill, dominating all below it. The overseer, the police constables and the school teachers make the middle stratum. At the bottom of this social hierarchy are the peasants'[6] The land belongs to the landlord, he has shares in the shipping company of the town, where some villagers work. The villagers have accepted social order as divinely willed, and dwell under his shadow of 'paternal benevolence', 'subservient complexes govern their every response to and contact with Creighton.'[7] Their day starts with the bell of breakfast of Creighton, and when the lights of his house are switched off, they go to sleep. Even Ma and Pa's routine is planned according to this.

Villagers gather at the shop of the shoemaker for gossip. He is the only person who could read, and tell the news of the world. Another place of gathering is market place, and women gather under big cherry tree to gossip, beyond that they do not have world. They have faith in Mr.Slime. They hate overseer and sanitary inspector for whom the villagers are 'low down nigger people,' who could not bear to see one of their kind get along.

Pa and Ma, the old couple who lead a trans-historical existence, is a focal point of the novel. Ambroise Kom comments, '..... Pa and Ma, or Pa

alone, after the death of his wife, represent tradition and stability, the "rock", of the peasant consciousness.'[8] They also think that Mr. Slime is 'another Moses', who will bring them salvation. Pa partially understands the implications of Mr. Slime's betrayal.

The tension grows in the village as the news of strike in shipping company threatens the peace of the village. Mr. Slime attends the meeting with the Governor and the owners of the company to settle the matter of the wages; the riots begin, and the news of riots terrorizes the villagers so that they prefer to remain in their houses. They fail to understand that it is the first liberation struggle. The rioters want to kill Mr.Creighton but Mr.Slime saves him. Till then they do not understand the connection between them. Michael Cotter comments, 'Beyond the confines of that village, their larger horizons are the typically mythical, or imagined, concept that they have conceived of the 'Mother Country.'..... their concept of themselves cannot spring solely from within themselves.'[9] After riots the village once again comes to normality. For many days nothing happens.

The people do not believe the news of Creighton's land-selling until the shoemaker gets eviction order. Sandra Paquet comments, ' There is a painful irony in the shoemaker's conclusion that the village can neither initiate nor accommodate itself to change, for in spite of his superior understanding and knowledge, the shoemaker is caught up in the same

incapacity he recognizes in his fellow villagers.'[10] Nobody takes collective action against this. The lawyers, doctors, teacher Mr. Slime, overseers are all involved in the treachery. The villagers get confused as the eviction orders begin to be issued to all. It is a lethal shock to them as Ambrose Kom States, 'Unfortunately the liberation struggle, which, in the beginning, appeared to be a popular revolution, quickly turns into a bourgeois affair.'[11] Maximum economic exploitation through the sale of land leaves them dehydrated of the human urge for togetherness. Each is lost in his individual problem of survival - exclusively economic because they have no money to purchase the piece of land on which their house stands. Their lives have lost the very foundation of survival. The last shock is received by the villagers when they hear that old Pa's house is owned by the headmaster and his last days will go in the Alms house, the state burden, where no respectful man desires to go.

The traumatic experience of confiscation of land by the colonizers and their agents leaves the colonial society unhinged. Yet it carries within it the seed of hope for the future as, at least, its two members - G and Trumper - prepare themselves to search for possible strategies to change the exploitative environment, at the end of the novel.

References

1. George Lamming. *In the Castle of My Skin* (England : Longman Drumbeat, 1953).

 (All the quotations cited are taken from this edition).

2. Mary Donnelly, "Mother Country, Father Country, *In the Castle of My Skin* and Oedipal Structure of Colonialism, "*Ariel*, Vol. 26, No.4, Oct.1995, p. 11.

3. Sandra Pouchet Paquet, *The Novels of George Lamming* (London Heinemann, 1982), p. 19.

4. Alice Walker, *In Search of Our Mother's Garden?* (NewYork : Harcourt Brace Javanovich, 1983), p. 17.

5. Sandra Paquet, op.cit., p. 23.

6. Ngugi Wa Thiong'o "George Lamming's *In the Castle of My Skin*" in *Critics of Caribbean Literature*, ed. Edward Baugh, (London : George Allen and Unwin, 1976), p. 48.

7. Ibid, p. 48.

8. Ambrose Kom, "*In the Castle of My Skin*, George Lamming and the Colonial Caribbean, "*WLWE*, Vol. 18, No. 2, Nov. 1979, p. 408.

9. Michael Cotter, "Identity and Compulsion : George Lamming's *Natives of My Person*", *New Literature Review*, 1977, p. 29.

10. Sandra Paquet, op.cit., p. 25.

11. Ambrose Kom, op.cit., p. 408.

(3) *Brother Man* (1954)

Roger Mais, born in 1905, spent his early childhood in Kingston; at the age of seven he moved with his family to the Blue Mountains in the Parish of St.Thomas. He joined the civil service and left it within a year, and worked at many other jobs. He was novelist, journalist, poet, painter and playwright. Always outspoken and a champion of the underdog, he was imprisoned for six months in 1944 for writing the notorious article, "NOW WE KNOW." His novels are *The Seed in the Ground* (1943), *Blood on the Moon* (1950), *Storm Warning* (1950), *In the Sight of the Sun* (1952-53), *The Hills Were Joyful Together* (1953), *Brother Man* (1954), and *Black Lightening* (1955). He lived and travelled in Europe only to return to Jamaica in 1954. He died of cancer in 1955.

To move from Lamming's *In the Castle of My Skin* to Roger Mais's *Brother Man*[1], is to shift the centre of concern from the rural, labouring class colonial setting to the urban, slum colonial setting. The novel links two areas of Caribbean family experience. The inter-relationships activating individual family units are reciprocated by the inter-relationships within the communal family of the town slum. Gordon Rohlehr notes how 'the dispossessed of the towns' in Roger Mais's novels are 'able to reconstruct a community in spite of the harshness of their milieu and to knit fragments of communal experience into a single perception of tragedy, character flowing into character as if the entire group were a single person.'[2] The novel

concentrates on two kinds of familial relationships-

I) Man - woman relationship

II) Communal family relationship

Through contravention between the spiritual life of the hero, John Power called as 'Brother Man', and the sex-oriented life of the ordinary community of the slum, Roger Mais scans the possibilities of meaning inherent in the antagonistic urges of the body and the spirit. The most intimate experience, especially of the body, so vital for comprehending the multiracial and hybrid Caribbean society, is successfully validated by the novelist by employing the device of family relationships - both individual and communal.

I) Man - Woman Relationship

The novel centre-stages three family groups.

i) Girlie and Papacita

ii) Cordelia and her husband

iii) Jasmina and Shine

i) Girlie and Papacita - The first couple of Girlie and Papacita comes under the category of good and evil. Girlie is a working class woman, and Papatia schemes criminal activities which are centred on his single-minded desire to become rich. For them, the biological urge is the foremost priority.

Their perception to understand each other is only through body. Their urge of sex is so strong that they are delighted to hurt each other. The chorus brings about the expected resolution of conflict between Girlie and Papacita. They are in the room, and Girlie is making the room tidy. 'He watched her sweeping, tidying, making the room like new, without letting her know that he was watching her, he watched her every movement, feeling deep down that hunger for her that kept him coming back after every escapade. . .'(pp.21-22) When Girlie ignores him, the tension between them rises, and it becomes unbearable for Papacita. Without talking they communicate their feelings of mistrust. They break the silence with verbal attack. Gillian Dooley comments, 'Their verbal sparring turns physical, and they fight until he can overcome her resistance. He forces her to have sex...... .'[3] Their deep urge to keep themselves bodily related gives them 'deep physical satisfaction that was like nothing else on earth.'(p.28)

Girlie and Papacita are acute in expression of love, they feel delighted when they attack each other. Edward Brathwaite comments 'What we see here is . . a natural resolution of tension between 'physical' Papacita and Girlie.'[4] Girlie is constantly jealous about Papacita who she thinks must have love affairs with other women. Papacita does not want any kind of responsibility. Gallian Dooley comments 'their bond cannot survive Papacita's need to escape commitment, aggravated by Girlie's jealousy, which eventually leads her to murder him.'[5] They fail to understand the

soul of the body and concentrate only on body which leads both of them to insanity. They are incapable to turn physical love into true love with complete mutual understanding. Without trust and sacrifice, only jealousy, hatred remain at the core of their relationship. Kwame Dawes thinks that Papacita signifies male dominance so he is very aggressive in sex, almost feels happy to rape Girlie. According to her, 'His desire to dominate is rooted in a sense that this is the only way to avoid the humiliation of being called something else than a man by Girlie.'[6] In reality, it is Girlie who constantly provokes him to hurt her; her sexual advances are more powerful than those of Papacita.

ii) **Cordelia and her husband -** On the other hand, Cordelia is without her husband who is in jail on charges of possessing ganja. Her 'singleness' has no meaning in the community, without her 'husband she has no 'presence'. She feels embarrassed while walking on the street, thinking that the people make comments on her. Chorus once again comments on behalf of the community.

'Cordy's man get tek-up to' ganga ...
- Bra Man show de gospel way ...'(p.8)
She feels lonely and insecure because she is aware that the community in which she lives endorses the kind of relationship between men and woman in which the woman is dependent on the reputation of her better half for

the sense of self and visibility within the community. She lives with her child, and with her sister, Jesmina. She cannot express her body's urge and thus becomes sick. Her illness forces her to advance sexually towards Brother Man. She actually goes to him for spiritual solace, but fails to attract him, as he refers to her as "child". She gets frustrated and turns to Bra Ambo, the obeah man, to have revenge against Brother Man. Bra Ambo does not understand her need, when she fails to express her real desire. Her child gets sick and becomes serious, instead of going to Brother Man for healing, she turns to Bra Ambo. His magic does not work and she smothers her child. In anger and frustration, she commits suicide. Kwame S. N. Daves comments, 'Her actions are prompted by her economic and social dependence on the male figure.'[7] In fact, her 'body' frustrates her, and leads to her insanity.

iii) **Jasmina and Shine** - Jasmina is unable to tell her love feelings to her lover Shine, who expects her to communicate them. In ice-cream parlour, when they meet, 'He was hurt ... hurt and puzzled, ... her own silence thwarted him, cancelled him out like a digit, and he was hurt and angered and dumb.' (p.86) But her need for love overcomes the communication barrier. In their last meeting, she suddenly desires to speak with him. Brother Man teaches her the value of communication. She confesses her fear to him and then finds herself triumphant in communication.

II) Communal Family Relationship

Community, the extended family of Brother Man, lives in Kingston slum, where everything is in scarcity, except talking. They talk and talk. 'The tongues in the land clak-clack almost continuously, going up and down the full scale of human emotions, human folly, ignorance, suffering, viciousness, magnamity, weakness, greatness, littleness, insufficiency, frailty, strength.' (pp. 7-8) The talking produces a sense of physical relatedness. Deprived of essential facilities , they compensate them with talking. They gossip and feel pleasure because gossip gives them excitement and thrill. Gillian Dooley comments,' This gossip is partly communication in self-defence-people's attempt to deflect the pity and shame of their own situations on others they can imagine as even more unfortunate than themselves.'[8]

Brother Man tries to help the slum dwellers as a preacher. He is a Rastafarian man. Community believes his healing power. He is their messiah, their faith healer and confessor. They go to him for spiritual solace. He is a Christ figure for them. People came up to him in the crowd, and touched their handkerchiefs against his clothes, and laid 'the handkerchiefs on their sick, and they became well. And Bra Man didn't even know it was done'. (p.109) People follow him, listen to him, obey him.

Minette, the abused prostitute is rescued by Brother Man, (former John Power). He brings her to his house, he is a cobbler making boots, and Minette helps him to polish them. She has been introduced as a sleeping temptation to the Brother Man. She faithfully serves him, but her natural impulse of sex pushes her to advance towards Brother Man. His first exchange with Minette ends with 'peace and love'. That indicates Brother Man's tenuousness, his position and his integrity as the spiritual guide of his community. The inadequacy of Brother Man's dedication to the spiritual content of existence is skilfully decoded by Roger Mais in Brother Man's ambivalent attitude to the dying dead bird. The bird smashes into the window glass and falls with a dull thud. Brother Man holds that bird in his hand It tries to flutter but Minette knows it will die. She tells him not to try to save it. She feels that she is also like that trapped fluttering bird. The bird dies. A boy, Joe, watches it and asks Brother Man to give it to him. Brother Man asks him,

'What you goin' to do with it son?'

'Cook it , sah.'

Brother Man looked at him, through the torn shirt at the thin wasted belly, without a word he reached out and put the bird in boy's hand ...

'It is such a little bird,' said Brother Man.

'Nightingale, sah, Eat sweet.'

'Eh?'

'It eat sweet, sah. Good eatin' bird dem.'

'Ah', said Brother Man.

He looked at the boy, and their eyes met and held. Brother Man said, as though he had weighed the matter in his mind had come to a decision. 'I guess that's all right son.' (p.30).

It indicates that Brother Man chooses body's need, rather than spiritual value of pity. On the unconscious level he feels, for the first time, the need of reconciling with the physical. But still he is confused. He cannot give satisfactory answer to Minette what love means. He, of course, is not yet ready to accept physical need as an integral part of his own.

Once while healing the people, Brother Man is charged with counterfeiting the money. The community at once, loses faith in him. The news comes that a young couple is murdered, by an unkempt and bearded Rastafarian black assailant. The fake Rastafarians mislead the mob and they start chasing Brother Man. They attack and beat the innocent man who has always used his healing power compassionately and not for profit. He is badly humiliated by the mob ... 'as a central, linking figure whose

religious figure might have welded the community of the poor into a whole, Brother Man has failed. As a spokesman for the folk he is finally too introspective and isolated ... His commitment to the community is at odds with his private vision of "peace and love".[9] His inner serenity leaves him detached and passive in the eyes of the community.

Brother Man believes in spiritual, metaphysical love by rejecting biological need of the body. He cannot relate himself bodily to his community, who knows only the need of the body. They humiliate his body to express their frustration. And, for the first time, Brother Man understands the meaning of the body. He is rescued by some of his followers. Minette is one of them. She heals his wounds. He responds to Minette's sexual advances. His spiritual identity is complemented by his sexual identity. Thus he becomes a normal man. By blending spiritual with sexual he finds the new meaning with the human content. The spiritual exclusive of sexual or vice versa, are both incomplete. He comprehends that there should be proper reconciliation of both the urges. They are not antagonistic but complementary.

Minette becomes the follower of Brother Man. He ponders over himself and the new knowledge. -

'He saw all things that lay before him in a vision of certitude, and he was alone no longer.

'Look at me,' he said.

Her gaze meet his, unfaltering.

'You see it out there, too?

She looked up above the rooftops where the great light glowed across the sky.

She said, 'Yes, John, I have seen it.' (p.191)

She now calls him 'John'. It indicates his transformation into a normal human being. He is now empowered with new understanding so that he may know the true needs of his community.

Roger Mais has divided his novel in five parts, every part begins with a chorus. Thus it becomes a dramatic novel. Chorus represents family of the community and position of Brother Man as the head of the family. His healing power connects him deeply but as soon as he loses it, his position is threatened by the same community. He overcomes his fear of 'body' and finds the new meaning of the body. Edward Brathwaite comments, 'Here,are resolved the basic conflicting elements of love of the spirit and of the flesh, which are the burden of this book.'[10]

The community targetting its act of revengeful violence against one of its members in a recurrent image which plays an crucial role in a number of novels. In the final scene of Thiong'o's *A Grain of Wheat*, that revengeful crowd, on listening to the confession of the guilty man, realises suddenly how they and the guilty man share the same weakness of the

urge for survival at the cost of one's commitment to the community. In Kamala Markandaya's *No Where Man*, the white crowd's violence against the Indian protagonist in England results in his ultimate sense of despair and death. The crowd becomes an alien force in John Hearne's *Voices under the Window* which brings destructive clarity to the protagonist. In *Brother Man*, the crowd's violence gives creative courage to the protagonist to face the truth about himself.

.

References

1. Roger Mais, *Brother Man* (London : Jonathan Cape, 1954).

 (All the quotations cited are taken from this edition).

2. Gordon Rohlehr, "The Folk in Caribbean Literature," in *Critics on Caribbean Literature*, ed., Edward Baugh, (London, George Allen and Unwin, 1978), pp. 27-28.

3. Gillian Dooley, "Patterns of Communication in Roger Mais's *Brother Man*", in *The West Indian Fiction*, ed., R.K.Dhawan, (New Delhi : Prestige, 2000), p. 18.

4. Edward Brathwaite, "Roger Mais's *Brother Man* as Jazz Novel," in *Critics on Caribbean Literature*, ed., Edward Baugh, (London : George Allen and Unwin, 1978), p. 106.

5. Gillian Dooley, op. cit., p. 19.

6. Kwame S.N.Dawes, " Violence and Patriarchy : Male Domination in Roger Mais's " Brother Man", *Ariel*, Vol, 25, No. 3, July 1994, p. 35.

7. Ibid, p. 46.

8. Gillian Dooley, op.cit, p. 17.

9. Michael Gilkes, *The West Indian Novel*, (Boston : Twayne Publishers, 1981), p. 37.

10. Edward Brathwaite, "Roger Mais's *Brother Man* as Jazz Novel",op. cit., p. 112.

(4) *The Lonely Londoners* (1956)

Samuel Selvon, born in 1923 in Trinidad, belonged to Trinidad East Indian Community. After local schooling, he entered the Royal Naval Volunteer Reserve, and served as a wireless operator on a mine sweeper. For some years he lived in Tacarigua, between Paradise and El Dorado. He was novelist, journalist, and a playwright for radio and T.V. His first novel is *Brighter Sun* (1952), his other novels are - *As Island is a World* (1955), *The Lonely Londoners* (1956), *Turn Again, Tiger* (1958), *I Hear Thunder* (1963), *The Housing Lark* (1965), *The Plains of Caroni* (1970), and *Those Who Eat the Cascadura* (1972), *Moses Ascending* (1965), and *Moses Migrating* (1965). He received Guggenheim award twice for his writing, and the Humming Bird award from Trinidad. He made London his home, but frequently visited the Caribbean islands. He died on April 16, 1994.

Samuel Selvon's The Lonely Londoners [1] is the first novel from his trilogy, the other two being, *Moses Ascending* and *Moses Migrating*. These novels come under the group of the 'exile' novels. Moses Aloetta Esq. is the exiled protagonist of these three novels through whom Selvon shows the evolution of the Caribbean psyche in response to exploitative colonial environment. Selvon's choice of the name of the protagonist i.e. 'Moses' is, as he himself explains, without any Biblical reference. It is very common name in West Indies and has nothing to do with the Biblical character Moses

who was supposed to be very close to god, who offered land to the Egyptians. Selvon's Moses has no land, but waste land.

Moses is an ideal human being in *The Lonely Londoners*. His long stay in London does not hamper his humanity. His sufferings as an exile have not destroyed his human core. In *Moses Ascending,* the human core is gradually substituted by the urge for economic survival and his lust for money to achieve power for status as a black in white man's country. In *Moses Migrating,* again, Selvon used ironic title, to show how Moses regards England as his own Mother Country. He migrates to his original mother country from London only to migrate once again to England. His rootlessness is tragic. He becomes a hollow man. His migration shows the complete destruction of self. He is confused because now he is nowhere man, a man hanging between two identities. Imperialist ideology of power and culture destroys Moses' capacity of humanness, even his capacity to locate meaning. Under the veil of comedy, Selvon explores the tragedy of the Caribbean Psyche.

The Lonely Londoners is a tragic tale of a disillusioned section of self-exiled humanity haunted by loneliness, poverty, homelessness and insecurity. The Caribbean characters in the novel come to London, the so-called Mother Country, in the hope of getting better jobs, but find themselves reduced to objects of hatred, humiliation and dehumanization on account

of their black skin and colonial status. These characters include Moses Aloetta, Galahad, Tolroy, Captain, Bartho-Bart, Lewis, Daniel, Big City, Harris and Five-Past-Twelve belonging to different parts of Caribbean islands.

As members of families with intimate network of strong inter-relationships, the characters are victims of persistent sense of nostalgia-the warm memories of home and native land complemented by a powerful desire to return home. George Lamming confesses how 'Most West Indians of my generation were born in England. The category West Indian, formerly understood as a geographical term, now assumes cultural significance.'[2] They want to enjoy the warmth of their place, home, country because. 'everyone cagey about saying outright that if the chance come they will go back to them green islands in the sun.'(p.122)

The family relationship in the novel can be divided in three kinds -
I) Surrogate family relationship
II) Tolroy's familial relationship
III) Man - woman relationship

I) Surrogate Family Relationship : Moses and his friends

The hopelessly scattered and confused boys long for physical and psychological anchorage. V. S. Naipaul projects this experience through Ralph, the protagonist of his novel *The Mimic Men*.[3] Ralph thinks of himself

as a ship wrecked, cut off physically from his ancestral landscape when he confronts the chaotic reality of London. Selvon's group then develops, out of necessity, surrogate family of themselves with Moses as their surrogate elder brother and guardian. Moses willingly shoulders the responsibility of settling the boys. 'he hardly have time to settle in the old Brit'n before all sorts of fellars start coming straight to his room in the Water when they land up in London from the West Indies.' (p.7) They land up in hopeless condition on the doorstep of Moses with one set of luggage, no place to sleep, no place to go. First he has to offer them food and room until he finds a room for them somewhere, not in Water, which is already full with the West Indians, in London metropolis. His long stay in London tells him how hard it is to find a room for Londoners, as the black West Indians are burden on the society who, as J. P. D. points out, 'are driven to combine as pirates or parasites on the fringes of a host society which regards them with indifference or hostility, and with an often unacknowledged fear of contamination.'[4] Even if it is very hard to find a room, Moses always welcomes the fellars on Waterloo station with compassion. His heart sinks when he sees a broad, hopeful smile on their faces. He at once becomes their friend, philosopher and guide. Like a welfare officer he scatters the boys around London. With the soft heart he goes to receive a fellar named Oliver alias Galahad. 'He don't know how he always getting in position like this, helping people out.' (p.9) English people hate the boys from the

West Indies. ' They send you for a storekeeper work and they want to put you in the yard to lift heavy iron. They think that is all we good, for , and this time they keeping all the soft clerical jobs for them white fellars.'(p.36) Moses first clears the illusion of England before the fellars, that it is a place where hate and disgust and avarice and malice, sympathy, pity, sorrow all mix up. Still Moses helps them all minding his own business and also others. It is hard for Galahad to find a job, Captain has left the study of law and his father has stopped sending him money. He always creates problem for Moses. Still Moses is compassionate towards him. He has such an innocent face that, 'the soft heart was touched once more.'(p.39) To borrow money or to pawn something is Captain's business as he has no job. Barthomolomew - Bart, in spite of his light skin, fails to get a room. Big City always wishes to buy out a whole street of house to offer his friends a place to live, by writing a notice "Keep the Water Coloured, No Rooms For Whites"(p.81) Harris, who is very polite and likes to observe English customs, likes to give parties; orders his people to behave and not to bring disgrace to him and themselves, and tells Moses to keep an eye on them, particularly Five Past Twelve. For every problem Moses is available at any time to them, working enthusiastically for them, remembering his old hard days. He wishes to reduce their chances of humiliation in the foggy, alien, cold country. He offers them his extended surrogate family any time , providing all of them food, shelter and clothing. His warnings, suggestions make their stay

bearable in the metropolis. John Thieme points out, 'the magic of living in the big city, has now turned sour.'[5]

Moses' joint family members completely rely on him for mental comfort. His room is their 'home'. Weekend meetings become a ritual for them, that nobody forgets to observe. 'Always every Sunday morning they coming to Moses, like if is confession, setting down on the bed, on the floor, on the chairs, everybody asking what happening but nobody like they know what happening, laughing kiff-kiff at a joke...'. (p.122)

II) Tolroy's Familial Relationship

Samuel Selvon creates space to set on trial the potentialities of the colonized black Caribbean family to survive in the country of the white colonizers by introducing the device of Tolroy's family in London. Moses meets Tolroy who has come to receive his mother at the port. But he seems frightened and nervous. Moses consoles him that it will be good to save money for the family. When he first came to London, Moses had helped him to find a job in a factory and he could save money but Moses himself is penniless. He finds him a room on Harlow Road. Now Tolroy wants a big house and immediately Moses tells him about a house down by the Grove with some vacant rooms - the information is given by Big city. Tolroy's whole family, his mother, Tanty Bessy, Lewis, Agnes and two children arrive. It is like a bombshell attack for him. He becomes so

frustrated that he could not understand how to react. 'Tolroy start to shiver with a kind of fright.'(p.14)

In the beginning Tolroy's big family becomes a problem for him. How will they economically survive is a big question for him, but is easily solved by Tanty and his mother who begin to work in a hotel and the houses of the white people. Tanty, with her talkative nature, creates new relations in Harrow Road, the area for working class where a lot of 'spades' live. None of the houses have bath so they have to go to the public bath, where she introduces ' a business on credit' to the community. They and the shopkeepers are happy because of this new kind of arrangement. Intimacy of family, relatedness of the members give Tolroy pleasure and a kind of solace. He could now play on his guitar. Such sense of the family and relatedness is seldom felt in London.

III)Man -Woman Relationship : The black boys and the white girls

The relationship between the black boys and white girls relationship is either (i) nominal or (ii) stable or (iii) steady to certain extent. The body's urge for sex is transformed into an important asset by the boys during their struggle for survival in the country of the oppressors. On the minimal level, their sex adventures are vital efforts to recover body's pride. On the conscious level, they struggle to create possibilities of meaningful relatedness of family life in various degrees. A number of such attempts

cannot go beyond mere sex pleasures. Some of them appear to develop as steady love relationships only to crumble hopelessly in the end. The very environment appears to prevent any healthy, stable love relationship between blacks and whites. On the unconscious level, the sexual act of the black with a white girl involves fulfilment of the desire for revenge against the white skin.

i) Nominal relationship

Five Past Twelve has women all over London. He just passes time with them. Galahad has a white girl friend called Daisy . '...Galahad feeling good with this piece of skin walking with him.'(p.75) He spends a lot of money on the girl to impress her, cinema, hotelling and brings her in Moses's room, who advises Galahad to take it easy. Daniel takes white girls to places to listen classics and see artistic ballet. Just to have company for sometime which provides them pleasurable moments, they have white girl friends. Their relationship remains tentative. Eric TabuTeau comments, 'They make it a point of honour to impress her with their moral qualities'' [6] Of course they feel prestigious to have white girls as their friends.

ii) Stable relationship

Brat loves a white girl Beatrice. Their relationship is intimate. As Brat is constantly changing rooms, she tries to find his location and keeps meeting him. She really loves Brat. Their love affair goes steady and, at

last, he tells Moses that he wants to marry her. He goes to her house; talks with her mother but father gets him out. However, the affair goes on, till he suspects her relationship with other boy. The proud girl leaves him and then he realizes his mistake. 'He must be comb the whole of London, looking in the millions of white faces... for weeks the old Brat hunt.'(P.50) His desolation and his desparate, enthralled search just for the sight of Beatrice ends with acceptance and quiet awe.

iii) Steady relationship to a certain extent

On the other hand, Captain has an Austrian girl whom he loves. Their steady affair goes on for several days. But Captain is never steady in any job he gets. He is always short of money. But the girl loves him so much that she pawns her things and raises money for him. Even if she does not find him, she gives money to be handed over to Cap. When she does not see him for long then she sends Chelsea Police after him and then he starts changing places in order to evade police. His second affair is also steady with a French girl to whom he provides false information that he owns garage in partnership, it is a better job, and on top of that, he marries that girl. She arrives with her luggage in Daniel's room. He leaves room by taking eight pounds from him. They live in the hotel, his wife gets money from France every week and they live on that. After that she finds work in a store but Cap remains idle, having affairs with other girls.

If she vexes, he throws her out. According to Eric TabuTeau the behaviour of West Indians with white women 'is partly the result of the white woman's patronizing behaviour towards the immigrants and therefore the consequence of the failure of their relationship.'[7] For Cap England has lot of white pussies.

The white women are not all good and cultured. They have their fantasies about sex, 'they feel they can't get big thrills unless they have black man in the company and when Moses leave afterwards they push five pounds in his hand and pat him on the back...'. (p.93) Still whites want to treat blacks as slaves and blacks want to treat whites as enemies. The racial memory of the Middle Passage haunts the blacks and perverts their relationship with the white girls.

The life in the metropolis destroys the relationship between Lewis and Agnes. Lewis marries Agnes, Tolroy's sister. When he goes on night shifts he begins to suspect his wife, as Moses tells him some horrible stories of the broken marriages. He returns and beats her; she does not understand for what. When it becomes unbearable she leaves Lewis. She learns the rights of women and sends legal notices for compensation. In the end they get divorce. The urban life erodes the innocence of the rural folk! Lewis returns to Moses' room to lead a bachelor's life once again.

Selvon's perspective of historical and racial experience of exile in the illusory Mother Country differs from Lamming's. Selvon believes in the capacity of the ordinary working class Caribbean to survive even in the most hostile environment. His characters in *The Lonely Londoners* are frustrated yet they retain their sanity in the face of socially, economically, culturally and psychologically harrowing experience. On the other hand, Lamming shows that intellectually developed educated Caribbean psyche finds it more difficult to face the situation. In his 'exile' novel, *The Emigrants*[8], Collis the writer is scared by the horrible peace and discipline of Mr. Pearson's house. He goes to the lavatory, not 'to relieve himself but to rescue his sanity.'[9] Dickson, the student, is so humiliated by the traumatic experience of the scrutiny of his naked black body by the white ladies that he avoids human contact 'sleeping in a dungeon by day and slipping out at night for a breath of air.'[10]

Moses observes all the changes in his fellars, feels their passions, needs, and tries to comfort them in his own way. His heart is full of compassion for them; their suffering becomes his suffering. Everybody has his share and corner in the mind of Moses. 'Sometimes listening to them, he look in each face, and feel compassion for every one of them, as if he live each of their lives, one by one, and all the strain and stress come to rest on his own shoulders... sometimes tears come to his eyes and he don't know

why really...'. (p. 123) The lonely Londoners succeed, however chaotically, in surviving only because of Moses' steadfast faith in human relationships.

References

1. Samuel Selvon, *The Lonely Londoners*, (London : Longman Caribbean, 1956, this edition 1972).

 (All quotations cited are taken from this edition).

2. George Lamming, *The Pleasures of Exile*, (London : New York by Allison and Busby, 1960, this edition 1984), p. 124.

3. V. S. Naipaul, The Mimic Men, (Harmondsworth : Penguin, 1977).

4. K. Ramchand, "Song of Innocence, Song of Experience, Samuel Selvon's *The Lonely Londoners* as a Literary Work", *WLWE*, Vol. 21, No. 3, Autumn, 1982, p. 645.

5. John Thieme, "Rule Brittania? Sam Selvon : Moses Migrating, Harlow : Longman, 1983", *The Literary Criterion*, Vol. xx, No. 1, 1985, p. 255.

6. Eric TabuTeau, "Love in Black and White : A Comparative Study of Samuel Selvon and Frantz Fenon", *Commonwealth*, Vol. 16, No. 2, Summer, 1993, p. 90.

7. Ibid, pp. 91 - 92.

8. George Lamming, *The Emigrants*, (London & New York : Allison & Busby, 1954).

9. Ibid, p. 135.

10. Ibid, p. 257.

(5) *The Mystic Masseur* (1957)

Vidiadhar Surajprasad Naipaul,(born in 1932) is from Trinidad whose grandfather came there, as a Banaras trained Brahmin from India to teach and to work on the cane fields. His father Seepersad, a reporter for Trinidad Guardian, passed on to Naipaul his interest in writing and journalism. Naipaul learnt in Queen's Royal College at Port of Spain. He left Trinidad and came to London where he read English at University College, Oxford. He worked as a reviewer from 1958 to 1961 for The New Statesman. London remains his commercial centre. After twenty-three, he took to writing seriously as a career. He has accumulated as a novelist, story writer, essayist and journalist, most of the major British literary prizes. His awards include the John Llewellyn Rhys Memorial Prize for *The Mystic Masseur* (1957), the Somerset Maugham Award for *Miguel Street* (1959), the Hawthornden Prize for *Mr. Stone and the Kinghts Companion* (1963), the W. H. Smith Award for *The Mimic Men*, the Booker Prize tor *In a Free State* (1971), and the Phoenix Trust Award for general achievement. He won the Nobel Prize for literature in 2001. His novel, *A House for Mr. Biswas* (1961), is considered as the masterpiece. Some of his other publications are *The Middle Passage* (1962), *The Suffrage of Elvira* (1958). His latest book is *The Writer and the World* (2002).

V. S. Naipaul's *The Mystic Massauer*[1] is one of the earliest attempts to scrutinize the crippling uncreativity of the colonial environment. He shows

how the individuals are transformed into caricatures in a farce as the struggle for economic survival gradually changes into struggle for power through money in the economically, socially, racially and culturally insecure Caribbean society. The novel emerges as a comic narrativization of the progress of its hero along the social ladder from a mere temporary primary teacher to a Member of British Parliament. The process of his upgradation is, however, paralleled by that of his moral degradation from his authentic East Indian identity as Ganesh Ramsumair to his perverted British identity as G. Ramsay Muir. At the end of the novel, the apparently successful man of honour is striptesed to expose a sterile being denuded of all human content that makes survival meaningful.

In the exploitative environment of colonial West Indies, an individual from the majority black community is , generally sustained by his own family as well as the communal family through a deep sense of mutual relatedness. However, Naipaul finds that even family is incapacitated to fulfil its vital function of protecting and sustaining individuals. The nature of Ganesh's relationship with his family is indicative of the deadening impact of the colonial situation both on the family and the man. It involves, mainly, his relationship with his wife Leela, his father-in-law Ramlogan, and his aunt, Great Belcher-named after her physical peculiarity.

As a member of the minority Hindu communal family, Ganesh inherits its cultural traditions. But he realises as a boy only how these traditions become a shameful burden and, hence, a probable hindrance in the struggle to survive in a multiracial society. In Queen's Royal College, he always feels awkward in Indian dress, and is ashamed of Indian name. He spread a story that it is really 'Gareth'. Then, the ceremony for making him real Brahmin takes place. They shave his head and give him a saffron bundle and tell him to go to Banaras and study. It is all symbolic but Ganesh takes it seriously. Dookhie, the shopkeeper, stops him. The students in his school laugh at him. Ganesh gets a job as a teacher in primary school in a leave vacancy. The headmaster tells him, 'this school is to form, not to inform.'(p.24) Mr. Miller's return marks the end of Ganesh's teaching career. After the death of his father, he returns to Fourways; performs all the Hindu funeral rituals. All his relatives gather, among them his aunt, Great Belcher is there. He enjoys double pleasure in Fourways as an educated man and man whose father is recently dead.

Naipaul further introduces Ramlogan, the seller of confectionery and his daughter Leela. Through Ganesh's relationship with them Naipaul presents two kinds of familial relationships -

I) Son-in-law and father-in-law relationship

II) Husband and wife relationship

I) Son-in-Law and Father-in-Law Relationship : Ganesh and Ramlogan

Ganesh's introduction into Ramlogan's family as its son-in-law carries a potential of providing the orphan man with intimate family bonds which can sustain him during his struggle for economic success. Unfortunately, his relationship with his father-in-law fails to develop the embryo of human core as it remains mutually exploitative, and , hence, static and sterile. Ramlogan is a typical Caribbean Hindu father in search of a husband for his educated daughter. The regretfully limited number of prospective young men compels the man into absurd tricks to trap Ganesh into acceptance of his proposal of marriage with Leela. For instance, he invites the young man to his house to feed him, food being a major bait for the familyless man.

Ramlogan's successful conspiracy of winning Ganesh as his son-in-law is, however, followed by his ruthless exploitation by the educated Ganesh. Education becomes, for Ganesh, a strategy for compelling the otherwise diplomatic man into helpless submissions. As Srinath points out, 'It is not until he moves to Fuente Grove and settles down in his father-in-law's house after cleverly fleecing all his property as dowry that he is first set on the road to success.'[2] Ganesh manages to squeeze from Ramlogan, his father-in-law, a cow and a beifer, fifteen dollars in cash and a house in Fuente Grove and forces him to cancel all the bills, the expenses

he has done on his marriage, which actually Ganesh is supposed to pay, as a dowry. As Hindu religion gives full authority to son-in-law to exploit his father-in-law, Ganesh immediately starts working upon his newly got power. Later, when Ganesh becomes economically powerful, he seizes the business of taxi run by Ramlogan to reach people to Ganesh's house and temple in Fuente Grove. To teach him a lesson, Ganesh forces him to sell all his taxis to him on the prices he has settled and feels satisfied to turn his father-in-law into a pauper and let him live on his sympathy.

Ganesh's society provides no alternative patterns to a life style, which resolves around money. Ganesh develops the same materialistic attitude and he decides to use his educated tricks on the same society from where he has developed this attitude. In Fuente Grove, he publishes his first autobiographical book 'The Years of Guilt', and then, 'A Hundred and one Questions and Answers on Hindu Religion' by Ganesh Ramsumair, B.A. It is Beharry the wine seller, and the great Belcher who suggest to him the career as a massager like his father. On the suggestion of Beharry he adds 'mystic' before his name and starts wearing Indian dress which is suitable for the additional qualification 'mystic' M.B.E. He cures one black boy suffering from fear of the black clouds, by using psychological approach. This case becomes his first commercial success. Then his graph of success continuously starts going high. There is no looking back.

II) Husband and Wife Relationship : Ganesh and Leela

The barrenness of the relationship between Ganesh and his wife Leela reveals the tragic impact of money-mania on the East-Indian colonial society ruthlessly engaged with the game of advancement. Although Leela is educated, Ganesh beats her. It is their first formal affair done without any resentment. It means much to both of them, 'they had grown up and become independent. Ganesh had become a man; Leela a wife as privileged as any other big woman.'(p.60) In this way their family life begins. Leela is now typical Hindu obedient wife and he 'a man'. Her identity is completely merged in Ganesh. His word is order for her and, to act over it, is her duty.

Family becomes the battlefield for money-oriented superiority-inferiority tactics instead of a promise of protection. Leela is humiliated by her rich sister, Soumitra when Ganesh still struggled for success in the earliest stage of his financial career. But, as Ganesh reaches heights of economic success it is time for Leela to show her sister her wealth. She starts wearing jewellery. Soumitra used to display her wealth when Leela was poor. In East Indian society the status of a woman depends upon how many children she bore and how rich she is. Now it is Leela's turn. She is rich and busy, helping her husband in every work, checking proofs of his book, preparing for his mystic practice and involving in it all - Great

Belcher, Beharry and his wife Basson, and her father, Ramlogan. The tent turns into pandal, his house turns into temple where they never forget to take entry fee. He appoints his relatives to sell spiritual books. Soumitra's husband also gets involved. Ganesh then starts his taxi business. He is obessessed with economic success. As Shashi Kamra points out, 'Ganesh is seen as a man who moves ahead only by rejecting loyalties and responsibilities. He feels free with a new name, an new profession, unhampered by his wife or friends and the world before him.'[3] He exploits his own community. Leela becomes business supporter of Ganesh, forgetting they are the family. Leela displays his books by inches and size, most of them are unread but marked with pencil at random. He is no bigot. 'He took as much interest Christianity and Islam as in Hinduism ... he had pictures of Mary and Jesus next to Krishna and Vishnu, a crescent and star represented iconoclastic Islam.' (p. 139) J. P. D. calls it, 'a predatory world in which the trickster rules supreme.'[4]

Ganesh now becomes a philosopher and arbiter. He is often invited in village panchayat of Trinidad in the councils of elders, and he gives judgement in a case of minor theft or assault. 'His arrival at such a meeting was impressive. He came out of his taxi with dignity, tossed his green scarf over his shoulders, and shook hands with the officiating pundit. Then two more taxis came up with books.'(p.161) It is the beginning of his political career. He has not taken it seriously but Narayan C. S. through his news

paper, 'Little Bird', starts exposing the fake activities and the collection of funds for destitutes. Ganesh starts his own paper - The Dharma, and the political war begins through letters. He fills the nomination for Trinidad's first general elections. Indarsigh, his Oxford friend, helps him to give speeches on behalf of him. Swami and Pratap arrange several prayer meetings. Beharry designs posters. One day when he arrives late at home he sees a man colouring a poster, " 'Hello, Sahib,' the man said causually, and went on filling the letters. It was Ramlogan."(p.202) It signifies how he has ruined his father-in-law. Leela also never regrets over the treatment to her father. She even feels very happy that he has given some of the election duties to Ramlogan. 'Man is the second time in my life you make me feel proud of you The first time was with the boy and cloud. Now is with Pa' (pp.202-03).

Before polling day, Ganesh decides to suspend mystic activity and holds the ritual of reading Bhagwat. He wants to exploit even religion for his political success. Leela and Ganesh practise Hindu religious rituals According to Macdonald, 'meaning has gone out of them'.[5] Ganesh represents East Indian Community of Trinidad which as Shashi Kamra comments, 'was stunted society with the forms of tradition and culture surviving, but the core lost, submerged, destroyed : rendered meaningless and unimportant.'[6] Ganesh relates dignity with economic power. He buys the wine shop of Beharry, his friend although Beharry had always advised

and taught him the strategies of success, and had even painted the name plate after Ganesh had won the election- 'Hon'ble Ganesh Ramsumair, M.L.C,' (p. 205) Even there is no emotional attachment between Leela and Ganesh. The couple is childless, it is symbolic of inner barrenness. Leela is educated, but she has lost her capacity to think, to protest. Economic power brings their moral fall. They mistake means for end and end for means. Ganesh gives up his practice, sells the house in Fuente Grove and buys a new fashionable one in Port of Spain district of St. Clair. By that time he stops wearing dhoti and turban altogether. He hypocritically pledges his life to fight against communism in Trinidad and rest of the world, when he fails to negotiate with strikers in September, 1949. Tremendous change comes in the life of Ganesh. 'He went to cocktail parties at Government House and drank lemonade. He wore a dinner jacket to official dinner.' In 1950 he was sent by the British Government to Lake Success and his defence of British colonial rule is memorable.' (p.219) In 1953 Ganesh was made an M.B.E. Fawzia Mustafa comments, 'Ganesh Ramsumair's transmutation into G.Ramsay Muir MBE, ... does suggest that his career marks the character's voyage to "whiteness", a conceit ... as the sign of colonialism's power ... as the predetermined end of all its cultural identity formation.'[7] Mimicing the European culture, Ganesh loses his original cultural identity completely.

As compared to Moses in *Moses Migrating*, Ganesh has achieved a status by aping foreign culture and by gaining wealth. Moses can have

neither economic nor political power. But, in order to achieve economic power, both of them have bargained with their original identity. Ganesh's journey from poverty to power indicates the journey of the Caribbean society which is made impotent spiritually due to utilization of all possible resources for getting money, Fawzia Mustafa calls it 'bastardization of cultural capital... .'[8] *The Mystic Masseur* describes the barrenness, and uncreativity of the environment. Ganehs's fall is the fall of his society. Naipaul selects ironic title - 'mystic' refers to spirit and 'masseur' to body. The very combination 'Mystic Masseur', shows absurdity.

References

1. V.S. Naipaul, *The Mystic Masseur*, (England : Penguin Books, 1957).

 (All the quotations cited are taken from this edition).

2. Dr.C.N.Srinath, *The Commonwealth Novel*, (Bangalore : Prasaranga Bangalore University, Bangalore, 1997), p. 7.

3. Shashi Kamra, *The Novels of V. S. Naipaul : A study in Theme and Form*, (New Delhi : Prestidge, 1990), p. 61.

4. J.P.D., "A Book Review of John Thieme : The Web of Traditions : Uses of Allusions in V.S.Naipaul's Fiction," *Commonwealth* Vol. 10, No. 2, Spring, 1988, p.123.

5. Bruce F. Macdonald, "Symbolic Action in Three of V.S.Naipaul's Novels," *The Journal of Commonwealth Literature*, Vol. ix, no. 3, April 1975, p.44.

6. Shashi Kumra, op. cit., p. 14.

7. Fawzia Mustafa, *V. S. Naipaul*, (Cambridge : Cambridge University Press, 1995), p. 54.

8. Ibid, p. 51.

Conclusion

Mittelholzer's *A Morning* transforms the workplace family into a microcosm of multiracial stratified society, illustrating the precipitative tensions through their inter-relationship from economic, social (skin colour) and psychological perspectives. In *In the Castle*, Lamming presents the process of child's growth rooted in the relationship with his poor working - class mother signifying, through it, the colonial history of exploitation of the village. Mais's *Brother Man*, on the other hand, underlines the crucial problem of coming to terms with sexuality, through his treatment of man-woman relationship with reference to urban slum community. In *The Lonely Londoners* Selvon concentrates on the struggle of emigrant black minority to confront the white oppressive environment, and to survive through their surrogate communal family relationship. Naipaul tries in *The Mystic Messeur*, to comprehend the sterility of Caribbean society as revealed through the lack of meaningful relatedness in the familial relationships in the process of struggle for money and power.

CHAPTER FOUR

THE NOVELS OF THE SIXTIES

The novels of the sixties negotiate with the problem of meaningful relatedness in the Caribbean society through exhaustive exploration of individual and family relationship. The novels included in this group are-

1 V. S. Naipaul's

 A House for Mr. Biswas (1961)

2. Wilson Harris's

 The Eye of the Scarecrow (1965)

3. Michael Anthony's

 The Year in San Fernando (1965)

4. Samuel Selvon's

 Moses Ascending (1965)

5. Jean Rhys's

 Wide Sargasso Sea (1966)

(1) *A House for Mr. Biswas* (1961)

V. S. Naipaul's preoccupation with the theme of sterility of the Caribbean society links his *The Mystic Masseur* with his *A House for Mr. Biswas*. The Mystic Masseur investigates the process of deterioration of Ganesh, a victim of greed for money and power. *A House for Mr. Biswas* may be supposed to mark the next stage of that investigation. Here, Naipaul

experiments with the possibility, however small, of struggling for meaning on behalf of the society compelled into strategies for economic survival. Naipaul projects the hero's struggle, in the novel, as a conflict between individual and family. The dynamic relationship between Mr. Biswas and the Tulsi family contrasts with the static relationship between Ganesh and his family.

A House for Mr. Biswas [1] is normally responded to, by a majority of its critics, as a valuable incorporation of an individual's struggle for 'identity', or for realization of 'self'. Phil Langran generalizes on V. S. Naipaul's concern with individual self in his statement, 'Naipaul's fiction is framed by an insistence on the separateness of individuals'[2] Renu Juneja seems to agree with this view indirectly when she considers that 'Naipaul's protagonists break away from an active communal life which they identify with mental tyranny.'[3] In spite of the apparently individualistic nature of Naipaul's concern, *A House of Mr. Biswas* illustrates Jameson's assessment that ' the story of the private individual destiny is always an allegory of the embattled situation of the public third-world culture and society.'[4]

The novel, with its epic length, yields to a kaleidoscopic multistructure of meanings, emanating from its hero, Mr. Mohun Biswas. 'Family' is the exclusive means through which Naipaul authenticates

Biswas's role as the protagonist. The hero's personal history from childhood to death is, in essence, the history of his relationship, as an individual, with two families - Mrs. Tulsi's and his own. He is both a rebel and a creator. While rejecting the out-dated society of Tulsi family, he accepts the challenge of creating a new society in the form of his own 'house'. Thus, he fulfils the historical role of a leader by laying down foundation for a meaningful new order necessitated by the changing social and economic environment. Economic context of Biswas's rebellion against Tulsi family relates it to a change from feudal to democratic society. The novel may also be interpreted as the history of the East Indian Community, as indentured labour force, being repeated in the Tulsi family system with its colonizer-colonized pattern of relationships. Biswas's revolt against the family is the revolt of the colonized, and his success in having his own house for his own family - however battered and absurd - typifies the liberation of the colonized from the clutches of the colonizer. On the most essential level, Biswas's urge to build a house symbolizes the human urge to create opportunities for meaningful relatedness.

The familial relationships in the novel are woven around its protagonist - Mohun Biwas. The stages of his life from birth to death may divided on the basis of his roles in the families as follows -

I) As a son of poor parents

II) As a son-in-law of a joint family

III) As a father with his own house/family

I) As a Son of Poor Parents

Biswas represents the lowest class of society as the son of a poor family. The critical nature of his struggle for economic survival, right from childhood is evidenced in his relationship with the members of his family. He belongs to the indentured East Indian labour community, especially, to Brahmin Hindu family. His horoscope at birth declares that he will bring doom to his parents, i.e., Bipti and Raghu. The pundit says to his parents, 'The only thing I can advise is to keep him away from trees and water He will have an unlucky sneeze. Much of the evil this boy will undoubtedly bring will be mitigated if his father is forbidden to see him for twenty-one days.'(pp.16-17) From birth his unlucky life begins with neglect and malnutrition. Any mishap is connected to his sneeze and finally it is connected to the death of his father by drowning. After his death, the trouble shooter Dhari, their neighbour, compels them to leave the land and the family disperses. Sister Dehuti, whom he loves most, is sent to Tara's as her maid; his brothers, Prasad and Pratap, are sent to long distant relatives to graduate themselves in the skill of cane labour system. Bipti, at Tara's pity, lives in the huts made for servants, and Mohun with the mother. Their foremost priority is to survive, to have food and shelter.

The next ten years of Biswas are less chaotic. He is put to school 'after a birth certificate had been fudged up and his existence therefore publically guaranteed.'[5] The entry in his birth certificate before father's occupation describes him as a labourer's son. He is treated harshly by the teacher, Mr. Lal. Flogging and recital are daily occurance and a Lord's Prayer in Hindi. His first years of learning are very dry and boring. For eight months he is put in pundit Jairam's house to learn a spiritual profession. He is taught Hindi and some scriptures. There, he is 'treated with abstract and high-minded cruelty.'[6] Then he starts working as a helper in Ajodha's rum shop. There, his brother Bhandat suspects him as Ajodha's spy. As soon as he gets opportunity, he flogs him with belt for missing of one dollar. His humiliation brings him to his mother with hope that she will tell him not to go there. But as Warner has noted, Biswas 'although living with his mother, becomes emotionally estranged from her.'[7] As a widow, a destitute, his mother completely relies on the sympathy of Tara. She fails to give him emotional support and he feels that he is really alone at Pigotes.

II) As a Son-in-Law of a Joint Family

Biswas's status as labourer's child never allows him dignity from others. 'For the next thirty-five years he was to be wanderer with no place he called of his own, with no family'(p.40) Economic insecurity lands Biswas in the Tulsi trap. His art of sign painting brings him to Hanuman

House of Tulsis. He is exposed to feudal system of extended Hindu Family
who are rural peasants living in urban Trinidad. Tulsis' Hanuman House
is a big feudal system, representative of colonial rule. Mrs. Tulsi is the symbol
of imperial power. The hierarchical distinctions are an intrinsic part of the
establishment. Because of her age and ancestral role, Mrs. Tulsi holds an
honorary presidential position in the domestic affairs. Seth is her man- of -
business who is the chief prosecuctor at family tribunals, the counsellor
and agent of her will as well. Older sisters like Padma are respected because
of their age. Hari, as a family priest, holds the higher position. There are
some "lesser husbands", whose divisions and subdivisions among the adults
as well as the children exist. As Warner points out, 'Apart from age-
classification, there is a clearly defined division of labour, well demonstrated
at times when Mrs. Tulsi has a fainting spell.'[8] Special food is made for
Hari, general food for children and husbands and daughters. Rooms are
allotted according to the gradation, special 'Rose-room' for Mrs.Tulsi. Owad,
the elder son of Mrs.Tulsi who attends Roman Catholic college of Port of
Spain and visits every weekend and the younger, Shekhar who is being
coached to enter the college, are kept separate from the turbulance of the
old upstairs. They are given special brain feeding meals, of fish in particular.

According to the gradation, there is division of work in colonial
Hanuman House which regards its members as labour force. The duties of

Miss Blackie, the Negro servant, are vague. The daughters and their children swept and washed and cooked and served in the store. The husbands, under Seth's supervision, worked on the Tulsi land, looked after the Tulsi animals, and served in the store. In return, they were given food, shelter and little money, their children were looked after. ' Their names were forgotten; they became Tulsis.'(p.97) Tulsi husbands serve their purpose 'by fathering new generations of "Tulsis", and by contributing to Tulsi commercial interest.'[9] Children of the Tulsis are considered as assets. Ramadevi comments, 'Thus Hanuman House, with its leaders, its schemes of prescribed duties and responsibilities, its own law and order..... a coherent reconstruction of the clan but reveals a slave society on closer examination.'[10]

The Tulsi house is an imperialist social, economic and cultural power that colonizes Biswas by implementing most treacherous strategies. He gets acquainted with Tulsi family when he goes there for painting a sign board for Tulsi shop. He sees Shama, the younger daughter of Mrs. Tulsi; likes her and dreams a romantic adventure with her. But before he starts his adventure, he is caught when he tries to pass a love letter to her. Mrs. Tulsi and Seth settle their marriage, because he is Brahmin, a high caste Hindu, the one and the only asset of Mr. Biswas. Before marriage he is promised a separate house and an independent job. Thus, he becomes part and parcel of Tulsis, one more addition in the sons-in-law category. Coming from nuclear family atmosphere, Biswas is exposed to a large family unit. After

marriage when he demands his dowry, a house and a job, they keep it postponing, until he realizes he is blackmailed and , he has 'nothing to recommend him except a talent for sign-painting, and the fact that he is a Brahmin and therefore an accessible target for Hindu snobbery.'[11] When he is expected to become one of the Tulsis, he, at once, rebels but retreats as he has no job and a house.

In Biswas, Naipaul embodies the society's awareness of its slave-status and its determination to rebel. Biswas observes the animal existence of the family members of Tulsis. He is restless to find the passivity, the paracitical nature of the members for whom 'acceptance' is all like the community of *In the Castle of My Skin*, which passively accepts the colonizers as patriarchal authority in the earliest stage of colonialism. In Hanuman House, which indicates imperial power by its stupendous structure, Mrs. Tulsi, the great matriach is the supreme authority. The chaotic complexity of the house disturbs him. He refuses to surrender before the colonial authority of Mrs. Tulsi and Tulsidom where nobody is treated as human being but as a cheap labour force. But he is now trapped. Imperialistic tactics are used on him by giving him false promises. He is betrayed.

The apparently absurd methods of protest of Mr. Biswas, the only available weapons for a lonely fighter, are received as a serious threat by the supposedly cultured, civilized and wealthy Tulsi family. Biswas's

rebellion is on the allegorical level, the history of rebellion of the colonized against the colonizer. He is helpless, powerless yet he revolts. In the beginning, his oral protest shakes the 'peaceful authority' of the Tulsis. He begins to insult the family members by giving them funny names - 'the little Gods', for Owad and Shekhar, 'Big Boss' to Seth, for Hari, 'the constipated holy man', and for Mrs. Tulsi 'The old Queen'. 'The old Hen', 'The old cow'. 'How the little gods getting on today, eh? he would ask.- - -'And how the Big Boss getting on today?' (p.104) is the way of his taunting. Then he tries to persuade Govind, one of the son-in-laws. Biswas wants to get him on his side as a fellow sufferer by telling him that his motto is 'to paddle my own canoe.' But Govind has surrendered to the Tulsis, and has been degraded. He tells everything to Seth. At once Biswas is summoned and demanded apology. They never forget to remind him that they feed him. He shouts, 'The whole pack of you could go to hell! ... I not going to apologize to one of the damn lot of you.'(p.111) He resists against the total absorption in the Tulsi clan. His will to keep the struggle continued, becomes stronger. He turns to physical insults, he spits on Owad, the elder god, on which he receives blocks from Govind, but he is satisfied that at least they feel insults.

One of the most effective strategies, employed by Biswas to tease the bosses of Tulsi family, is to expose their cultural hypocrisy. He points out repeatedly various cultural and religious practices of the supposedly

conservative Hindu Brahmin family which are nothing but a slavish mimicry of the white colonial master's culture and religion. On the serious level, he helps the decadent social system to realize its own weaknesses. He openly begins to ridicule the practices of orthodox Hindus and their hypocrisy. 'Well, since I been in this house I begin to get the feeling that to be a good Hindu you must be a good Roman Catholic first.' (p.125) He starts calling Hanuman House a 'monkey House' which is decorated by two monkeys, Owad and Shekhar. His insults reach at a climax when he meets Misir, a Hindu, who works in Sentinel, and provide him a stunning information about Tulsis, '..... You know what I see? A pig with two heads'. 'Where?' 'Right here, in Hanuman House, from their estate.'(p.168) Misir is interested in printing this story. Biswas thus takes revenge on Mr. Seth who writes, in the birth certificate of his daughter Savi that her father's occupation was 'labourer'. According to Fawzia Mustafa 'rather than a simple desire to be rid of family, Biswas' obsession lies more with his need to declare his individuality, so that his eccentricities, though no more unusualtake on the dimensions of a rebellion.'[12] The world of Tulsis is so compact that they do not allow a man from other religion in their house, or even they do not have any relations with other communities of different races. They accept no change. Biswas wants to suggest to them that the transition is taking place outside and they should widen 'their horizon. He is amazed to see that the wife beating is normal and flogging the children is

' a ritual'. It is all beyond his edurance. Saterndra Nandan remarks,' Biswas' character shows enormous resilience and capacity for growth. This springs from an inner faith in the value of human personality.'[13]

In Tulsi family, Hindu religious activities are mechanically observed. Hari chaunts Sanskrit hyms, whose meaning he does not understand. Rituals are performed without any significance, or nobody tries to comprehend the significance. They celebrate Christmas in Creole style by taking brandy, eat salmon on Good Friday. The Tulsi sons perform puja by wearing crucifix. Chinta uses Hindu incantations in combination with a candle and a crucifix. Mrs. Tulsi is accustomed to the practices of Catholicism. If somebody gets ill, Hindu prayers, Indian and African superstitions and Western science are called upon to cure the ill. They do not have real respect for either religion. Naipaul comments in *The Middle Passage*, 'Trinidad was and remains a materialist immigrant society, continually growing and changing, never settling into any pattern, always retaining the atmosphere of the camp.'[14] Biswas exposes their cultural hypocrisy by telling them that he is the member of Arya Samaj, the society of the scientific, modern thinkers. Biswas represents modern generation. He is atheist for Tulsis, but his petty abuses have great significance which they fail to comprehend.

Biswas's success in getting an independent job and an independent housing facility for his own family is the first step towards realization of

his urge for meaningful relatedness. He is offered a place at Chase, where he could run a shop independently. For the first time he is going to enjoy his family life away from the Tulsis. However, Biswas fails to do his business which runs into debt. By burning the shop on Seth's advice to get insurance money, he returns to Hanuman House. His first attempt gives him marginal success, but it is important that he tries to escape from chaos, 'from the suffocating servility of the Tulsis.'[15] Biswas's second attempt brings him to Green Vale, where he sees the barracks for the labourers. He, at once, takes a vow to build his own house. As a child he has taken that vow when he is expelled from Ajodha's house. 'I am going to get a job on my own. And I am going to get my own house too.'(p.67); He reads novels that take him to the outside world. He becomes a driver cum sub-overseer at a salary of twenty-five dollars a month. He now becomes the responsible member of the society. He has started earning for his family.

III) As a Father with His own House/ Family

Biswas is struggle for liberation as the colonized reaches crucial stage when he plans for building his own house. When Seth gives him the insurance money, he plans his dream house. 'He wanted, in the first place a real house, made with real materials. The house would stand on tall concrete pillars' (p.210) His relationship with Shama always remains physical without the feeling of togetherness. His real house will strengthen

those familial bonds, which he has always wished for. His real house will offer complete security, economic as well as personal, where relations will be respected, sharing love, affection and care, respect and dignity. He buys a Christmas gift of a doll's House, for his daughter, Savi, which indicates his desire for beauty and order. Chandra Joshi thinks that 'by giving a present to his daughter Mr. Biswas flouts the Tulsi code to assert his individuality.' [16] His attempt is frustrated by Tulsidom with severe taunts which irritates Shama. She throws that house which shatters to pieces. That shattered dream house is an assault against his own person. After the doll's house incident Biswas brings Savi with him. He tries to entertain her and makes her stay pleasurable. But Savi does not seem to enjoy. However, he has some chances of family life. Shama returns with Anand and Myna.

In revolting against Tulsi house, Biswas revolts against a dead environment which negativizes all possibilities for meaningful relatedness. His newly built house is his own creation - however imperfect it may be. It has potentialities for meaningful relations between members of its family as a mutually trustworthy and beneficial non-exploitative system. Even before Biswas builds his house, he is anxious to be meaningfully related to the members of his family, as a father and as a husband. He builds his first house on the land, Seth has shown, by borrowing money from Ajodha. A house with garden, he starts building bit by bit, raising the finance for it.

But he lives alone in that house. Shama as usual is in Tulsi family. He becomes a visiting father. His second attempt is also frustrated by the cane labourers by burning the house, and killing his only companion, Tarzen, a dog. His nervous breakdown brings him once again to Hanuman House.

Finally, he makes the decision and comes to Port of Spain, where he meets Mr. Burnett, the editor of The Sentinel and his career as a journalist begins. He gets a job on his own talent for first time, without the influence of Tulsis. He becomes 'uncle Biswas' in Tulsi family. His whole family comes to live with him. With full capacity, he shoulders his responsibility. Again the bout of building his own house at Shorthills occupies his mind. He builds the house, it is the physical expression of his self, his human core, independent soul! His life is now full of happiness. All members of family are with him. There are moments of enjoyment. The excursions, picnics, hotelling, are occassional moments. He owns a car; his children receive scholarships advance in their studies. Shama's behaviour is also changed. Her evolution from master to human being takes place only because of Biswas. He helps her to come out of the imperialistic attitude, in which she was trapped.

Biswas's struggle to build the house is closely related with his relationship with the wife and children. He is now head of his own family. As Satendra Nandan states, 'His rebellion, becomes positive in terms

of human relationships and his vision of a house of his own.'[17] Awareness of the responsibilities and relationships with his family members gives a substantial force to his house. Satendra Nandan comments again, 'What gives significance to the quality of Biswas' experience is his persistent desire to understand life and to make a sense of a chaotic world..... Mr. Biswas' appeal lies in the fact that he has remained himself.'[18]

Biswas' urge to build the house exhausts his energy and he falls ill, collaspses in the office, is entered in the hospital and then brought home. Shama is all the time with him. His final relationship with her is a measure of his achievement. 'It gave Mr. Biswas some satisfaction that in the circumstances Shama did not run straight off to her mother to beg for help. Ten years before that would have been her first thought. Now she tried to comfort Mr.Biswas.....'.(p.7) In his own house, he dies contentedly.

The establishment of Biswas's familial house parallels the down-fall of the Tulsi order. As Hanuman House is crowded Mrs. Tulsi moves to Shorthills and then to Port of Spain where all the members come out with their true colours. Cheating and betrayal, acquiring money by false means, become the regular practice. Mrs.Tulsi loses her control. Owad marries a Presbyterian, goes to live in her house and becomes father of two daughters, which is the thing of contempt for Tulsi. Shekhar, marrying a rich Hindu, moves to her house to look after their business. Seth's power reduces and the power of Tulsi family is transferred to Owad. After the

death of Mrs. Tulsi, the structure collapses completely. The journey of the Tulsis is from prosperity to poverty that of Biswas, from poverty to prosperity.

The Tulsis is a typical East Indian society which refuse to change and cling to their false, cultural ideas. Herbert Marcus rightly points out, 'any society which encourages and engenders dependency - a desire for security rather than creativity and equality and is coercive, necessarily utilizes the past as a weapon of control, hampering its members from moving into present : it is an inadequate society.'[19] On this background, Biswas' struggle is a mature response to his existence which marks his achievement as a man who foresees changes, and acts in time. Shashi Kamra appreciates the novel for Naipaul's realization, of the 'relationship between individual and society, society and social reality, the particular and the universal, past and present, at different levels of consciousness.'[20] It is through individual and family relationship rather than through the relationship between individual and society that Naipaul decodes the Caribbean persona's struggle for meaningful relatedness.

References

1. V. S. Naipaul, *A House for Mr. Biswas*, (New Delhi : Penguin Books India Ltd. 1961).

 (All quotations cited are taken from this edition).

2. Phil Langran, 'Earl Lovelace and V. S. Naipaul : Representations of Trinidad,' *The Literary Criterion*, Vol. xxxv, No. 1 & 2, 2000, p. 46.

3. Renu Juneja, *Caribbean Transactions : West Indian Culture in Literature*, (London and Basingstoke : MacMillan Education Ltd. 1996), p. 7.

4. Frederic Jameson, " Third World Literature in the Era of Multinational Capitalism," *Social Text*, 15, (Fall 1986), p. 69.

5. William Walsh, "V. S. Naipaul : Mr. Biswas," *The Literary Criterion*, Vo.ix, Summer 1972, p. 33.

6. Ibid, p. 33.

7. Maureen Warner, '2 - Cultural confrontation, Disintegration and Syncretism in "A House for Mr.Biswas," ' *Caribbean Quarterly*, Vol. 16, No. 4, Dec. 1970, pp. 70-71.

8. Ibid, p. 71.

9. Ibid, p. 72.

10. N. Ramadevi, " A House for Mr.Biswas : Home and Identity", in *The Novels of V. S.Naipaul : Quest for Order and Identity* (New Delhi : Prestige, 1996), p. 60.

11. Gordon Rohleher, "The Ironic Approach :The Novels of V. S. Naipaul, "in *The Islands in Between : Essays on West Indian Literature*, ed. Louis James, (London : Oxford University Press, 1968), p. 132.

12. Fawzia Mustafa,*V. S.Naipaul*, (Cambridge :Cambridge University Press, 1995), p. 61.

13. Satendra Nandan," A Study in Context : V. S.Naipaul's *A House For Mr. Biswas*," *New Literature Review*, 1977, p. 25.

14. V. S.Naipaul, *The Middle Passage*, (London : Andre Deutsch, 1962), pp. 57-58.

15. N. Ramadevi, op.cit., p. 61.

16. Chandra B. Joshi, *V. S. Naipaul : The Voice of Exile*, (New Delhi : Sterling Publishers Pvt. Ltd. 1994), p. 132.

17. Satendra Nandan, op.cit., p. 25.

18. Ibid, p. 25.

19. Herbert Marcus, *The Ideology of Advanced Industrial Society*,(London : Routledge and Kegan Paul, 1964), p. xvi.

20. Shashi Kamra, *The Novels of V. S. Naipaul*, (New Delhi : Prestige, 1990), p. 84.

(2) *The Eye of the Scarecrow* (1965)

Wilson Harris (pseudonym for poetry only KONA WORUK) was born in 1921, at New Amsterdam, British Guiana(Guyana). He was educated at Queen's College, Georgetown. He was a Government surveyor. He travelled extensivley through Guyana. He now makes his home in U. K. He has travelled widely lecturing and holding posts of writer-in-residence in Australia, New York,Texas, Toronto, Cuba. He has also lectured at the University of the West Indies. He has received many awards, including the Arts Council Grant in 1968. He was Commonwealth Fellow in Caribbean Literature, Leed University, Yorkshire, U. K.1971. Delegate to the National Identity Conference, Brisbane, 1968, Delegate to U.N.E.S.CO. Symposium on Caribbean Literature, Cuba, 1968. His novels are *Palace of the Peacock* (1960), *The Far Jounrey of Oudin* (1961), *The Whole Armour*(1962), *The Secret Ladder*(1963), *The Eye of the Scarecrow*(1965), *The Waiting Room*(1967), *Tumatumari* (1968), *Ascent to Omai* (1970), *Black Marsden*(1972), *The Companions of the Day and Night*(1975), and *Genesis of the Clowns* (1975), *Da Silva, Da Silva's Cultivated Wilderness* (1977). He is the writer of short stories, critical essays and others forms also.

In the case of Caribbean writers, the obsessive burden of the history of guilt and sufferings threatens to negativize any possibilities of creative

future for their land. Wilson Harris also confesses his obsession with 'individual guilt and collective hsitory'[1] as a writer. As a visionary artist, he believes the tragic history of his native land not as the destiny of the isolated section of humanity but as a repetition of histories in all ages and in all nations. For him, the sense of despair for the recial past should be overcome by the sense of hope for humanity as a whole because all time and space-specific realities merge into the ultimate reality of Creation or Womb. Harris thus arrives at the creative realization of human condition essentially in metaphysical terms in his novels.

The sense of despair arises, according to Harris, from man's unwillingness in the age of science to probe into the nature of reality by utilizing the potentialities of his power of imagination. He argues that imagination 'opens up areas in ourselves, helps us grasp conflicts and eclipsed sensibilities, urges us in a way that allows us to transform our age.'[2] He regrets that arts and sciences accept cultural, economic, political and historical realities as fixities so that the way to re-assessment of those realities is closed. He pleads for open dialogue with the past by activating the power of imagination which can offer alternative vision of hopeful future. As he states in one of the interviews, "The fate of man as an economic animal condemned to servitude is wholly sustained by a static cultural inperative whereas, seen in another light, that imperative may turn into the mask of sacred flux of identities whose creative potentiality

cannot but deepen the conscience of history, the remedial scope of the arts and sciences.'[3]

As a novelist, Harris negotiates with the double challenge - that of making his philosophical vision available to others, and that of creating faith in them about the possibility of such a vision. His novels are a persistent struggle to confront this challenge both thematically and structurally. It necessitates the complementarity of two methods of narrativization - the abstract philosophization and the concrete fictionalization. In the majority of his novels like *The Palace of the Peacock*[4] *The Far Journey of Oudin*[5], *Ascent to Omai*[6] and *Tumatumari*, Harris balances the abstract against the concrete through specification of plot and characters. *The Eye of the Scarecrow* is, probably the only novel in which he maximizes the role of the abstract and minimizes the role of the concrete. The metaphysical realization of the Oneness is offered in the form of a confession on the part of the narrator through a diary which presents a chain of memories. It is a gradual process - the drama of consciousness in three acts or stages, as given in three books - 'The Visionary Company,' 'Genesis' and 'Raven's Head'. In the first Book, the narrator explicates the multi-layered relationship between himself and his so-called childhood friend, L -. The second Book shows the two friends undertaking the ambitious expedition of discovering the ancient city of Raven's Head for excavation of gold mines.

The third Book narrates how the expedition closes on the chaotic end - both friends meeting with the fatal accident of aeroplane-crash.

The title of the novel, 'The Eye of the Scarecrow' is an abstract-concrete symbol of its theme and structure. 'Scarecrow' is an empty structure which becomes meaningful when it is dressed. The 'eye' of the scarecrow mirrors whatever it sees. As Hearne explains, it is 'both reflector and captor'[7] of reality and the inner reality. It stands for the sacred capacity of human intelligence/imagination to spring to life the inner layers of meaning hidden in the outer, reality-reality as it is. Thus, 'the Eye of the Scarecrow' is the image in which Harris registers his cognizance of apparently contradictory aspects of reality. It connotes the simultaneity of two dimensions of reality -dead yet living, positive though negative, factual and instinctual. The novelist projects the 'scarecrow' poetically as having 'a single eye which turned and looked - without appearing to make any effort to see - both ways in the same blank instant.'(p.75) As he describes further 'it' was 'engaged in preparing a new map of the fluid role of instinct which had never ceased continuing to move and outline an inherent traverse and cradle of regeneration.' (p.76)

Harris establishes the unity yet difference between two dimensions of reality - The inner and the outer or the metaphysical and the scientific - by representing them as two separate yet united personas, the Narrator,

and his friend L-. In fact, the novel is a crucial statement of the relationship between them on the metaphysical level.

The most important strategy employed by the novelist for concretizing the metaphysical experience is the location of the two personas -- The Narrator and L -- in the context of familial relationships. He evokes the illuminative content of his miraculous vision of human condition by allowing the relationship between the two to evolve so as make it also a process of revelation. The three stages of the process of evolution of the relationship between the Narrator and L -- may be seen as follows :

I) The Narrator and L - as friends, defining their separateness.

II) The Narrator and L - with the common parentage so that their identities merge and separate alternatively.

III)The Narrator and L - as sexual rivals which achieves the dissolution of their identities.

The 'family' of the Narrator and L - emerges as a mirror and a microcosm of human history in the novel. As men, the two enter various culture- specific roles in the course of their relationship with women. Significantly, the novelist retains the anonymity of the two as well as of the men and women, referring only to the role-models. The novel, in a sense, evolves men-women relationships so as to make them parts of the ultimate reality of the Womb. It may be presented thus -

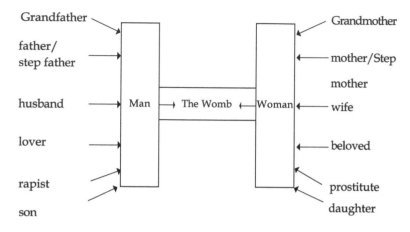

The relationship between the Narrator and L - is activated strictly within the illumined circle of vision. L - stands for scientific approach to life and its realities whereas the Narrator stands for the metaphysical or imaginative approach. L - is significantly an engineer, a man of machines with utilitarian conscience. The Narrator contrasts himself with L -, describing L - to be 'sober and matchless good sense, judgement, responsibility restrained, indifferent' while he describes himself to be 'the striking unpredictable one' (p.40). The terminology to qualify the uncreative nature of scientific realism includes words referring to its being fixities, static, dead, self-indulgent, self-sufficient, classical, absolute, pure, materialistic, transparent, deaf, dumb and nihilistic. On the other hand, the terminology that defines the instinctual nature of spiritual or imaginative realism includes reference to its being full of humility,

illumination,, explosion, inpurity, absurdity or its being living, immaterial, dream-oriented, distorted and unconventional.

I) The Narrator and L - as Friends

The novel centrestages the Narrator and L - relationship as they impersonate the crucial approaches to reality. The first stage of its evolution establishes their separateness. The Narrator wonders at the enigma of their relatedness as close childhood friends. It serves as the background for his symbolic journney into the past highlighting 'the transient figures of the insensible past into ideal erections against chaos, standing within a measureless ground plan of spiritual recognitions, intimacies and identities'(p.16)

In the first part of the novel : 'The Visionary Company,' Wilson Harris gives the framework of the novel for visionary interpretation. The Narrator 'I' introduces his family which includes his mother, grandfather, grandmother, and L - his friend. Through his family, he represents three generations. His grandfather who belongs to African ancestry, second is the Narrator's parents who belong to plantation slavery and the third the Narrator himself representing present generation. The past, present and future are brought on same plateau, which indicates timelessness. Harris depicts family of man as timeless phenomenon. 'I' narrates the history of British Guiana from 1920 to 1940 when British Guiana was undergoing the

economic depression. Over the span of forty years, there were series of grave conflicts between capital and labour, parties and powers, institution and masses. It is as Harris explains in the introduction to the novel, a historical nightmare with 'profound sense of insecurity, blasted dreams in which history (as universal given tool) was both culprit and nightmare, the ground of nihimlism and pessimism'[8]

The Narrator writes diary where dates and places are mentioned. It is an autobiographical experience he tells. Geographical and historical realities are delibarately mentioned. He dissolves geography and history together. A diary opens on 25-26 December 1963 and closes on 25th September 1964. According to Jean-Pierre Durix these dates, 'a nine-month period which echoes the birth of Christ while starting where the Son of God comes to this world, forming a mirror-like reflection of a temporal sequence.'[9] His diary is a document of past and present. His entries are not chronological. The events are in constant flux. The entries of an experience related in 1948, the novelist clarifies,' will be written for outside of that year a free construction of events will emerge in the medium of phenomenal associations all expanding into a mental distinction '(p.13) The Narrator hopes his diary will prove the first reasonable attempt for an open dialogue.

At the time of Guiana strike, the Narrator meets L - when he was eight. He is now with him standing on the terrace of the building at Water

Street near the Demerara river. River indicates the river of consciousness. Looking at the reflection he remembers his slave past, the parents who crossed the Atlantic ocean. The barracks of Water Street are meant for the slaves. The Narrator perceives their impoverished condition, their deadly labour and their punishments. He remembers the funeral procession. 'tragic spring of the dead moves secretly and steadfastly across every continent.....'(p.17) Plantation slavery is the limit of the tragedy. Political history is stained with blood those who are involved in it are criminals, they are nihilist, the stigma on humanism. For the Narrator it is the grimest redeeming clue to the memory. But beyond L -, he sees the clouds and the shining sun the symbol of hope. He calls sun a shepherd, Eye of the universe, who keeps watch on everything underneath. The ghost of the past vanishes. He arrives back in the modern times, in present at Demerara township where the barracks of slaves are demolished. Time changes. Michael Gilkes comments, 'The narrator's own heterogeneous, free floating consciousness is able to move backwards through time and past experience, returning with a re-vision, an informed, re-construction of the 'scandal' of history.'[10]

In the dream, the plantation slavery haunts the Narrator. He sees the slaves are killed mercilessly by the landowners, either by hanging or by bullets. Then he sees the dying procession of the strikers in the abyss of the Water Street. According to Hearne, Wilson Harris, introduces dreams

'so that in the end, by the potent magic of image, all the fragments of our strange, broken heritage may begin to act one upon the other, become whole within our instinctive grasp.'[11] In the abyss of past, which is already dead he tries to find the mystery of death. Death, suggests the possibility of life, the change which Harris expects in positive terms. The events are not stuck in the passage of history.

The Narrator remembers his family. As a child he is with his step-grandmother in East Street at grandfather's lodge. He leaves his grandmother with other women, as community gathers in his grandmother's house, and goes to the house top. There he meets his nurse, one of the family members. 'Her name was Cromwell or Crumb Well or the Crumb (of reality) - WHITCH -MAKES - WELL.' (p.22) He feels womb/ crumb/well, and the chemistry of love. 'Womb' suggests the creative-positive future, possibility to understand reality; and 'crumb' suggests the break off from the past to confront the future with positive insight. The Narrator describes the grandfather's house.

The quotation from Bible, 'In my Father's house are many mansions ' becomes the chorus of the novelist's journey through the labyrinth of inner consciousness. It signifies the capacity of sacred Imagination to create many possibilities lying latent within the apparently dead outer reality. His religious sense of the sacredness of Imagination underscores the

significance of religion for him. Harris expresses his views on religion in his interview with Stephen Slemon, 'I believe that revolution has its seeds in religion Religion must be concerned with immense truth.'[12] In his grandfather's house he finds a secret room which further leads him to another secret room - it is suggestive.

The Narrator's act of pushing L - in the canal suggests possibility of L-'s transformation. Then L- becomes his 'Own guage of future extremity. This dawning conscience within me of the guilt of freedom was due to his insensibility and instrumentality.'(p.26) The Narrator becomes part and parcel of a medium of both conscious and unconscious activity, he pulls out L - from the water. Jean Durix points out 'They become the complementary instruments of a common desire to explore the unknown.'[13] On the behalf of The Narrator L - experiences the horror of the past. Writer enables L - to experience the dehumanizing treatment of slaves by the hands of the owners. When he comes out he turns out to be one of the slaves.' '.....his clothing foul, dripping and wrinkled into the alien folds of another skin.'(p.26) Actually it is the narrator's metamorphosis.

In the grandfather - figures, the novelist visualizes different phases of racial history. The Narrator's grandfather who serves the landlord stands for the colonized, dutiful in his obedience to the master, but aware of the

master's injustice to the poor of his own community. At the time of the great strike tenants are unable to pay the rents. The Narrator goes with grandfather, to collect the rents. In grandfather's opinion landlord must not take rents. Only one tenant, Anthrop could give the rent. The Narrator sees Anthrop's wife with twins whom she feeds. Anthrop also has twin brother who is an engineer. The Narrator suspects that engineer Anthrop is the father of L - because he has heard the rumours that his mother is related to him. The engineer Anthrop disappears mysteriously and is found dead in the river. The Narrator's father also disappears after the charge of alleged murder; but he thinks that his father is innocent. The fate of the Narrator and L - is the same. Their lives go parallel to each other. They are the two sides of reality. The reality of the plantation slavery and the colonial past.

In another grandfather-figure, the colonizer is seen as a landlord with estate which he has accumulated by his chauvinistic behaviour at the time of colonial period. 'I hated my grandfather's property which seemed capable of turning around in my mind into an unreal triumph. . . I experienced once more the chaos I knew.'(p.32) Then his flashback takes him to Sunday school experience of excursion to upriver in a boat. Sea sick he falls asleep and finds that the boat goes backward again, it turns round and heads back again down. He is in utter confusion. It suggests the historical past to be cyclic not linear.

To understand the reality, exile is inevitable. It is suggested through the Narrator's operation of the eye. He is hospitalised. To forget the past, anaesthesia is essential. Operation is essential for better perspective, as Gilkes puts it. 'It brings inevitably, a condition of "alone-ness." This is the potentially creative aspect of "exile".'[14]

II) The Narrator and L - with the Common Parentage

In Second Book once again Harris gives the Biblical reference. He entitles the chapter, 'Genesis', which indicates the origin. Such reference he has used earlier in his novel *The Palace of the Peacock*, where he has shown the seven days' journey which represents the creation of earth by God in seven days. In 'Genesis', he tries to explore both the meanings - the Biblical meaning of man's origin, and philosophical meaning of the origin of human race. Genesis means the womb of the mother - her capability of regeneration. Woman appears in various forms in this chapter. L - 's expedition for search of the ancient city, Raven's head, for excavation of gold mines at the bed of the river represents the search for inner reality. L -'s attitude towards excavation is purely scientific, whereas for the Narrator, it is search of truth. Sexual experiences which go on confusing identities mark the second stage of evolution of relationship between the Narrator and L -. The writer leads the reader towards the integration of all identities - woman as mother, wife, and beloved.

The Narrator first sees his mother-in his grandfather's mansion. Grandmother and father accuse her for something and she weeps bitterly. He sees her reflection in the mirror, mirror suggests that such reality also is repeated elsewhere. His mother's tears stand for the suffering of the racial past. Such image is repeated in Harris's other novel, *Carnival* .[15] The Narrator pushes L -'s mother in engineer Anthrop's arms. She too becomes his own gauge. Then he wants to help her when he realizes she is his own mother. 'L - and I suddenly stumbled upon the faint but "timeless" footprints of a self - created self.'(p.47) It is his dream where he sees his mother weeping for his step-father. In dream he is the lover of the mother and when he wakes up he finds himself in her arms. It is Oedipal complex. The news arrives that his father is dead by drowning. Jean Durix explains, 'Wilson Harris suggests that in order to penetrate the surface of perceptions, one must go beyond a strict identification with a fascinating double.'[16]

The second stage, represented in the Second Book, closes significantly on the introduction of the Narrator and L - as sexual rivals in their relationship with the so-called prostitute, Hebra, employed by L - to guide them to the lost city of Raven's Head. As the Narrator confesses. 'It was the most difficult trial and conviction for me to begin to accept the unpalatable truth that we - who sought to make her plaything - were her maternal joke as well .(twins of buried and divided fantasy)'(p.53) The

Narrator constantly oscilliates between dream and reality, between positive and negative personality, between 'womb' and 'tomb'. Such kind of discontinuity is continued throughout the novel. For Benjamin, discontinuity facilitates the narration because 'while the past can be repeated this repetition is not a retrieval but a reiteration of the different within the different.'[17] In Harris's novel nothing is static.

By merging two identities into one, Harris crumbles the fractured past. The process of crumbling refers to the active transformation that the womb of the space will bring the change. John G. Moss remarks, 'Historical experience is very real to Harris, but as an aspect of the endless present and not of the receding past.'[18]

III) The Narrator and L - as Sexual Rivals

The relationship between the Narrator and L - culminates in their being sexual rivals - both are equally involved in Hebra's rape. It re-creates the centrality of the womb in all human relationship. The Third Book thus marks the third and the most crucial stage of the relationship. Raven's Head refers symbolically to the image of the scarecrow. It is the name of a lost city. According to oral tradition there are two Raven's Heads. The practical L -'s interest is in the lost ancient city, and the spiritual Narrator's interest is in its spiritual reality. Mining of the riverbed suggests symbolically need to reach the depths of inner reality. Hebra, L - and the

Narrator bring together biological principle of sex instinct. Hebra stands for woman as a beloved and a whore or prostitute. L -'s and the Narrator's identities are merged. The 'I' turns into 'we' : 'It' stands for the principle of this relativity, which is timeless and spacelss. Male, Female merge without any distinction.

Four dimensions of reality are presented through four gates of the ancient city. Raven's Head town is significantly called in the oral tradition as 'Hebra's Town.' The location of the place is like this : The Raven's Head at the north, Hebra's gate at the south, the Suspension Bridge on the west and Sorrow Hill on the east. Hebra takes responsibility to guide them. She takes them to the thick forest, which stands for ambiguous past. She brings them to the Raven's Head. They use her as a sex object, they rape her and kill her. In the novel, *Carnival*, the same experience is depicted by Harris. The rape of the woman is highly suggestive in that novel. It is partial figuration of history. The novel begins with the, 'idea of a post-colonial state as an abortive culture, a culture that has been raped by the outside.'[19] The fear of illegitimacy should be aborted in order to make legitmate relationship between present and future. The figure of woman is crucial to Harris's novels. Her roles change, as MacWatt points out, 'as the virgin, the bride, the 'earth-mother' (and other mothers), the fallen woman, the femme fatale The whore Madonna a combination of two archetypal poles or extremes.'[20] The rhythm and the cycle of human

existence is embodied in the figure of a woman.

L - digs deep into the ground, suggestive of inner reality, but the Narrator is frustrated to see L-'s lack of imagination. With his spiritual eye, the Narrator wants to understand reality (Caribbean reality) Their plane crashes in the forest. The jungle's extra-human dimensions suggest-timelessness and offer a glimpse of eternity, while the constant renewal of the vegetation confirms its existence within a cyclical time pattern.

The grandfather figure recurs in the last part when an old man and a young boy are shown to be going together in a horse-driven carriage with mysterious driver. The relationship between the two undergoes the transformation similar to that between the Narrator and L -. The two, apparently strangers, are the grandfather and the grandson who again are substituted by the comprehension of their being one - a shepherd.

They depict two stages - ancient and modern. The two stages of history are brought together. Grandfather becomes a Biblical figure, he becomes shepherd, guardian of lambs. The relationships are also thus, in constant flux. The horse, because of blindfolds, lacks the true perception, hence the accident takes place. The carriage collides with the sacred cow. They are stopped by the sacred cow because grandfather and the boy are engaged in a mechanistic, materialstic race for survival. The need of inner perception is awakened by the cow. Most living creatures have limited

perception of their surroundings as Durix puts it, 'probably because they would not normally be able to bear the whole extent of reality.'21

In the end the Narrator writes letter to L - in which he argues that oral or written language is creative. For the Narrator 'Language is one's medium of the vision of consciousness..... language alone can express (in a way which goes beyond any physical or vocal attempt) the ultimate "silent" and "immterial" 'complexity of arousal.' (p.95) Language suggests a dialogue, inner dialogue, the dialogue between the conscious and the unconscious. The Narrator advises L - that practical knowledge of science and technology must be combined with poetic vision and tells him to come out of that stock imprisonment. L -accepts defeat. The Narrator closes letter with, 'IDIOT NAMELESS' 25th September 1964'(p.108) The realm of metaphysical vision appears 'idiotic' or 'absurd' from traditional point of view, and the timeless reality is nameless. Possible search of the womb will give rise, according to Harris, to new family, new culture. So, in the novel, the family relationships are narrowed down to single male /female reationship which is again narrowed down to single principle of Creation through Hebra's identity as prostitute and mother.

References

1. Wilson Harris, *The Eye of the Scarecrow* , (London : Faber and Faber, 1965) this edition, 1974, p. 108.

 (All quotations cited are taken from this edition.)

2. Michel Fabre, "Interview with Wilson Harris," *WLWE,* Vol. 22, No. 1, Spring 1983, p. 9.

3. Wilson Harris,"A talk on the Subjective Imagination," in *Explorations,* (Aarhus : Dungaroo Press, 1981), p. 57.

4. Wilson Harris, *The Palace of the Peacock,* (London : Fabre and Faber, 1960) All his novels are published by Faber and Faber.

5. _____, *The Far Journey of Oudin,* 1961.

6. _____, *Ascent to Omai,* 1970.

7. John Hearne, "The Fugitive in the Forest : A Study of Four Novels by Wilson Harris," *The Journel of Commonwealth Literature,* No. 4, Dec. 1967, p. 101.

8. Wilson Harris, "Author's Note," in *The Eye of the Scarecrow,* (London: Faber and Faber, 1974) no page number.

9. Jean-Pierre Durix, "Ripples in the Water : An Examination of *The Eye of the Scarecrow,*" *WLWE,* Vol. 22, No. 1, Spring 1983, p. 57.

10. Michael Gilkes, (ed.), The Literate Imagination : *Essays on the Novels of Wilson Harris*, (London : Basingstoke : Macmillan Caribbean, 1989) p. 5.

11. John Hearne, op. cit., p. 112.

12. Stephen Sleman, "Interview with Wilson Harris," *Ariel*, Vol 19, No.3, July 1988, p. 53.

13. Jean Durix, op. cit., p. 60.

14. Michael Gilkes, *The West Indian Novel*, (West Indies : Twayne Publihsers, 1981), p. 147.

15. Wilson Harris, *Carnival*, (London : Fabre and Faber, 1985).

16. Jean Durix, op. cit., p. 61.

17. Andrew Benjamin, 'The Crumbling Narrative : Time, Memory and Overcoming of Nihilism in 'The Eye of the Scarecrow",,' in *The Literate Imagination : "Essays on the Novels of Wilson Harris,* (ed.), Michael Gilkes, op - cit., p. 84.

18. John G. Moss, "William Blake and Wilson Harris : The Objective Vision," *The Journal of Commonwealth Literature*, Vol. ix, No. 3, April 1975, pp. 29-30.

19. Stephen Slemon, op. cit., p. 53.

20. Mark MacWatt,"The Madonna / Whore : Womb of Possibilities (the early novels)," in *The Literate Imagination.* op. cit., p. 31.

21. Jean Durix, op. cit., p. 57.

(3) *The Year in San Fernando* (1965)

Michael Anthony was born in 1932 at Mayaro, Trinidad. He is novelist and journalist. Educated in Trinidad, he has been living in San Fernando since 1970 as an official of the Ministry of Culture. He had lived in London in 1955 and 1968, and, for two years, worked in Brazil. It was Vidia Naipaul who persuaded him to write prose. His first novel is *The Games were Coming* (1963). *The Year in San Fernando* (1965) recalls some of his own early experiences when he worked for a rural family during his 12th year. His other publications are - *Green Days by the River* (1967), *Streets of Conflict* (1976). He has written number of short story collections such as *Sandra Street and Other Stories* (1973), *Cricket in the Road* (1973). He has contributed to many anthologies and journals including *Caribbean Prose* and *Bim*.

In *The Year in San Fernando*,[1] Michael Anthony fictionalises the autobiographical experience of a child exile compelled to work as a servant in an upper class white family in San Fernando. The novel registers, through child's consciousness, the difference between two families, one to which the child belongs, and another to which he is sent. The simultaneity of the presentation of two life-styles being lived by the boy-one, actual and the other, through memory-facilitates the evaluation of mutually contrastive areas of social experience within the Caribbean colonial context. The two families

represent two aspects of Caribbean society. Francis's family stands for the rural, economically-handicapped black majority while Mr. Chandles' family stands for the urban,, economically-privileged white minority.

Edward Baugh decodes the significance of the novel in terms of its capacity to 'verify some basic universal truths of the human condition.'[2] More specifically, it may be regarded as an expression of the basic human urge for meaningful relatedness. Through the child-hero who lacks the adult knowledge of human relationships, Anthony offers a valuable insight into the positive and negative potentialities of economically conditioned institution of family, Caribbean in particular, and universal in essence.

The novel moves between the rural working class family and the urban upper-class family. The familial relationships in these two kinds of families can be divided as follows -

I) Black mother - black son relationship in rural working -class family.

II) White mother - white son relationship in urban upper-class family.

III) White master - black servant relationship.

I) Black Mother - Black Son : Ma and Francis

Francis's childhood within his own family, narrated at the beginning of the novel, marks the first stage of his growth from childhood to adolescence. It also shapes his experience of meaningful relatedness as being

intense and intimate. He represents majority black poor class, for whom economic survival is priority. They are hectically engaged in getting money, particularly Caribbean women, as their's is the matricentric society. Francis belongs to such family, living in Mayaro, the rural part of Trinidad. They live in an old house which ramshackles in rain. But Francis is very happy with his brothers Felix and Sil, and sister Anna, and his mother Ma. He enjoys symbiotic unity with Ma. Her devotion towards family is remarkable.

Francis's mother works at any job she gets to support her family. Alladi Uma comments on the role of the Afro-American women which is true in every sense about Caribbean mother/women, 'she has to be a stabilising factor in her children's life. While she has to inform them of the cruel life outside she has to be tactful not to make cowards out of them.'[3] The human values like "togetherness" and "relatedness' are clearly seen in Francis's family, Abrahams[4] calls it "breadth of relationships". She works in Mrs. Samuels' house. She has to do everything in that house, '. . . . to wash, starch, iron, cook, sweep-up, and to run errands, No one know about the pay but people could not help seeing how Ma slaved. They say she would run her blood to water.'(p.5) Francis knows how she toils for them. With his brothers and friends he enjoys playing cricket, stealing guavas, and the adventures in the forest. His attachment to his house and its surrounding and his physical attachment to his family

members is so strong that he remembers nostalgically how 'Being in bed on any other night and just stretching my hand across, I could touch Sil and Felix. Anna slept with Ma on big bed.' (p.17)

The economic needs compel Francis to alienate himself from his beloved mother and family. When Mr. Chandles, who works in the forestry office in Mayaro, asks Ma if she could send Francis at San Fernando to become a servant-companion for his old mother, she thinks that it is good opportunity for the boy to go school and earn, and learn the tactics of survival. She accepts the suggestion and declares her decision in the house. 'There was shock all around and all eyes turned on me. I was flabbergasted.'(p.3) From collective identity, his journey begins towards his individuation. He hates Mr. Chandles for his detached mannerism, but to reduce the burden of Ma and to exploit the opportunity of education, he goes with Mr. Chandles who has job in La Brea, at the Great Asphalt Company. It is the deep faith of the Caribbean child in his mother that gives courage to the twelve-year boy in the alien city to overcome the nostalgia of the first days in Mrs.Chandles' house.

II) White Mother - White Son : Mrs. Chandles and Mr. Chandles

By clarifying the inability of Mrs. Chandles' family to provide its members the vital sense of meaningful relatedness, Michael Anthony foregrounds the dangers of economic power, the goal of materialistic

colonial Caribbean society. As victims of the money and status mania, the mother and two sons sacrifice the essential for the sake of the inessential. The novelist encodes this perspective in the contrast between mother-son relationship in two families - Francis and his mother from the socially inferior family, and Mr. Chandles and his old mother from the socially superior family. In the house of Mr. Chandles, the mother and son live in the vacuum of unrelatedness. In the first meeting Francis guesses it, 'I was a bit unsettled by the manner of the meeting between him and this person he called mother I could not help thinking something was wrong between these two.' (p.13) Mrs. Chandles is against his relationship with Marva, a coloured lady. Mr.Chandles insists that he wants to marry her. He fears that he may not get the right share in the big property. The mother constantly reminds him how much money she has spent on their college education, on him and his brother Edwin. He accuses her that, because of her lust for money, their father died. Francis thinks, 'and my mother sending me here because she could hardly feed us all. Yet no such row could take place in Ma's house.' (p.46) It is typical industrial society where money matters more than human relationships. Their life is so commercialised that the human beings turn into commodities in the race for money. Their big houses are ugly from inside, full of hate and malice.

On the other hand, there is the boy and his mother. At Easter time, his Ma visits Mrs. Chandles. 'When I saw my mother 'Ma' I cried running towards her. I absolutely forget myself. I held on her almost delirious with joy. She squeezed me to her' (p.59) Their visit is full of passion and love. In *Crick Crack, Monkey* on the other hand, the rural girl in urban family is ashamed of her mother's visit, because her rural manners bring her embarrassment. European manners have changed Tee, but city manners never change Francis. It is a good chance for Francis to escape but Ma's reminder 'take education' controls him. Francis is self- made. He is not like 'G' the boy of his age, in *In the Castle of My Skin*, whose growth is constantly supervised by his mother. Francis wants to say to Mrs. Chandles, 'I was not an orphan and alone. Also my mother was somebody'. (p.64) Luengo agrees that 'Ma is strongest emotional link to Francis's pre-San fernando life and hence the hardest to weaken.'[5]

III) White Master - Black Servant : Mrs.Chandles and Francis

Francis enters the 'big city'. Mr. Chandles shows him his 'big house' with 'big pillars', and introduces him with his old mother, Mrs.Chandles. She scrutinizes him and that makes him uneasy 'a storm of home sickness swept upon me. I felt finally cut off from Mayaro I didn't want to think of home I could hardly think about it making my eyes fill up .'(p.7) Now he is in the company of refined people where every thing is big. But the big house of Mrs. Chandles could just provide him an attic room, some

old clothes, bundle of papers for bed. But, as Kenneth Ramchand pinpoints, 'Instead of lengthening out this listless mood, Anthony tactfully allows Francis's mind to take the course of natural recovery.'[6] Now he is a servant and Mrs. Chandles, master.

There is nobody except Mrs. Chandles in that big house. Francis is afraid of the big city. Anthony Luengo comments, 'Separated from his boyhood (and communal) environment for the first time in his life, Francis also feels a terrible loneliness'[7] Francis's activities are regulated by routine which as Ramchand again comments, 'Serve as social conventions in the social world'[8] of San Fernado. His family has prepared him with the stamina needed to encounter the hostile environment. His first acquaintance is with Brinetta, a maid servant of Mrs. Chandles, 'I liked her for many things, but specially for the way she spoke to me.'(p.25) She takes him to the market and introduces him to the people of shops and market and teaches him the tactics of bargaining before she leaves her job. Then going to market becomes a lease of freedom for him. His hunger for relatedness is fulfilled in the market : 'The vendors knew me well by now, and they could almost tell what things I came for, and how much I wanted.'(p.103)

The dead unrelatedness of Mrs. Chandles' house challenges the creatively oriented Francis into an honest effort to relate himself with the lonely, hated old lady her surrogate son. Now he begins to learn what Mrs.

Chandles like, red fish, boiled corn. Soon he learns her moods and whims of Mrs. Chandles. He tries to prove a 'real companion' to her. He makes her happy by saving money in shopping. Soon he learns : 'the old lady really wasn't so bad, it was the old age.'(p.35) He wins the heart of the old lady by massaging her legs; preparing food or tea or coffee; keeping her plants alive by watering in April. He also makes her friends happy by his presence. When Mrs. Princet comes to meet Mrs. Chandles, she is friendly with him. They taste cyder wine and enjoy Brazil nuts, 'This was an Easter Day beautiful in itself and beautiful because of Mrs. Princet.'(p.53) There are some moments when Francis makes the old lady laugh by telling her funniest and scandalous events from the school. 'I had succeeded in drawing convulsive laughter from her.' (p.55) Soon he learns that the lonely old lady is filling the vacuum of loneliness with his company. She also needs to be related with somebody.

When the unhappy Mrs.Chandles is on her death bed in the end, the boy shows maturity in dealing with her. She gives her estate to Edwin. Her family has lost its capacity of emotional support to each other. So family dies with her death. Francis thinks that she is going 'home' i.e., heaven, and he to his, at Mayaro. His heart is full of compassion for the old Mrs. Chandles, 'And I wished somebody could do something..... I didn't want anybody to die.' (pp.120-121) Her dying condition does not make him sentimental. He grips the fact of death; it brings calmer view of the situation

. It is the sign of his growing to maturity. He extends steady, sympathetic hand to the dying Mrs. Chandles to say good bye.

Francis's relationship with Julia, the urban friend of Mr. Chandles, is another attempt at meaningful relatedness which also indicates that he is entering the phase of adolescence. He likes her. He hates her relationship with Mr. Chandles. During his stealing moments, he sees them in dark, making love, 'In a strange way Julia kept weighing on my mind I said to myself, "She's pretty but she's only a tramp!"..... And I lay in pain for sometime.' (p.58) Their relationship comes to an end in rainy season. But he understands that he starts loving her sister Edin, young and charming. According to Luengo, 'while he has grown old enough to appreciate surface changes, he is still too young to understand what is happening to him sexually, in a wider and deeper sense, psychologically.'[9]

Francis's hunger for relatedness remains unfulfilled within the masters's family even if he has friends and they have secret moments at farms, on play grounds or at the backside of his house. Hence, he turns to the world of nature. He is deeply interested in the growing cane plants, the leaves , the flowers, their cycle of growing and dying in his one year stay in San fernando. He arrives there at the time of Christmas, when the cane saplings are just grown in the fields. His search for relatedness in the deadened environment of Mrs. Chandles' house is compensated by his relatedness with the environment and the objects. His urge to create

meaningful relationship is indicated through the details his mind observes. His mind observes every bit of sound, smell and sight. He hears, for instance, the 'whish-whish' sound of the vehicles it means rain, quietness in the atmosphere means 'heat'. Anthony has given each and every detail to indicate the child's need of companionship. Critics criticize him for the exhausting details but Kenneth Ramchand also states, 'The novel involves us in the feel of a peculiarly 'open' state of consciousness the author achieves this effect by a scrupulous adherence to the Boy's point of view.'[10] He feels rain and wants to give that feel to Mrs. Chandles. Then he shows a bright rainbow to her and remembers the rainbows at Mayaro sea. 'At Mayaro if you were on the beach you could see the whole archstood there, both feet in the water.'(p.84) Registering every detail on the screen of his consciousness declares his strong inner urge to be related.

Anthony's novel explores the rural and urban cultures. Merle Hodge's *Crick Crick, Monkey* also reveals her concern with it. However, Anthony limits the experience of his boy-hero to the period of one year, whereas, Hodge shows greater stamina to probe into the nature of impact of the urban culture on her girl-heroine. But both uncover their anxiety for the sterility of urban culture to give birth to any meaningful relatedness within the institute of family, which emerges as the microcosm of the Caribbean society in the two novels.

References

1. Michael Anthony, *The Year in San Fernando*, (London :Heinemann in Association with Andre Deutsch, 1965).

 (All the quotations cited are taken from this edition).

2. Edward Baugh, "Since 1960 : Some Highlights" in *West Indian Literature*, ed. Bruce king, (London 'and Basingstoke : The MacMillan Press Ltd. 1979), p. 80.

3. Alladi Uma, *Woman and Her family : Indian and Afro-American - A Literary Perspective*, (New Delhi : Sterling Publishers Pvt. Ltd., 1989), p. 65.

4. Roger Ambrahams D., *Deep Down in the Jungle* (Chicago : Aldine Publishing Co. 1970).

5. Anthony Lucngo, op. cit., p. 90.

6. Kenneth Ramchand, *The West Indian Novel and Its Background* (London : Faber and Faber ,1970), p. 210.

7. Anthony Luengo, "Growing up in San Fernando : Change and Growth in Michael Anthony's *The Year in San Fernando*," *Ariel*, Vol. 6, No. 2, April, 1975, p. 88.

8. Kenneth Ramchand, op. cit., p. 213.

9. Anthony Luengo, op. cit., p. 83.

10. Kenneth Ramchand, and Paul Edward, "Introduction" to *The Year in San Fernando,* (London : Heinemann in Association with Andre Deutsch, 1965), p. viii.

(4) *Moses Ascending* **(1965)**

Samuel Selvon's central concern in his London trilogy - *The Lonely Londoners, Moses Ascending* and *Moses Migrating* - is the emigrant black community's problem of survival in a white society. The three novels uncover the process of gradual degeneration of Moses, the hero. The spiritual urge of Moses to be meaningfully related to his own people by offering them a surrogate family, in *The Lonely Londoners,* deteriorates in the economic urge to survive in *Moses Ascending.* The exploitative environment finds it degenerated further to the biological urge in *Moses Migrating.* It is significant that Selvon concretizes this change in terms of the protagonist's decreasing urge or a family/home. In the first novel, Moses is anxious to offer a surrogate home for the emigrants from his own country. In the second, the surrogate home gives place to a house run by Moses as a profitable business. In the third novel, the very urge to have a home is lost - homelessness becoming a permanent condition of the exile - psyche. Selvon's method of narration changes accordingly. The serious mode of *The Lonely Londoners* gives place to the comic in *Moses Ascending,* and to the farcical in *Moses Migrating.*

Moses Ascending [1] opens with Moses' mock-heroic argument in defence of his plan to purchase a house in London, and to isolate himself from his own black community. The effect of struggle for survival on the

colonial emigrant black community has been devastatingly destructive. Moses wants to write annals of their anguish in his memoirs. He has gone through the ordeals. Arrived from the warmest islands of the Caribbean to the country of the 'evil weather' i.e. London, the exiles have to set for their work in those early evil hours of the morning. Though unable to cope with the cold weather they have to get up early. All low paid and low level jobs are meant for the blacks : polish the brass and crome; wash the pots and pans; unlock the doors and tidy the papers on the desk; flush the loo; straighten the chairs; hoover the carpet; press the switches; start motors; empty the dustbins; ashtrays and stak boxes; peel and spuds; sweep the halls and grease the engines. Heavy and dangerous jobs are meant for them on low wages. Even though the spades work so hard they hardly manage to save money. They either die or vanish in the crowd of London.

Now Moses wants to do another experiment with himself. He struggles to achieve meaningful relatedness in economic terms. He is overconfident that his economic superiority would give him a status in white society, in spite of his black skin. Moses' ambition to become a landlord is fulfilled. He purchases a house at Shepherd's Bush. He is no more a tenant who lives in the rat hole. Thus he ascends from the position of a tenant to that of a landlord. Occupying the house Moses Says, 'I can not tell you what joy and satisfaction I had the day I move into these new quarters. Whereas I did have a worm's eye view of life, and now I had bird's eye view. I was Master of the House.'(p.10)

Once Moses comes into the position of a 'Master' his human core deserts him. He acts like a white master, the colonizer. He is completely happy with himself, feeling that he is the chosen race to enjoy the splendour and the power. He is educated man obsessed with materialistic ambition. Lamming comments on such people, 'we have had to live with a large and self-delighted middle-class who have never understood their function..... what is to be done with people who regard education as something to 'have' but not to 'use'.[2] Moses forgets his 'live and let live' motto and avoids any kind of contact with his own people, because they bring disgrace. He did not want 'to have any of the old brigade living in my house, and the rumour went that I had forsaken my friends'.(p.10) Becoming a landlord he, at once, becomes the part of the white society with his uncontrollable lust for highest possible rents masked under his apparent freedom from the white prejudice against the coloured as tenants. He states with pride, 'I wasn't one of them prejudiced landlord what put No kolors on their notices. Come one , come all, first come, first served, was my mottos. It was also my policy to avoid any petty restrictions for the tenants who was giving me my bread. Live and let live was another motto.'(p.10)

The nature of sacrifices and compromises - physical, moral and psychological - compelled on a black exile in white society is illuminated by four kinds of familial relationships of Moses as the landlord of the house -

I) Black master - white servant relationship

II) Landlord and tenants relationship

III) The emigrant - communal family relationship

IV) Man - woman relationship.

I) Black Master - White Servant Relationship

Moses, as a master, wants to enjoy his position. He wants 'a hand' to help him as an assistant. He appoints, Bob, a white man somewhere from Midlands. 'My blood take him..' (p.10) because he is a willing worker, eager to learn the ways of black man. He learns quickly how to make peas and rice and make beef stew, 'and left everything in his hands so I could enjoy my retirement.' (p.11) Moses allows Bob complete freedom of the house. Bob as a white emigrant comes to seek his fortune in London and fortune comes to him in the form of black Moses without any struggle.

Bob is illiterate, and poor. Moses is black, educated, rich landlord, and the master. Their very relationship is abnormal, hence, bound to fail in colonizer's white society. The possibility of meaningful relatedness evaporates in the lust for economic power. Soon Bob becomes Moses' Man Friday, now he is free to write his memoirs. Bob is a loyal servant and respects his black master, 'under my employ he realize that black people is human too.'(p.11) The rent is regularly collected, deposited in bank; Bob manages the household things effectively. Moses' relationship with Bob is

very mechanical and money-oriented, so it is barren. Their superficial relationship turns into betrayer -betrayed. As Bob leaves to meet his girl friend, in his absence, Moses understands that he has not fulfilled the promises of repairs he made to the tenants but has taken advance money from them. But he shirk to take responsibility so hands over Bob's business to Galahad. However, when Bob returns with his girl, Jeannie, Moses cannot reject him. He secretly desires for her although they get married. When Bob catches Moses raid-handed, scrubbing the back of his wife, it is Bob's turn to rule his black master. At once from the top position from his pent house, he comes to the basement, the desired condition of white master for blacks. Susheila Nasta comments, 'although he feels he has reversed the colonial relationship with 'old Brit'n,' Moses's dream of having finally 'arrived' in London is slowly shattered.[3] He basically remains a man from the Caribbean land. He ascends economically but descends morally. He ascends in his knowledge of reality that he is black. His temporary position as a landlord ends in basement of his own house in unstable social position.

II) Landlord and Tenants Relationship

When police warn Moses for illegal activities he summons Bob for the details of the tenants. To his surprise he finds that a mini-world resides in his house - a woman from Barbados, Alfonso from Cyprus, Ojo from Africa, a conductor from Bangladesh, Macpherson from Australia, two Pakistanis Faizull and Faruk - and Brenda and Galahad. Some of them

are illegal immigrants. They are ready to give extra money for their hide. This mini-colourful world' becomes a threat to him, he wants to rescue himself. But Bob tells him about the 'capital interest' which he could gain by illegal means and that 'pull' possesses his soul. Then to give shelter to illegal emigrants becomes flourishing business for Moses. Michael Fabre comments," 'Honest' Moses accepts corruption like any other man..... ."[4] Now he does not even bother when Faizull slaughters a sheep in his backyard, as it is a serious offence in London. He gives permission to Faizull on one condition that he will have the choicest cut. "I may have some trouble with the police over this business," I point out.'(p.63) Moses learns the tactics of squeezing the money from legal excuses. He gives permission to the battalions of illegal Pakistani emigrants, even offers their ladies his penthouse.

Moses wants to become a writer. Writing is a creative activity. But his economic ambition makes him uncreative. Writing needs an honesty to experience. However, he wants to escape the reality of his black skin and his colonial status. His career as a writer to write memoirs, itself reflects total barrenness. His authentic self which was alive in *The Lonely Londoners* is not there.

The 'mini-world' which could have provided Moses with material fails him because of his inability to communicate with the inhabitants. He

is unable to find the right language. He is interested in noting how Faizull sacrifices the sheep, but he is not interested in that man's cultural identity which he tries to maintain in spite of risk. Some people are there from his own islands but he does not know who they are except Galahad and Brenda. Galahad ridicules him, 'You think writing book is like kissing hand? You should leave that to people like Lamming and Salkey. You don't even know that we have created a Black Literature making the whole world realize our existence and our struggle.'(pp. 49-50) Of course Galahad is also not completely dedicated to his Black Power movement but he has a certain sense of understanding and he hopefully looks towards Moses as an anchorite. It is inevitable that Moses can not become a writer. Michael Fabre comments, 'Selvon directs his irony at both. The blatant rhetoric of so-called revolutionary writing also comes under satarical attack, for its aesthetics remain far behind its message of human renewal.'[5]

III) The Emigrant -Communal Family Relationships

Moses' strategy of survival includes his efforts to isolate himself from his own emigrant communal family in London. However, the blacks are eager to exploit his support only because he is economically powerful man. Galahad and Brenda try to explain the Movement of Black Power to him. He keeps himself away from them, because he thinks, 'It is always your own people who let you down."(p.36) He warns them that they could

not hold any meeting in his house, or demonstration in front of his house. He does not want any trouble from police. When he is caught by the police though he tries to avoid their meeting. Police put him in jail and Galahad tries to exploit this opportunity. They pull him in their group. Then very earnestly he tries to save their leader by paying all his money for his rescue, the leader afterwards turns to be a fraud. But he is not sure of his permanent attachment with their group. He oscillates between the two worlds. The security and status of the white world beckons him, and the insecurity of black world threatens him. Eric TabuTeau comments, on the West Indians dilemma, 'if on the one hand I choose to remain faithful to my people - I lose any chance of being admitted by the Europeans If on the other hand I opt for integration, I must be prepared to be ostracized from my people who have to call me a renegade.'[6] Like epileptic bouts Moses sometimes acts like a martyr and sometimes like an outsider. He likes to join the Black community with Bob and even Brenda and Galahad need his presence in their group because, 'It is always good to have a white man around, it alloys suspicion.'(p.82) His community betrays him and blackmails him due to illegal emigrants. They establish their authority over the basement room. Essential relatedness is absent from both sides and thus it turns into the failure to form a communal family.

IV) Man-Woman Relationship

The opportunity to be meaningfully related sexually either with Brenda the black girl, or with Jeannie, the white girl, cannot be exploited by Moses, the hollow man. Galahad, his old friend, asks for the room. He rejects because he wants to keep himself away from him. But as soon as Brenda, his charming coloured friend, comes to ask him, he immediately offers her basement for the party work of Black Power, on one condition that she has to do the household work. She accepts the offer demanding freedom to carry on their own business without any interference. Bob and Moses sexually incline to her. But constantly eludes Moses to have that chance.

When Bob announces his arrival with Jeannie, Moses is overwhelmed with joy. He arranges welcome party for them. Right from the beginning Moses wants Jeannie. In the absence of Bob she calls him to scrub her back and Moses becomes her willing partner. Kenneth Ramchand points out how the coloured person is 'socially insecure and sexually overcharged

.[7] Moses fails in his attempt to have sexual relationship with disloyal Jeannie. Their relationship is sterile.

Moses struggles to survive through his second experiment by remaining with colonizer society and accepts illusory identity as a British by rejecting authentic identity as a Caribbean. His house remains a building.

House is a place of solace, a home and a family. But he fails to form a meaningful family. His house remains, a body without soul. It is really a tragedy of Moses, the representative of Caribbean emigrant community, who descends morally though ascends economically. Moses is a medium through which Selvon expresses the limitedness of black man's struggle as an exile to integrate with white society.

References

1. Samuel Selvon, *Moses Ascending*, (London : Davis Poynter, 1965).

 (All the quotations cited are taken from this edition).

2. Quoted in Mervyn Morris, "The Poet as Novelist." The Novels of George Lamming," in *The Islands in Between*, (ed.), Louis James, (London : Oxford Uni. Press, 1968), p. 84.

3. Susheila Nasta, "Samuel Selvon : Prolific ! Popular !", (The article included in *Moses Migrating*), (Washington D. C. : Three Continents Press, 1992), p. 185.

4. Michael Fabre, "Moses and the Queen's English : Dialect and Narrative Voice in Samuel Selvon's London Novels" : *WLWE*, Vol. 21, No. 2, Summer 1982, p. 123.

5. Ibid, p. 390.

6. Eric TabuTeau, "Love in Black and White : A Comparative Study of Samuel Selvon and Frantz Fenon, "*Commonwealth*, Vol.16, No. 2, Summer 1993, p. 90.

7. Kenneth Ramchand, *The West Indian Novel and Its Background* (London : Faber and Faber, 1970), p. 45.

(5) *Wide Sargasso Sea* **(1966)**

Jean Rhys was born in Dominica in 1894. She left Dominica for England in 1910. She belonged to the "Left Bank" group in twenties. James Joyce, Hemingway and Ford Madox Ford encouraged her for writing. Her novel, *Wide Sargasso Sea* (1966), won theW. H. Smith Award for 1967 and, that same year, the Heinemann Award. She has been the recipient of the Arts Council Bursary, 1967, and Royal Society of Literature Prize. Her other novels include *Postures* (1928), *Quartet* (1929), *After Leaving Mr. Mckenzie* (1931), *Voyage in the Dark* (1934), *Good Morning Midnight* (1939). Some of her collections of short stories are *Sleep It off Lady* (1976), *The Left Bank and Other Stories* (1927) and *Tigers are Better Looking* (1968). She now lives in Devon, England.

Jean Rhys's novels introduce an essential perspective in Caribbean fiction. They contribute vitally towards comprehending Caribbean experience in all its complexity. She focuses on the most tragic fate of the Caribbean white ex-plantation owners' minority community in the post-emancipation era. It offers rare opportunity of insight into the reversability of the exploiter-exploited relationship. Thus, her novels liberate the Caribbean whites and blacks from the historical trap of the oppressor - oppressed relationship as they clarify how it is a reversible, repetitive and, hence, a permanent aspect of human condition.

In *Wide Sargasso Sea*[1], the traumatic condition of uprootedness of the white ex-plantation owners' community finds its most appropriate co-relative in the individual's relationship with the family. The novel presents the tragedy of Antoinette, a creole white girl, covering her life from childhood to her premature death. She symbolizes a sense of homelessness, and of despair for the inability to fulfil the urge for meaningful relatedness both as a family and as a community. Hence, the novel may be seen as an evolution in five stages -

I) The state of homelessness

II) Search for home

III) Discovery of illusary home

IV) Home lost

V) Home destroyed

Rhys models her novel on Charlotte Bronte's *Jane Eyre*. She visualizes a parallel between the fate of Antoinette and that of the first creole wife of Rochester, the mad woman in the attic, from Bronte's novel. She gives the marginal woman in the original novel, exiled both culturally and sexually, a past and a name.

I) The State of Homelessness

Antoinette's family life as a child reflects her community's state of

homelessness due to their sense of insecurity for being the targets of revenge by the black majority, and their inability to cope up with the unexpected situation of poverty and loss of social status. In the first part of the novel, protagonist Antoinette remembers her past, her childhood in Grandbois in Jamaica. Her mother, Anette, speaks good English and French, once a highly privileged woman, who enjoyed power and glory. She got a black maid servant, Christophine, as a wedding gift from her father. Now she is a widow with two children, a daughter Antoinette, and the handicapped son Pierre. She is unable to adjust with the new situation because hatred for whites has contaminated Jamaican air. Her Coulibri estate is covered with weeds and plants as it is neglected because emancipated black servants refuse to work on it. They get threats. They hate them. As a child, Antoinette is also a victim of their hatred. "One day a little girl followed me singing, 'Go away white cockroach, go away, go away Nobody want you. Go away."(p.23) The experience of poverty and hatred trains Caribbean women to survive in any situation. But Anette is not equipped with all these tacties. From power to poverty is very hard for her to cope with. Once she enjoyed, status as a rich woman who owned black slaves. Now her only hope is her black maid servant Christophine, a powerful, trustworthy and faithful obeah woman who even after emancipation, does not leave them. The heat of the hate in the, atmosphere makes Anette restless. Some of the whites manage

to sell their properties and leave the island but Anette has no chance. As John Hearne states she belongs to 'a marginal community run over and abandoned by History.'[2] The daughter remembers, 'Now we are marooned, 'my mother said,'now what will become of us?'(p.18)

There is always a frown on Antoinette's mother's face because of hateful laughs of the passing people. Antoinette tries to understand her and wants to help her but her mother is thoroughly engaged in her own sorrowful condition. The little girl is neglected when she needed her mother most. She wants to reach out, 'I hated this frown and once I touched her forehead trying to smooth it. But she pushed me away, not roughly but calmly, coldly, without a word, as if she has decided once and for all that I was useless to her.'(p.20) Outside the house, the girl and her family are persistent victims of racial hatred. When the child is exposed to her cultural and racial difference from the blacks, she can not comprehend it deeply. Thorunn Londsdale comments, 'What is most apparent is the children's acute but confused awareness of cultural identity, and that this combined with an inadequate development of feminine persona and sense of self, explains exiled positions both sexually and socially.'[3]

II) Search for Home

Family, that cannot fulfil Antoinette's urge for relatedness, obsesses the child with its loneliness, neutrality and fear. She struggles to search for

home on the unconscious level through creating relationship with the surroundings of the house, on the one hand ,and with the black maid, Christophine, on the other. The lonely child searches for solace in the surrounding. She passes her time in the company of nature, 'Our garden was large and beautiful as that garden in the Bible - the tree of life grew there. Orchids flourished it was a bell-shaped mass of white, mauve, deep purples, wonderful to see. The scent was very sweet and strong.' (p.19) Sometimes she goes to sleep in the gardem.

The relationship between Antoinette and her black maid as well as surrogate mother Christophine, plays a crucial role not only in the life of the heroine but, more significantly, in the vision of the novelist. Jean Rhys affirms, through it, her grasp of evolution of society as a process of positive development in spite of its history of hatred. Through Antoinette - Christophine relationship, the novelist shows how a community struggles to survive meaningfully through its families and individuals although its collective historical compulsions may be destructive. In the novel, the white-black relationship is mainly negative but indicates positive possibilities. Through the creole white girl's relationship with the black maid, Rhys opts for the creative future for the racially stratified Caribbean society where the whites and blacks will overcome the historical guilt of skin and be integrated in positive human relationships. Christophine fulfils the girl's need of companionship love and care.

Christophine is 'da', and Antoinette is 'doudou' of Christophine. It is a comforting name Christophine gives to Antoinette - it means 'my dear', 'my child', 'my lovely one'. Christophine knows and at which place the lonely child could be found. She picks her up from garden where she falls asleep. It is she who understands her need of companionship. So she introduces Tia, a black girl to her, a daughter of Christophine's friend, Maillotte. One day Tia wears her dress and Antoinette has to wear the dirty, torn clothes of Tia. In front of the white guests mother finds it emberrassing; scolds Christophine who reminds her that the child has only two dresses. 'You want clean dress to drop from heaven? Some people crazy, in truth.'..... She grow up worthless. And nobody care.'(p.26)

Christophine's physical comfort helps Antoinnette to bring her senses back. Her touch gives Antoinette confidence. Christophine does it so naturally as if she were her real mother. She spends most of her time in kitchen with Christophine. She sleeps next to Antoinette's room. She sings patois song for her at night. It is an elegy. It means, 'The little ones grow old, the children leave us, will they come back?' and the one about the cedar tree flowers which only last for day.'(p.20) Christophine tries her best to maintain the balance between emotional and physical growth of the child. Her mother has deserted her but Christophine is 'oassis' for Antoinette. According to Maria Olaussen Christophine's most important function as a powerful protector and nursing mother-figure suggests

ironically how 'The life of the white family is now in the hands of a person who once was part of their property.'[4]

Antoinette's mother is fully engaged in the strategies for economic survival. As Olaussen rightly points out 'These qualities, such as beauty, fragility, dependence and passivity, make it impossible for her to change actively their situation.'[5] Her survival in feminine way is concentrated on getting a new husband. She marries white person Mr. Mason Cosway. As a perfect imperialist, Mason never fails to call the black servants 'niggers.' Her marriage brings temporary economic stability in her life. As a widow of a slave owner and a daughter of a slave owner, Anette always fears attack by the natives. She tries to persuade Mr. Mason to leave Coulibri and go to live in Trinidad or in Antigua where he has his estate, but he is overconfident about his imperialistic power. Anette never forgives him for his overconfidence.

The step-father - Mr. Mason Cosway - always remains 'Mr. Mason' or 'white pappy' for Antoinette. The atmosphere of the house becomes European after his arrival. Antoinette says, 'We ate English food now, beef and mutton, pies and puddings. I was glad to be like an English girl but I missed the taste of Christophine's cooking.' (p.35) Their richness becomes the cause of hatred for the people. They set fire to their house. Their black servant, Myra, leaves handicapped Pierre in the burning house

to join the burners outside. The fire kills Pierre and the caged parrot. Their death turns Anette insane. Mr. Mason escapes from his responsibilities and duties toward his family. He makes arrangements for Anette's stay in a new house with some black servants; sends Antoinette to the convent, and returns himself to England.

Antoinette's search for home is expressed also in her attempt to befriend Tia, the little black girl. 'Soon Tia was my friend and I met her nearly every morning at the turn of the road to the river.'(p.23) She enjoys wandering and swimming with her. But the colour of their skin, totally different complexions, reveals that they are different, separate. Sometimes it becomes cause of teasing to each other. Antoinette thinks Tia cheated her even though she has taken somersault under water, the bet decided between them to win pennies, which are now in the hands of Tia. 'Keep them then, you cheating nigger,' I said. She said She hear all we poor like beggar, Old time white people nothing but white nigger now, and black nigger better than white nigger.'(p.24) Unconsciously the seed of hatred is sown by the changing human environment in the minds of innocent children. Antoinette is confident that Tia's family will give them support, after the burning of the house. 'As I ran, I thought, I will live with Tia and I will be like her I saw a jagged stone in her hand. We stared at each other, blood on my face, tears on hers. It was as if I saw myself. Like in a looking glass.'(p.45) Antoinette herself is the product of mixed blood, the product

of Caribbean hybrid culture; so Tia becomes her mirror image. Jean Rhys always wishes to be black, so she has created her black half, Tia. Both the colonizer and colonized are trapped in complex Caribbean enviornment. Antoinette's childhood is destroyed by the racial hatred and it creates permanent psychological problem of insecurity.

III) Discovery of Illusory Home

Trapped by the abnormal historical conditions, Caribbean society is compelled into the policies of mutual exploitation for self-interest. It is seen in the way in which Antoinette's father, Mason, compels Rochester to accept marriage with his daughter by settling a large amount in his name and in the way in which Rochester, the young moneyless white man from England rejected by his family, accepts the proposal due to his need of economic security. Marriage offers home for the homeless girl, at least, for a brief period. It is like discovery of illusory home by the girl.

Rochester has 'come to the West Indies in search of wealth in the shape of a rich wife.'[6] Antoinette once again feels insecure. Her second dream indicates her fatal destiny. A man with weapen directs her to a buildng in the deep forest and forces her to climb the fortlike building, the dark house, ' I follow him, sick with fear but make no effort to save myself; if anyone were to try to save me, I would refuse. This must happen.'(p.p.59-60) Her dreams are significant. They provide her marginal escape from

the hostile world as well as prove indicative of her future. According to Maria Olaussen, her second dream, 'contains even more clearly the fear of sexual violation.'[7] Antoinette refuses the proposal of Rochester but Rochester does not give up. He does not want to return to England 'in the role of rejected suitor jilted by this Creole girl.'(p.78) He promises her peace and happiness. Richard, her step brother, is also involved in the marriage transaction. Thirty thousand pounds have been paid to Rochester without any question or condition. No provision is made for Antoinette. Urbashi Barat states, 'human relationships here, governed by the cash nexus are directed solely towards extracting the maximum of profit for the individual,no matter they destroy others in the process.'[8]

As the husband of the estate owner's daughter, Rochester gets rich fortune and becomes a man of status. After one week in Spanish town Antoinette and Rochester come to Massacre, the hilly region of Jamaica, the ancestral place of Antoinette, which she loves most for its beautiful surroundings. It is called Paris of the West Indies. For Rochester it is a lonely place but for her, 'I love it anywhere in the world. As if it were a person. More than a person.'(p.89) ' This is my place and everything is on our side.'(p.74) Her association with nature is from childhood. Nature is her trustworthy companion, where betrayal has no place. There honeymoon days are idyllic. Rochester appreciates her every move. When she throws stone he watches her gently. He begins to love that place even

if some time he feels scary. For Antoinette it is a paradise. Dr.Ram Kundu comments, 'She has kind of communicative friendship with the "frangipanni" trees.'[9] On their first night at Granbois, the bride and bridegroom are greeted with two wreaths of frangipanni flowers. Antoinette is happy in her family, but this family cannot survive because it is based on exploitative relationship between husband and wife. Antoinette enjoys a brief period of their married life. She takes him to wonderful places, gives information about trees, birds, flowers.

IV) Home Lost

Antoinette's brief period of passionate love-relationship with the husband is followed by the period of estrangement between the two. The illusory home is lost. Unfortunate girl who suffered from homelessness in her mother's family is made homeless once again in her own family house by the crooked husband. However, Rhys adds a special dimension to her study of the Caribbean situation through the portrayal of Rochester as a white exile in Caribbean Islands. The man is obsessed by the inner conflict between his attraction for the beautiful wife and his sense of insecurity because of her so-called heredity of insanity.

Rochester does not suspect the betrayal of Mr.Mason until he receives letter of Daniel Cosway, step brother of Antoinette, who reveals the heredity of madness in the family of Cosways. He poisons the life of

innocent Antoinette and tells him that he is not the first person to kiss her and tells him about Sandi, the creole friend of Antoinette. Daniel is dissatisfied man, who wants share in estate. When he sees he cannot get it, he takes revenge on his sister. All relationships in the novel are dead relationships. Mr. Mason's marriage to Anette and vice versa, Rochester's marriage to Antoinette, Daniel's disclosure of insanity in family, originate in the crucial need for economic survival, or economic power or economic stability. It is almost like the relationship between son and mother in *The Year in San Fernando*, Mr. Chandles and old Mrs. Chandles. Commercialization of the human relationships is seen in the big cities, where human being is commercial commodity. Rochester is filled with insecurity. The letter of Daniel gives him chance for escape. From that day his behaviour with Antoinette changes and he decides towards calculative moves. He begins to call her 'Bertha', a traditional name for servants.

When Rochester begins to sleep in dresssing room and neglects Antoinette Christophine smells the danger . She wants to caution Antoinette but the girl remains passive. She tells, 'All women, all colours nothing but fools. Three children I have. One living in this world, each one different father, but no husband, I keep my money. I don't give it to no worthless man.'(pp.109-110) Then she tells her to win his favour once more. But Rochesfer does not budge by these tactics. Then she gives her very

practical advice, 'A man don't treat you good, pick up your skirt and walk out. Do it and he come after you.'(p.110) Even she tells her tricks to squeeze her own money from him by making the excuse of sickness and go to Martinique to live. But Antoinette does not want any disgrace by breaking the marriage because she is the victim of European social norms.

Rochester starts asserting his authority and it causes estrangement between husband and wife. Antoinette feels lonely and frustrated. Christophine cannot tolerate the humiliation of an innocent girl. First she consoles her by singing songs, telling funny stories, starting with 'Listen doudou che.'(p.114). But it does not work for long. Then she bluntly tells her that Rochester is interested in her money not in her. Christophine has dared to ask her step brother Richard, ' she should be protected legally. A settlement can be arranged and it should be arranged.'(p.114) Rochster now wants to assault her dignity as a wife. He enjoys sex with Amelia, their black servant girl, beyond the thin partition of Antoinette's room. But she wants to win his love, and it is her last attempt. She persuades Christophine to use her obeah to make him love her. Even if Christophine knows that it will not work she does it for her doudou. But Rochester thinks that she tries to poison her. He plans to go away from insecure place as early as possible. He decides to take her to England, and never stops calling her Bertha, the colonial strategy to efface the identity of a person. Antoinette and Rochester both are the victims of colonial practices,

he as an exiled insecure man and she as the victim of Victorian norms of family security. Urbashi Barat comments,'Their marriage, again, is an image of the colonial experience which enriches the colonizer but impoverishes and enfeebles the colonized.'[10] Her urge for relatedness through sex is destroyed. She becomes insane, like her mother.

Christophine tries to rescue Antoinette from the clutches of Rochester. He is afraid of Christophine, but 'Antoinette loves her with touching warmth. In her unbearable grief she can come only to Christophine, her 'da' a surrogate mother figure and finds comfort by touching and smelling her.'[11] Christophine earnestly requests Rochester about Antoinette, ' She don't satisfy you? Try her once more If you forsake her they will tear her in pieces-like they did her mother.'(p.158) She reminds him, 'its you come all the long way to her house - it's you beg her to marry What do you do with her money, eh?' 'leave the West Indies if you don't want her no more She marry with someone else. She forget about you and live happy.'(pp.158-159) Christophine knows her limitations. Rochester threatens her of police over her illegal obeah practice, then she leaves the place wishing better life for Antoinette. The history repeats. The history of Anette becomes the history of Antoinette. Anette is exploited by the black servants Mr. Mason has kept to take her care. She dies in madness, in dejected and rejected condition. The same fate is reserved for the daughter.

V) Home Destroyed

Home turns into prison for Antoinette when she is transferred to England, beyond wide Sargasso sea, the vast distance that she will never cross. By that time she has lost her sense of time and place. She is now Bertha. She asks, 'So between you and I often wonder who I am and where is my country and where do I belong and why was I ever born at all.'(p.85) He delibarately displaces her because he finds that Jamaican atmosphere is familiar to her and it keeps her sane. Christophine rightly calls him 'Satan self.'(p.132) He keeps her in prison of Thornfield Hall for her crime of infidelity but infidelity by men is accepted norm in European society. Antoinette creates her illusory world in madness recreating the image of her mother and family. Rochester denies her good clothes and the comfort she longs for. Veena Jain comments, 'Rochester's inability to understand Antoinette's feelings and passions is England's failure to comprehend the negro world.'[12]

Antoinette survives through hallucination and dreams and insanity. It is an attempt to create, on the imaginary level, the desired situation. Antoinette also tries to recreate her meaningful relationship with the members of her family and place. She enjoys the healthy image of her mother, her Coulibri garden, that smell of frangipanni flowers, orchids. The touch of her red dress brings back her sanity because it has smell of her soil,

her sun ! She sees Tia and Christophine and her burning house. At once she finds the solution and burns Rochester's house and jumps into the Tia's world. Feminist critics point out that by burning the house she escapes from the prison of patriarchy.

Antoinette is unfortunate . She never has a house, a home. Her mother's house is burnt; then she has to leave her own house of Jamaica; and the third prisonlike house she burns herself. Antoinette from childhood is homeless and familyless, so, incapable to survive. Her family fails to give her sustenance. Her journey from childhood till her suicide is the journey in search of authentic family relatiosnhip. Her mother's and her insanity is not hereditory, but the bad forces of the enviornment turn them insane.

Both Christophine from Jamaican creole family and Dilsey, in William Faulkner's *The Sound and Fury*, a maid servant in American family hail from ex-slave communities. They look after their own family and the family of the masters. They negociate with life and emerge as the women of power and self-respect. Even though they are marginalized and oppressed victims of racism, sexism and imperialism they could according to Kundu, ' offer a counterpoint / solution to the problem of identity / selfhood - not only to black but also to the white women of their respective milieu. Both anticipate, though, in different ways, the New Woman of later era.'[13] Louis James points out, 'There are many islands in the novel,

geographical social and mental. - and the complexity of the fragmentation of West Indian experience it is also a stage for the search for the 'substance of life'.....There is one island, the creative human spirit.'[14]

The feminists believe Antoinette to have succeeded in destroying the prison of patriarchal power by burning the alien house. However, it should be noted that the insane girl's act of burning is associated with the image of the home, across her mindscape, with everything she yearned for throughout her life. Thus her act of destruction on the physical level is also an act of possession on the unconscious level.

References

1. Jean Rhys , *Wide Sargasso Sea*, (New York and London : W. W. Norton and company INC, 1982, first pub. in 1966).

 (All the quotations cited are taken from this edition).

2. John Hearne, "Wide Sargasso Sea : The West Indian Reflection," *Cornhill Magazine*, 1974, p. 324.

3. Thorunn Londsdale, "The Female Child in the Fiction of Jean Rhys," *Commonwealth*, Vol. 15, No. 1, Autumn, 1992, p. 62.

4. Maria Olaussen, "Jean Rhys's Construction of Blackness as Escape from White Feminity in "Wide Sargasso Sea", *Ariel,* Vol. 24, No. 2, April 1993, p. 71.

5. Ibid, p. 71.

6. Urbashi Barat, "Jean Rhys and the Colonial Experience", in *The West Indian Fiction,* ed, R. K. Dhawan, (New Delhi : Prestige, 2000), p. 68.

7. Maria Olaussen, op.cit., p. 78.

8. Urbashi Barat, op.cit., p. 66.

9. Dr. Ram Kundu, "Wide Sargasso Sea : Intertext as Device for Post-Colonial Assertion", in *Commonwealth English Literature,* ed. H. K. Bhatnagar, (New Delhi : Atlantic Publishers and Distributors, 1999), p. 41.

10. Urbashi Barat, op. cit., p. 69.

11. Dr. Ram Kundu, op.cit., p. 42.

12. Veena Jain, "Jean Rhys's *Wide Sargasso Sea* : A Rewriting of History", in *The West Indian Fiction,* ed. R. K. Dhawan, (New Delhi : Prestige, 2000), p. 76.

13. Rama Kundu, "Counterpointing the "Mammy" and the "Da" : A Case of Study of Dilsey in William Faulkner's *The Sound and Fury* and Christophine in Jean Rhys's *Wide Sargasso Sea*", in *The West Indian Fiction,* ed. R. K. Dhawan, (New Delhi : Prestige, 2000), p. 81.

14. Louis James, "How Many Islands are There in Jean Rhys's *Wide Sargasso Sea*?", *Kunapipi*, Vol. xvi, No. 2, 1994, p. 81.

Conclusion

In *A House for Mr.Biswas,* Naipaul emphasizes the problem of meaningful relatedness with exclusive emphasis of the economic aspect of the struggle, the heros rebellion against the feudal joint family system. The hero's success in building a house for his family discloses Naipaul's hope in the possibility of meaningful relatedness for the Caribbean society. The Eye of the Scarecrow is visionary work of art in which Wilson Harris overcome the racial sense of guilt through celebration, on the metaphysical level of the ultimate truth of all humanity - with its specific histories and geographies is unified as the creation of God and in its origin of the Womb. The difficult challenge of concretizing the abstract inner vision is met by the novelist by using the valuable device of family to link different phases of history. Micheal Anthony, in his *The Year in San Fernando,* offers a valuable insight into the two cultures symbolized by two families - one the rural, low class and suppossedly inferior, and the other urban, middle-class and suppossedly superior. *Moses Ascending* is Selvon's preoccupation with the problem of meaningful relatedness for black emigrant minority in a white society. He exposes the black myth of equality with the whites through achievement of economic power. Jean Rhys's Wide Sargasso Sea centralizes the problem of meaningful relatedness for the peripherial white minority in Caribbean society.

CHAPTER FIVE

THE NOVELS OF THE SEVENTIES

The individual and family relationship provides a valuable means of probing the cross-racial and cross-cultural possibilities for meaningful relatedness for the novels in the seventies. They include -

1. Merle Hodge's

 Crick Crack, Monkey (1970)

2. George Lamming's

 Water with Berries (1971)

3. Samuel Selvon's

 Those who Eat the Cascadura (1972)

4. V. S. Naipaul's

 Guerrillas (1975)

(1) *Crick Crack, Monkey* (1970)

Merle Hodge was born in 1944, Trinidad and grew Growing up in Curepe, Tirnidad. Merle won the Trinidad and Tobago Girls' Island Scholarship in 1962, enabling her to study French at University College, London. She has travelled widely in eastern and western Europe. She has worked as a governess, typist, and has translated a collection of Leon Damas'

poetry. In the 1970's she became lecturer in French at the University of West Indies. *Crick Crack, Monkey*, (1970) is her first novel.

The centrality of woman as mother in Caribbean family structure offers a special dimension to Caribbean women's fiction. In their novels, family is the microcosm of society; and the characters, bound in a network of familial relationships, enact the historical situation of tensions. Their approach is holistic rather than feminist.

Crick Crack, Monkey[1] is a part of Merle Hodge's ambitious project to assert 'cultural sovereignity'[2] of the Caribbean. It narrativizes the inner journey of a little girl from Tantie's - her surrogate mother's - home in the village to Beatrice's - her aunt's - urban home. The novelist floodlights the living content of the rural/peasant culture by scanning the negative impact of the dead content of metropolitan culture on the girl. The critics have rightly centrestaged the novelist's achievement in facilitating comparison through simultaneity of presentation of two cultures. For instance, Marjorie Thorpe[3] discusses how the novel works through a structural opposition between Tantie's creole world and Beatrice's colonial world. Simon Gikandi finds the novel significant for its value, 'in the author's capacity to sustain both the creole and colonial cultures as opposed sites of cultural production which the "modern" Caribbean subject cannot transcend entirely, nor reconcile.'[4]

The novel concentrates on the two kinds of families representative of the two kinds of culture. One is rural working-class family and another is the urban middle-class family. In both, the relationship between the daughter and the surrogate mother remains central -

I) The rural working - class surrogate mother daughter relatinship.

II) The urban middle -class surrogate mother - daughter relationship.

The specific Caribbean cultural context of the novel may be enriched by deconstructing its in-built structure of meaning in economic and sociological terms. Through the two cultures-one supposedly inferior and another, superior - the novelist symbolizes the universal sociological phenomenon of the urge of the lower class to rise upwards and achieve the status of the higher class. The process of Tee's being groomed into a middle class lady reveals the adjustment, compromise, compulsions and sacrifices of the lower class to achieve economically superior status recognized as social respectability. Tantie's and Beatrice's worlds are not mutually exclusive choices available, they are essential stages of development which mark an on-going process. Tantie and Beatrice are two stages of the sociological history within economically conditioned human situation. Tee's trauma underlies her urge for meaningful relatedness. The novelist's concern for the destructive nature of superior culture springs from her faith in meaningful relatedness as the essential human need, threatened, at every

stage of social history by the economics of survival.

I) The Rural Working -Class Surrogate Mother - Daughter : Tantie and Tee

The pendulum of Tee's experience as a girl moves between fwo families alternatively. In Tantie's family, the relationships are supportive and creative. It is an extroordinary family which includes almost all orphan children to whom she loves and attends. It is the artistic recreation of what Hodge explains as ' a family framework which has nothing to do with the traditional nuclear family - - - children are shared here by a network of houscholds.'[5]

Tantie's inclusive family gives the children 'home', security, where nothing is private. Lynn. Z. Bloom states, 'The most significant dimensions of maternal heritages that offer the nurturing and conveyance of a sense of self, the transmission of human valueswho serve directly or indirectly, as positive role models, and the fostering of a group identity - national, racial or cultural.'[6]

Tee's childhood experience with which the novel opens, is the death of her mother and a newly born child. After the death of Tee's mother, 'Then Papa went to sea.....Whether he could find Mammy and the baby.'(p.10) Aunt Beatrice whose 'high-heels and stockings voice tock-

tocked.'(p.9), wants the custody of Tee and Todan but aunt Tantie, who is Tee's father's sister, refuses to give it. The intimate relationship with Tantie and grandmother Ma provides her affectionate care and protection. Michael alias Mikey is adopted boy by Tantie as she has adopted Tee and Toddan. Joe, Krishna, Doolarie are their friends, the children of their neighbourhood. Basadeo, and Ramlal, the Hindu, are their neighbours. Tantie lives with them in complete harmony.

The vavacity of Tee's childhood home is foregrounded in its informal, public, collective and intensely passionate participation of family experience as contrasted with the formality, privacy and coolness of the sophisticated members of Aunt Beatrice's family to which Tee is, later, shifted. Tantie's house is full of movement and sounds. It is full of 'fiercely raucous love.'[7] Tantie's company was 'loud and hilarious..... .' (p.11) Chasing the fowls, dance , mirth, play, joy, loud voices and sounds are part of the yard of Aunt Tantie. With Mikey, they have stealing moments. They go to Santa Clara in his box-car scooter and enjoy cinema. 'Life was wonderful when he was out of job, and in a good mood...... '(p.13) Uncle Herman and Nero are trouble for them because they are very strict and their visit forces them to hide somewhere but as soon as they go they enjoy Tantie's anger. Whenever Mikey threatens to go home, she comes to senses, 'An' go down by you mother an where she go put you? On top of the roof? Under the house?the lil ol' -

house falling - down on she head?.....' (p.12) and when he comes back she takes his special food, thick slices of bread with butter, large mug with cocoa, and other items in his room. Tantie has a tact to bridge the relations. Her 'loud care' brings more fun in Tee's life. Everything is collective in Tantie's house, the sorrow the happiness and anger. Her family gives them all the total sense of fulfilment and the origin of power and stamina Simon Gikandi comments, 'Tantie's world represents "belonging and security."[8] In Tanties's community Tee has collective identity.

Relatedness is a concrete physical experience for the little children in Tantie's home. With touch, they affirm their relateness with each other. Snatching, hauling, battering with dish cloth, catching, holding, embracing are usual happenings. Children sleep with Tantie. Tee remembers when her papa left them - ' I fell asleep at night tightly clutching a bit of Toddan's night - clothes and with one toe touching Tantie.'(p.10) According to Juneja, 'Intimacy and physicality....., are also the defining terms of creole culture.'[9] Even their eating is accompanied by sounds of satisfaction with which they transfer the message of tasty, enjoyable food.As Juneja continues, 'The sounds bridge; they are charismatic : they are metaphors of interrelationships which thread and weave together the subjects with each other and with the world outside.'[10] Tantie's world is full of creative sources and resources.

As a member of the economically-handicapped class, Tantie carries, on the unconscious level, the sociological ambition of her class to imitate the economically superior culture of Aunt Beatrice. Hence, she is very firecely protective towards Tee and Toddan from"the bitch" aunt Beatrice who attempts to get their custody. She has a distaste for their European style living and her artificiality of behaviour, and is jealous of her car and big house in town, jealous in the sense that they might attract Tee and Toddan and in turn they will take them away from her. Aunt Beatrice arrives in the absence of Tanie, gives them chocolates and car ride. It is one of the tactics she uses like the white master to persuade a slave to obey. Tantie scolds them that they fall prey to her tactics. 'She reiterated for hundredth time what could have happened to us : we had jus' nearly get we arse kidnap !'(p.23) She protects them like a lioness. Owen Aldridge states her, 'language is like the physical universe.'[11] Tantie's family members are connected with sounds and voices. Renu Juneja rightly comments,'Tee's and other children's freedom to speak, and loudly, remains a crucial aspect of creole world.'[12]

The relatedness of Tee's childhood home extends to her grandmother, Ma Josephine, living in Santa Clara. Ma Josephine is the most respected lady in Santa Clara. She is an independent lady. She lives and enjoys her life on her own terms. In holidays, they go to her house on Ponte d' Espoir. Tee loves her and is very proud of her. 'Our grandmother, was strong, bony woman who did not smile unnecessarily.....told us' nancy stories.'(pp.24-

25) She takes them out at night and if it is full moon, it is bonus, and tells them the fancy, wonderful stories. In the end she says, 'Crick Crack ? Our voices clamered over one another in the gleeful haste to chorus back in what ended on an untidy shrieking crescendo :Monkey, break' ' back, On a rotten pomorac !'(p.25) When Ma passes saluting houses on the way she calls everybody with name and 'Oo-Oo ! a voice would answer from the depths of the house or from somewhere in the backyard.'(p.25) They enjoy swimming under her supervision, they play in the sand and catch the fish, then her stories take them to enchanted countries, valleys, hills, thickly covered with foliage, cool green darkness, sudden little streams. Renu Juneja states. 'Ma is the story teller whose oral history links Tee to her generational past and provides the models of resistance which may allow Tee to discover her 'true true name.'[13] Tee's great grandmother had refused to live in the condition of 'namelessness'at the time of slavery. She refused to answer on given name and her masters gave up and started calling her with her real name. Ma wants to inculcate the thought of protest, resistance and rebellion in Tee.

II) The Urban Middle -Class Surrogate Mother-Daughter : Aunt Beatrice and Tee

Introduction into an alien, though superior, culture is painful for the sister and brother-Tee and Toddan. It comes first in the form of their brief stay with Aunt Beatrice, who somehow manages to get their custody

for sometime. Toddan is a little boy, for whom everything is a novelty but for Tee it is hard to manage her stay. Beatrice tries to tell them not to play with 'coolie children' and they have only uncle Norman, uncle Herman and uncle Nero, not their real uncles. Jessica and Carol, the daughters of Beatrice refuse to share their toys with them. Even their maid servant, Bernadette, calls Toddan 'Flat-Nose.'(p.51) Toddan always says' I ain' living here. I livin by Tantie and Mikey.' (p.50) Aunt Beatrice tries to call them with their real names, she calls Tee, Cynthia, and Toddan, Codrington. But Tee protests,'But I took personal offence to her objection to Toddan's name. 'He name Todden,' I informed her sharply. 'Is I who name him.'(p.54) Tantie victoriously comes to take them away. Toddan leaps up into Mikey's arms and 'Mikey carrying Toddan and kissing him again and again.'(p.56), Tee, rushes down the path, distraught with joy.

Tee passes through three stages in her relationship with Aunt Beatrice's family -

i) Rejection of new home/culture and pride for old home

ii) Compulsions of new home/culture

iii) Acceptance of new home/culture and rejection of old home/culture

The sociological urge to offer better opportunities of survival to children compels Tantie into allowing Tee and Toddan in the custody of

Aunt Beatrice and her urban middle class family. Beatrice's family consists of two sisters and uncle Norman. The house does not seem to welcome her. She also feels awkward and uneasy because the house is big, with shining floor and there is silence everywhere. This 'silence' disturbs her. At night she feels uneasy, 'It was the first time in my life, too, that I was to sleep in a bed all by myself.'(p.106) In school, although she is in Carol's classroom, she has to sit in the back row. Teachers are very particular about selection of girls in Dramatic Society, where Tee has no place and she starts thinking that perhaps it is because she comes from 'lower school.' The inferiority complex disturbs her a lot, everything is 'superior' around her. She is not one of that class, she feels rejected and lonely. Aunt Beatrice tries her best to push her in dance class, persuade teachers to consider her, but Tee fails to push herself into that highly disciplined, clean, extraordinary atmosphere.

i) Rejection of new home/culture and pride for old home/culture

The process of growth of Tee is the process of obliteration of her authentic belief in the value system of Tantie's home. It begins with Beatrice's emphasis on the middle class value system so that the little girl is gradually compelled to question the validity of her own.

On Sunday Aunt Beatrice decides to take Tee for Mass. 'I appeared for Mass in a dress Tantie had made for me and which was my favorite.'(p.112) But for her aunt, it is niggery looking dress. 'Mass continued

to be a strain on my resources.'(p.112) The atmosphere of Catholic church is so quiet, compared to noisy rural church, that it disturbs her a lot, '..... it was as if the whole church, people and building, were coldly regarding me, waiting to pull me up when I fell out of line.'(p.113) At such occasions, Tantie's world beckons her. In order to return there, Tee requests Aunt Beatrice to send her to attend Moonie's marriage. But the aunt dismisses it calling it as a 'coolie affair,and Tee's eyes fill with disappointment. Now Aunt Beatrice stresses is the wrong and right things, and she successfully manages to tell Tee that Tantie's world is all wrong. At night, she has a dream of doll's marriage. She remembers Tantie's dalpouri and good hot pepper and Ma's pepper sauce. But now that world remains only in her memory. ' I dreamt that I was a bride and Tantie and Toddan were trying to get through the crowd of shrouded figures surrounding me.'(p.115) The dream indicates her separation from Tantie's world. She gradually excludes it and begins to include Auntie Beatrice's world in her mind.

Carol and Jessica refuse to accept Tee as their cousin sister. In school and at home they take precaution to exlude her from their company and they giggle behind her back.They do not 'seem to have established my existence at all.'(p.116) Auntie Beatrice always shows her the photograph of their white ancestress - 'Elixabeth Helen Carter.' Tee's poor mother was also named after her. Tee's god parents, Tantie and Ma are responsible for her mother's poor condition because they belong to low-class people, 'I began

to have the impression that I should be thoroughly ashamed for it seemed to me that my person must represent the rock-bottom of the family's fall from grace.'(p.119) Auntie Beatrice also reminds her about her dark colour. 'What you don't have in looks you have to make-up for otherwise !'(p.121) - she instructs the girl.

ii) Compulsions of new home / culture

Aunt Beatrice educates Tee so that she may know what is wrong and right, good and bad manners, high-class and low-class business. But her constant smiling and whispering irritate Tee as she is used to Tantie's loud anger. The silence of the house is perpetual assault on her. 'with Auntie Beatrice I was disarmed beyond all resistance, in an uncomfortable alien way.'(p.122) And after that Tee and Auntie Beatrice engage in lady business.

Set within the framework of colonial society, *Crick, Crack, Monkey* examines the Caribbean colonial society. Tee is divided between two cultures in which she lives and the culture she is indoctrinated to believe is superior. On the one hand, she has warm nurturing of Tantie and her domestic experience is overwhelmed by her, on the other, she is trapped in the colonial culture of Aunt Beatrice. Especially her European style middle class training and school education offer her a way out of the poverty in which she is raised. Drawn into two directions, Tee, cannot have both.

This tension is placed on the Caribbean colonial psyche where s/he forced to choose between comfort and poverty. The novel covers Tee's journey from rural to urban, and from urban to metropolis resulting in effacing her rural Caribbean identity. Caribbean society is in conflict with the values prompted by church and educational institutions. As an adult persona, Merle Hodge, expects the possibility of new emerging culture with the assimilation of positive aspects of two cultures through Tee's growth as an individual in two families from childhood to adolescence.

Colonial education successfully imbibes the values of European culture of Beatrice's family in Tee. In school she learns to remain slient. Discipline and manners are the vital part of learning. Their Sir, Mr. Brathwaite teaches them in, 'Art of Noiselessly Rising from our seats.'(p.81) There is a permanent inscription on the Black board in capital letters : 'THE DICIPLE IS NOT GREATER THAN THE MASTER.'(p.80) It indicates the 'capital' hold of colonial power. But for Tee it is a 'fascinated horror.' 'Glory and the Mother Country', 'a land of hope' fascinates her. Her crisis begins at school, the crisis of choice between Caribbean culture, which is Tantie's and colonial culture which is aunt Beatrices's. Simon Gikandi points out, 'Tee's cultural alienation is built around a crucial chaismic reversal : the tangible reality of the Creole culture is dismissed as an unreal construct, while the fictions promoted by the colonial textbook are now adopted as the "real" Caribbean referent.'[14] Tee eagerly waits for book van

at every Saturday. For her, 'Books transported you always into Reality and Rightness, which were to be found abroad.'(p.89)

Big R. C. school begins to transform her into other identity. In attempt to deal with the crisis Tee invents her 'other', when she is in third standard, 'I fashioned Helen, my double Helen entered and ousted all the other characters in the unending serial, She was the Proper Me. And me, I was her shadow hovering about it in incompleteness.' (pp.89-90) Her 'other' envelops her as she begins to take interest in wearing socks and stockings. It is, according to Gikandi, 'a mirror image of herself, who is, neverthless, white and thoroughly colonial.'[15] She looks forward to school. 'I looked forward to the day when I could pass my hands swiftly from side to side on a blank piece of paper leaving meaningful marks in its wake,'(p.33) and the outside agencies like Mrs.Hinds and school teacher engage in turning her into a 'proper lady.'

iii) Acceptance of new home culture and rejection of old home / culture

The tragedy of Tee, encountering the oppresive alien impact in her formative years, is complete when she is activated to hate her own home and people. When her teachers ask her name she immediately answers 'Cynthia'. She begins to elude the chances of going to visit Tantie's house. 'Carnival came, and I discovered that I did not even want to go home for Carnival..... the unmistakable niggeryness of the affair.'(p.123) Once

Carnival was rollicking fun for her with loud sound of band, colours and singing and dance. It had always been an event for Toddan Mikey and for Tee. 'All this was seeing again through a kind of haze of shame; and all those common raucous niggery people and all those coolies (p.125) She even starts feelling shame about Ma who is a market woman. 'Then I thought with bottomless horror suppose Bernedette and Carol and Jessica came to know of this !'(p.129) Her journey towards 'whiteness' rapidly takes place. Jesse Larson points out, 'Tee's love and loyalty to Tantie are strained as she grows up and begins to want the pretty clothes and tidy life Beatrice offers.'[16] Her 'other' Helen captures her identity. Her wish to be Helen is fulfilled by Auntie Beatrice's world. Tee goes to Tantie, and 'Cynthia' to Beatrice ! Her starts fresh with name 'Cynthia.'

The news of Tantie's visit is accepted as ' an earthquake' by Tee. For her, Tantie is ordinary nigger, a woman with no culture, no proper breeding, no sense of right and wrong, who will bring her shame on her arrival. Tantie arrives with Toddan, Doolarie and uncle Sylvester. Tee begins to shrink from Tantie. Hopefully Tantie brings out Tee's favourite dishes and all of them begin to eat. 'Tantie suggested : 'Well you don't want to eat a polorie or something ? What yu waiting for ?' I declined in alarm '(p.153) Tantie is clever enough to understand the situation and Tee's neglect, it is an assoult of her love, care and affection. Immediately she takes decision to go away from their sterile world. Without any regret she

withdraws in her own peasant world. Only for one moment Tee thinks to call them back. Tee's 'internal colonization'[17] is complete. This visit is almost the opposite of the visit of Francis's mother in The Year in San Fernando', where he goes eagerly into the arms of his mother and holds her tightly.

Significantly, economic insecurity defines the limitations of Tantie's home though it is compensated by a sense of meaningful relatedness to its members. It remains in the state of permanent instability. Tantie allows Tee to grow and adjust in new atmosphere without any interferece. Even if she is uneducated, she knows the value of education. Her outlook is very positive. Her delibarate withdrawl from Tee's world, provides Tee ample time to adjust. Aunt Beatrice first finds her name in the list of the scholars in the news paper, which suprises Tantie. Tantie celebrates her success by preparing dishes for community members, as G's mother prepares special Caribbean dishes for G's departure in *In the Castle of My Skin*. Tantie is also strong like G's mother ,she willingly gives permission to Aunt Beatrice to take her to the town for better and further education. Mikey is the adopted family member of Tantie. She knows that economic survival is essential for all of them, and for it, exile is inevitable. Hence, she accepts Mikey's departure to New York for work. A Caribbean woman as Alladi Uma points out, 'cannot forget that she is mother first and a woman later.'[18]

In the end, Tee surrenders herself to the calm, private, sterile world of Auntie Beatrice. When she becomes expert in 'lady business' her father sends her air-ticket to take her in his family in London. By that time she is in adolescent phase. She is still bewildered between belonging and security, Beatrice and Tantie; she cannot choose one.

Tantie appreciates Tee's going to London. She knows 'Literacy is a necessary requitsite for the mastery of the world/world and the self, even if it produces, initially, an alienation of self.'[19] Tantie's family-life cycle continues. Her world is creative where human core is respected. She has capacity to accept change. It is her 'family' which gives scope to Tee to grow individually. The inclusiveness of Carribean family is indicated through Tantie. Theirs is the positive outlook. Frantz Fenon states, 'There are close connections between the structure of the family and the structure of the nation the family is a miniature of the nation.'[20]

As an adult persona, Merle Hodge suggests the possibility of Tee's return with the assimilation of two cultures accepting creative and positive aspects of each. She entitles her novel in the terminology of peasant culture and suggests, indirectly, the choice of adult persona. The phrase, 'Crick Crack, Monkey,' is a part of the statement in oral tradition for closing a story, the grandmother narrates. It signifies that the story has ended.

The anthropologist, John Stewart points out how a social process involves' a tension between moral and practical systems and their constant adjustments, evoked by constraints levied from time to time by one against another.'[21] The novel may be regarded as one of the most powerful illustrations of this tension. The girl-protagonist's relationship with two homes/families - Tantie's and Beatrice's - validates the conflict between the human urge for meaningful relatedness and the compulsions of economic survival.

Reference

1. Merle Hodge, *Crick Crack, Monkey,* (London : Andre Deutsch, 1970).

 (All the quotations cited are taken from this edition).

2. Merle Hodge, "Challenges of the Struggle for Sovereignity : Changing the World versus Writing Stories," in *Caribbean Women Writers : Essays from the First International Conference,* (ed) Selwyn R. Cudjoe, (Wellesley, USA : Calaloux Publications, 1990), p. 206.

3. Marjorie Thorpe, "The Problem of Cultural Identification in *Crick Crack, Monkey,*" Savacou, 13, (Gemini, 1977), pp. 31-38.

4. Simon Gikandi, "Narration in the Post-Colonial Moment : Merle Hodge's *Crick Crack, Monkey,*" Ariel, Octo. 1989, Vol. 20, No. 4, p. 26.

5. Kathleen Balutancy, ' "We are all Activists" : An Interview with Merle Hodge,' *Callalao,* 12.4 (Fall : 1989), p. 655.

6. Lynn Z. Bloom, "Heritages : Dimensions of Mother Daughter Relationships in Women's Autobiographies,'in *The Lost Tradition,* (eds). Cathy N. Davidson and E. N. Broner, (New York : Frederick Ungar Pub. Co. 1980), p. 291.

7. Jesse Larson, "Review : *Crick Crack, Monkey." Internet.amazon.com*, 2002.

8. Simon Gikandi, op. cit., pp. 25-26.

9. Renu Juneja, *Caribbean Transactions : West Indian Culture in Literature*, (London and Basingstoke : MacMillan Caribbean 1996), p. 30.

10. Ibid, p. 29.

11. A. Owen Aldridge, "Literature and the Study of Man," in *Literature and Anthropology*, (eds.), Philip A. Dennis and Wendell Aucock, (Lubbock, Texas : Texas Tech Uni. Press, 1989), p. 46.

12. Renu Juneja, op. cit., p. 29.

13. Ibid, p. 28.

14. Simon Gikandi, op.cit., p. 26.

15. Ibid, p. 27.

16. Jesse Larson, op.cit.

17. Renu Juneja, op.cit., p. 31.

18. Alladi Uma, *Woman and Her Family : Indian and Afro-American - A Literary Perspective*, (New Delhi : Sterling Publishers Pvt. Ltd.,1989), p. 46.

19. Renu Juneja, op.cit., p. 35.

20. Frantz Fenon, **Black Skin White Masks**, (New York : Grove Press, 1971), pp. 141-142.

21. John Stewart, "The Literary Work As Cultural Document : A Caribbean Case," in *Literature and Anthropology*, op.cit., p.112.

(2) *Water with Berries* (1971)

George Lamming confronts, in his novels like, *The Emigrants*[1] and *Water with Berries,*[2] the challenge of comprehending the colonial and post-colonial emigrant black community's ordeal of survival in a white country as does Selvon in his London trilogy. *The Emigrants* outlines the deadening effect of metropole on the exile-Caribbean psyche. *Water with Berries* is more sustained exploration in exile-experience. If *The Emigrants* (1954) focuses on the tragedy of the blacks, *Water with Berries* marks development of the novelist's vision. It focuses on the tragedy of both the blacks and whites struggling for meaningful relationships but meeting with the only choice of destroying them in order to survive.

The very title of the novel, 'Water with Berries,' which refers to the religious 'ceremony of souls' related to the dead and the living in black culture, emphasizes the significance of undertaking the essential bond between the dead and the living. The rite symbolically involves the ancestors offering their complaints and requiring the living to undergo retribution over a period until they reach the point of reconciliation. Lamming, it should be noted, chooses Teeton, the black hero, as the narrator of this practice in his land to a young white girl, the worst victim of racial hatred on the land. For Lamming, the living including whites and blacks, have to exorcise the ghost of prejudice against skin- the sense of guilt for

the ancestral past-before they can build the future together through sustainable meaningful relationships. Lamming deliberately chooses three artist-protagonists to represent the vitality of their inner need for meaningful survival. He shows how the ruthless racial and economic environment changes the sacred need into an urge for violence and destruction in the process of their struggle to realise it.

The narrative exposes the black and white characters, and especially the three black artists, to a variety of experiments in relationships in order to create a family or to sustain a sense of home, away from homeland. These relationships can be divided in four kinds -

I) Man - woman relationship

II) Surrogate white mother - black son relationship

III) Father - son / daughter relationship

IV) Communal family relationships

I) Man - Woman Relationship

Man - woman relationship receives central inportance in the novel. The novelist provides multiplex perspectives of the struggle of the blacks and whites to be meaningfully related through formation of a family, or love by offering a variety of the white and black couples such as -

i) Black husband - white wife (Roger and Nicole)

ii) Black husband - black wife (Teeon - Randa)

iii) Black man - white girl (Teeton - Myra)

iv) White wife and white husband (Old Dowager and her husband)

v) White brother -in-law -white sister-in-law (Fernando - Old Dowager)

vi) Black man - white married woman (Derek - Nicole)

i) Black husband - white wife : Roger and Nicole

Roger , an East Indian, who arrives in London to fulfil his dream as a musician, marries a white American girl, Nicole, as a result of their love relationship. Nicole, is very devoted to him. She is his creative force. She takes care not to disturb him at day time when he practises piano. She feels proud of him, always supports him emotionally, and nurtures his talent. Sandra Paquet comments, 'Thanks to Nicoles willingness to compromise, their relationshiip is mutually sustaining until the crisis of Nicole's pregnancy.'[3] Derek's suggestion adds fuel to his fear of impurity when he comments, ' The child might be white you ever find comfort with Nicole again ; because she had given you this white impurity.'(p.139) He rejects fatherhood of the child. But Nicole affirms their pure relationship. She really respects his love. She agrees -though against her own desire - to abort the child for his sake, for his emotional security. But the rift between them makes her insane and she commits suicide. Ian Munro

comments, 'The suicides of Randa and Nicole mark the end of the isolated, aesthetic lives the three had created for themselves.'[4] His creative impulse is distorted because of his obsession, his colonial sense of order and an Aryan pride in racial purity. But without Nicole he cannot survive. It turns into his nervous breakdown and he becomes pyromaniac. He burns his room, hotel Mona and goes to burn Old Dowager's house but is caught by police on charges of murder and arson. His act of burning as Paquet interprets, ' is calculated to destroy the terms of his colonial relationship to the world in which he lives.'[5] The slave history, the colonial past and the racial hybridization are the facts of constant hindrance in the career of the artists, i.e. of Caribbean emigrant psyche.

ii) Black husband - black wife : Teeton and Randa -

Teeton fails to form a family with his wife Randa in San Cristobal because there is no faith and trust, in their relationship. He can not understand the depth of her love, her sacrifice for him. She gives away her body to rescue him from the political arrest, to an American ambassador. He has abandoned her after that and never tries to contact her. The news of her suicide comes to him. Artists are supposed to be sensitive but Teeton lacks that sense. Caribbean post - colonial situation takes away their sensitivity, their stamina and thus it results into the loss of essential human core in the words of Alladi Uma, - 'a mutually satisfying relationship.'[6]

iii) Black man - white girl : Teeton and Myra -

Teeton's few meetings with Myra, the lost daughter of Old Dowager and her lover Ferdinand, bring him at broader realization and deep understanding of the common, traumatic sufferings of the colonizers and the colonized, the victims of the past. Only deeper realization could release them both to form the meaningful relationship in future. Mutual breakthrough is necessary. Lamming brings both on equal level and treats them with mutual understanding.

iv) White wife - white husband : Old Dowager and her husband -

Old Dowager and her husband i.e Mr. and Mrs. Gore Brittain, never become life partners. Their relationship as husband and wife is seldom smooth. They are unable to turn it into permanent relationship. The husband's behaviour is monstrous. He has no claim of love on her. Old Dowager longs for passionate, romantic love relationship but her husband never responds to her in that way and remains impassionate and stone hearted. It breaks off their marriage.

v) White brother-in-law- white sister-in-law :Fernando and Old Dowager -

Old Dowager turns to her brother-in-law, Fernando, for passionate love. He offers her emotional support. Her romantic passions of love are softened by him. Their secret love affair turns into loyal and permanent relationship. The fruit of their loving relationship is Myra, their daughter.

vi) **Black man - white married woman : Derek and Nicole -**

Roger's wife Nicole fills orphan Derek's absence of family with her affection and care. He is inclined to Nicole and wishes to have sexual comfort from her. He is incapable of an enduring relationship with a woman. He destroys Nicole's family life by poisoning Roger's mind. He tells Nicole to abort the child. There is always a hidden desire in his mind to possess her. Roger and Nicole's family is his home. He never forgives himself for the death of Nicole and for causing the drift between husband and wife which leads him to the verge of insanity.

II) Surrogate White Mother - Black Son Relationship : Old Dowager (the landlady) and Teeton (the tenant)

The tragedy of familial relationship is depicted through the relationship of Teeton, the painter and revolutionist, and the Old Dowager, the surrogate white mother of Teeton. Their relationship as mother and son travels from intimate relationship to love and hate relationship of colonizer and colonized, which ultimately ends violently.

After the seven years' stay in London, Teeton has already decided to return to San Cristobal, but Old Dowager is unaware of his plan and Teeton is now in jeopardy how to tell it to Old Dowager. As usual, she arranges his room. 'He watched her and wondered what miracle of affection had turned this room into a home.'(p.14) Teeton's room is his independent province but he feels her presence in the room. The house and

room are in some way their joint creation,some unspoken partnership is there between them. He never feels that he is a tenant and Old Dowager never behaves like a landlady. Sandra Paquet points out, 'The Old Dowager's dependence on her lodger is the compensating factor in her old age.'[7] He is happy with Old Dowager, enjoys comfortable domestic life on an alien land. He has secretly joined Secret Gathering which is guerrilla revolturionatry group. 'And you of all people !"- this phrase was a bond of her affection for Teeton. ' It made him hear again the echo of voices which had mothered his childhood.'(p.27) Their genuine relationship makes his departure rather complicated. Margaret Nightingale comments, 'Teeton finds it unberably difficult to his English landlady, the Old Dowager, that he is to leave her, another act of desertion in his own eyes.'[8]

Old Dowager comes to his assistance when Teeton finds the dead body of Nicole in his room (probably suicide). Probable arrest on the charge of murder could have frustrated his plan to go to San Cristobal. Ignorant of his plan, she comes to his rescue. She orders him to dispose off the body and arranges a flight to an island in the North Sea where she has brother-in-law Fernando. There Teeton reveals his plan to Old Dowager. Ian Munro remarks, 'Prospero is dead, but his widow is represented by the Old Dowager, who as a survivor of the spirit of colonialism exerts a

subtle, mothering control over her colonial tenant.'[9] Teeton is trapped in the anger of Fernando who hates blacks and his stay in Old Dowager's house. On the other hand, Old Dowager does not allow him to leave her. She kills Fernando who suspects her interest in the young black man and threatens Teeton's life. Teeton decides to break from this prison of affection at once. Her murder becomes inevitable, 'their partnership was at an end.' (p.233) The call of Gathering, and the future is more important for him. 'He had burnt the Old Dowager out of his future. He had burnt her free .' (p.247) Then he feels so calm and free; he does not feel like a hunted animal. Snapping off the troubled relations and cutting off the bonds with the past is highly suggestive for the post-colonial Caribbean psyche. Violence becomes inevitable factor to confront the future and to start the new beginning for the possible inner indepedence.

III) Father -Son/Daughter Relationship

There is equally obsessive relationship between the East Indian father, Capildeo and his son, Roger on the one hand, and between Old Dowager's husband and his step-daughter, Myra, on the other. The third perspective of father-daughter relationship is offered in the relationship between Fernando the father and Myra, his daughter.

Roger's relationship with his father, Judge Capildeo, is also not harmonious. He rejects him as an archetypal hollow, mimic man. It is his

father who recognizes his taste for music, he himself has taught him piano and supervises his progress, 'But there was some deep conflict of spirit some subtle and bitter antagonism in their needs, which had set father and son apart.'(p.71) He is afraid of the landscpae of San Cristobal that everyone around him seems to take a mad delight in celebrating the impure, and he has inherited this horror of impurity. He always wants to go away from the chaos of his childhood, so he could never recongnize any links between him and San Cristobal. 'It seemed that history had amputed his root from some other human soil, and deposited him, by chance in a region of time which was called as island.'(p.70) He always feels insecure. His fear of impurity takes away the possibility to form a family with his father.

Myra's savage rape by the black workers' community of her father's estate on the island San Cristobal is the result of her supposed father Mr. Gore Brittain's brutal treatment to them. They satisfy their suppressed anger by revenging against the innocent Myra. She is mass-raped in front of her real father, Fernando. Ian Munro points out, 'Myra's fate is thus linked to Randa's and Nicole's, as Caliban's is to Prospero's, by a common relation to what Fernando calls the 'curse' of colonialism.'[10] Teeton gives Randa's painting to her and tells her about 'ceremony of the souls which is celebrated on Caribbean islands. Now Teeton feels it necessary to concieve the meaning of it in the light of complete understanding. Myra, the nameless,

bodiless, lonely wanderer of the heath, gives him the vision of the possible future. Otherwise the retaliation will continue like she gives syphillis to the men who come into her physical contact.

IV) Communal Family Relationship : Teeton, Roger and Derek

Disillusioned on their San Cristobal island, the three artists Teeton, Derek and Roger feel the need to preserve their identity as artists and their integrity as private persons. And the obvoius next step is self-exile. Their inevitable return embodies an act of repression. The novel explores their internal conflict after their seven years of stay in England, the country of the colonizers.

As an actor Derek has only one success as Othello. After that his acting career comes to an end. He is then qualified for the role of a corpse. Very humourously he comments,' Every corpse has his own angle, its own way of going stiff.'(p.67) His dream to become successful actor is seized away by the metropole London. He becomes more vulnerable after Roger's disintegration. Derek is like Ralph Singh in *Mimic Men*, who finds pleasure in punishing those who love him most. Then he turns his punishing scrutiny on himself. He is in the state of revolt when he wants to play his last role as a corpse in Circle Theatre, ' he cursed the origin of his oppressive failure. He was piling obscenities on the pastors' virtues, on the ignorant Chapel's exhortation to be and to come and to keep always

clean. he started to experience a strange relief.' (p.240) He now wants to exorcise the humiliation of the past by violating the virginity of Miranda, the actress who plays the role. Sandra Paquet states, 'Derek, as the designated 'corpse' in the drama, engineers his release from that role by violating the 'living' audience and actors.'[11] He rapes the heroine of 'A Summer's Error in Albion' on the stage and thus takes the revenge on the past, on colonizer. He burns the theatre. His deram is consumed in the fire.

The act of violence is shown through arson by three artists : Teeton burns the rock house and Old Dowager's dead body; Roger sets fire to hotel Mona; and Derek to Circle Theatre. It indicates the death of an artist. In an alien world their talent is condemned. Lamming justifies violence, - 'we are now equal in a new enterprise of human liberation. That horror and that brutality have a price, which has to be paid by the man who inflicted it.'[12] Teeton, Roger and Derek are arrested on the charges of murder, arson and rape. As friends they come together and share feelings and thoughts and form a family of three, but soon it is dispersed because of their insane acts.

In a sense, the act of burning homes by Teeton, Roger and Derek symbolizes their barrenness, their inpotancy to form a family through meaningful relatedness/togetherness. It indicates journey towards barbarism. The abnormal relationship between Myra and Fernando, Fernando's suspicion against Teeton. Old Dowager relationship, all indicate

brute existence. Blacks and whites, both are the victims of the racial environment and histroy. Whites who go to Caribbean islands are victims of blacks' rage and blacks' who come to white islands become the victims of whites. Such victimization is effectively presented in *Wide Sargasso Sea* by Jean Rhys, where the white creole family is persecuted by the blacks. It is also interesting to see that Samuel Selvon's exile Moses,survives by accepting British identity, whereas, the three artists of George Lamming struggle fiercely to assert their identity.

Reference

1. George Lamming, *The Emigrants*, (London and New York : Allison and Busby, 1954).

2. George Lamming, *Water with Berries*, (London : Longman Caribbean, 1971, this edition 1973).

 (All quotations cited are taken from this edition).

3. Sandra Paquet, *The Novels of George Lamming*, (London : Heinemann, 1982), p. 92.

4. Ian Munro, "George Lamming," in *West Indian Literature*, (ed). Bruce King, (London and Basingstoke : The MaCmillan Press Ltd., 1979), p. 141.

5. Sandra Paquet, op. cit., p. 93.

6. Alladi Uma, *Woman and Her Family : Indian and Afro-American - A Literary Perspective*, (New Delhi : Sterling Publishers Pvt, Ltd., 1989), p. 38.

7. Sandra Paquet, op. cit., p. 89.

8. Margaret Nightingale, "George Lamming and V. S. Naipaul : Thesis and Antithesis, " *ACLALS Bulletin*, 5th series, No. 3, Dec, 1980, p. 40.

9. Ian Munro, op.cit., p. 142.

10. Ibid, p. 142.

11. Sandra Paquet, op. cit., p. 95.

12. George F. Kent, " A Conversation with George Lamming," *Black World*, 22, No. 5, March 1973, p. 91.

(3) *Those Who Eat the Cascadura* (1972)

Those Who Eat the Cascadura[1] is Samuel Selvon's psalm of praise for the strongly bonded communal family. Situated in the post-colonial agricultural setting of a cocoa-field owner's estate, the novel demarcates an area where a future may take birth- a future in which the white-black-East Indian community with its discriminatory relationships will transfrom itself into a family of close-knit relationships between equal human beings. The novel narrates the story of a short-lived yet passionate love relationship between an East Indian worker-girl Sarojini and the white journlist visitor-friend of the estate owner, Garry Johnson. The communal family of the village helps the poor girl to sustain the beautiful relationship although it is destined to be unsuccessful. The community tries, through it, to fulfil the racial urge for meaningful relationship. Interestingly, Selvon injects the transracial experience of love with the race-specific cultural practice of obeah, in all its stages of evolution, so that the specifically cultural becomes trans-cultural in the process.

The novelist develops the theme of inter-racially bonded future for the West Indies by experimenting, especially, with three kinds of familial relationships-

I) Father-daughter relationship

II) Man-woman relationship

III) Agricultural communal family relationships

I) Father-Daughter Relationship : Ramdeen and Sarojini

Sarojini, the daughter of a Hindu-Ramdeen, is a labourer on cocoa fields. She is motherless young beautiful girl. Ramdeen is a drunkard. He is her father but she has no family. He has a small hut. He always wishes that she had never been born. When his wife, Kayshee, was in labour, he did not even appoint a mid-wife to help her. Mr. Franklin, the white estate owner and the obeahman Manko helped her but he remained outside the hut to drink wine : 'And then he felt like burning down the hut when it didn't turn out to be a boy-child. At least Kayshee could have left him with a boy before she died, so he could face his friends with some dignity. (p.63) It is a typical reaction of a Hindu father for whom the boy-child is an economic asset. The community comes forward to compensate for the absence of mother. When she is able to tote water from the well he stops paying attention towards her.

Ramdeen has betrothed Sarojini with Prekash, an overseer on the estate, in her childhood, according to the Hindu custom. Mr. Franklin, however, advises him not to marry her early. Ramdeen is interested in Prekash purely for economic support, he already has taken ten dollars as a dowry from him. And one day Sarojini turns out to be a goose laying a golden egg. An unexpected supply of twenty dollars starts coming from an unknown source to him. 'With his third drink he made the vow that Sarojini would die a spinster, that monkey would smoke Prekash's pipe as

far as the marriage was concerned.'(p.66) When Prekash presses the suit he makes all sorts of excuses, not denying his potential, he keeps Prekash 'a husband in reserve.' Sarojini also keeps postponing the marriage. She is aware of his limitedness, yet social compulsions of accepting him always disturbs her. A sense of unfulfilment and dissatisfaction gives rise to a sense of insecurity. She tells him, 'You wouldn't like me to say yes when I didn't want to, would you?' (p.19) She has little love for Ramdeen. There is a strange relationship, with none of the family affiliation, which is characteristic of the Indians. Sometimes he is quarrelsome and sullen but she is accustomed to it, 'she paid no attention, grateful that she had escaped from all his threats long enough to become a young woman and control her own affairs. Once she made him realize he could not affect her action in any way...' (p.61)

Of course, even if the father does not either love or care for the daughter, community becomes Sarojini's extended family - godfather obeahman Manko, mother- like maid servant of Mr. Franklin Eloisa, Dummy the deaf and dumb boy like a brother and exotic nature of Sans Souci her home. Their compassionate relationships remain strong throughout the novel.

II) Man - Woman Relationship -

The love - relationship between Hindu Sarojini and British Garry progresses from their prophetic meeting to their destined separation. At every stage, the members of her communal family, and especially the obeah man Manko, give her psychological support to make their relationship mutually responsive. Sarojini is an illegitimate child of the white landlord Mr. Franklin. Absence of parental love makes her emotionally insecure. Her urge for meaningful relatedness, which will offer her security-not individual but racial brings her to the threshold of Manko, an obeah man and her godfather. He really cares for her security. Both of them have complete understanding of each other. For him, 'She was a like a little girl, already sweetened by the hint of mysterious happiness.' (p. 21) She has complete faith in obeah power, and insists on his telling her, her future. In such matters, she becomes very stubborn. She becomes very excited when he tells her, 'I see a stranger, a white man, who going to make this girl forget everything and everybody.' (p. 22) And Garry Johnson, the writer - journalist friend of Mr. Franklin arrives to collect the information on the West Indian folk ways. Manko is the only person who is fully equipped with information, a useful man for Garry. Garry almost falls in love with Sarojini at first sight.

Selvon offers idyllic dimensions to the passionate love - relationship by allowing it to grow freely in the company of nature. From childhood

Sarojini finds solace from nature. She knows each and every spot of the Sans Souci forest, thick, lush green, full of dangerous but attractive sights. Along with her little friend, Dummy, she explores the nature. Like Lucy in *Education of Nature*, the poem of Wordsworth, nature takes her in her bossom and teaches her dignified living. Sans Souci is bountiful 'a variety of birdlife ... Every tree, every hedge and stray vine thrived and blossomed.' (p. 55) No wonder Sarojini grows without malice and anger for anybody. Dummy always shows her exotic secret places and with him she enjoys the treks. What Ram Kundu thinks about the nature of Granbois in *Wide Sargasso Sea*, is also applicable here - 'The place is very carefully captured not only through sights, sounds, smell, plant life but also through its people....'[2] Away from the human world, the lover and the beloved, like the Father and Mother of Mankind, come together sexually in the rich green spot within the deep forest. It reminds of a similar union between the beautiful Mumbi and young Gikonyo in the forest in Ngugi Wa Thiong'O's *A Grain of Wheat*.[3]

Sarojini knows her passionate romantic love affair with Garry will not last long. Hence, she decides to enjoy every moment with him. Her complete faith in obeah gives her psychological strength of optimism. Mr. Franklin's love for her mother , Kayshee, is also the struggle for meaningful relatedness. This struggle is expressed in better way in the next generation, that of Sarojini's. Instability is the drawback of their idealistic, idyllic love affair, but Garry never behaves like a master with her. She hides her poverty

from him. She brings good clothes from her friend Kamalla. She takes him in the forest from cocoa plantation and provokes him and enjoys wild sex with him. They are always seen together. Such relationship is accepted fact in Caribbean community. In spite of Prekash's warning Ramdeen neglects the fact.

The possibility of two cultures merging together is indicated through the relationship of Garry and Sarojini. Derek Walcott underlines, ' the creation of a culture that is the people's own through their Crusoe -like ability to make and remake out of necessity, to rename, to find new metaphors.'[4] Manko now is anxious for Sarojini because he knows her denstiny. He wants to stop her by warning her that something is wrong with Garry. At once Sarojini forces Garry to use Manko's medicine and she is sure he will cure him by his obeah power. Out of curiosity and for the sake of Sarojini's earnest pleading Garry approves the treatment for a piece of bobmshell that has remained in his head in bomb blast when he was in the army. That always gives trouble to him. Doctors have given up their hope. Manko starts his treatment, warning Sarojini to keep the fire burning outside his hut. Manko gives her 'a donkey-eye, for luck, 'Wear it all the time, and it will protect you. And make sure you don't mix up with any others because you won't be able to tell the difference.' (p. 92)

The intensity of love between Sarojini and Garry is tested at the time of hurricane, forecasted by Manko. Hurricane washes out everything, people take shelter in the school building, one of them is Sarojini. Estate agents, landlords warn people to remain inside by broadcasting on radio, in spite of the warning Sarojini goes outside to meet Garry at their usual spot in the forest. Prekash wants to stop her. When she does not budge he tries to rape her in order to keep her under his authority. It is his last and lame attempt to control Sarojini but she manages to escape. Coming on Mr. Franklin's estate in anger he discloses her departure for the forest. Garry is alarmed and runs outside with rope and cutlass, along with him Dummy and Rover, Mr. Frankin's dog, pet of Sarojini, her family members. Garry actually puts his life into danger; finds her under the fallen tree, 'one hand was clenched tightly and when he forced the fingers open he saw Manko's donkey eye.' (p. 147) It indicates her deep faith in Manko's power and in love. Both of them are ready to embrace death for the sake of love.

Superistitious rural girl and the scientifically oriented journalist faces the denstiny of separation after Mr. Franklin's knowledge of it. Garry's relationship with Sarojini disturbs Mr. Franklin who warns Garry that, it will not last long. Both of them understand it is the time for Garry to depart. She takes him in the forest on starry night for the last time. She is proud of his child within her womb - 'It had its roots in her love, and it was as

wondersome to her as to him, because she had thought she had nothing more to give and this thing blossomed in her and made silence more precious than words.' (p. 159) But for the last time she asks Manko to make Garry come back to the island. But he is helpless. However, Dummy's action tells her about the legend of Cascadura fish. She brings them, prepares them in an Indian way and gives them to Garry to eat. Eloisa tells the myth of cascado to him and he knows only Sarojini can do such things.

The meaning of the title is significant. The novelist refers to the native faith -

Those who eat the cascadura will, the native legend says,

Wheresoever they may wander, end in Trinidad their days.

The person who eats the cascadura surely returns to the island. It transforms despair into hope.

Next day keeping donkey eye on Garry's table for his luck, Sarojini departs from her lover but does not disclose that she is pregnant. Her pregnancy, the seed in her womb,reveals the possibility of new emerging culture. As Renu Juneja points out, 'it is possible to speak of an emerging core culture, which, whatever the local differences, share strategies for re-creation, for the cultural empowerment and full of self-realization of a people.'[5] In the end, Dummy mixes up the donkey eye with another and she can not make out which is hers. It symbolizes the assimilation of

cultures, and races beyond any recognition. There is no sense of helplessness in Sarojini. Her sense of meaningful relatedness is fulfilled although Garry leaves her. She willingly accepts his departure as an inevitable situation. She has now full faith in her child as a source of possible security and stability in future. Through Garry's and Sarojini's relationship, Selvon also has expressed his faith in positive future with possible mixture of the races.

III) The Agricultural Communal Family Relationships :

The political independence wipes out the image of the white landlord as the colonizer. Of course, his economic power continues his position of authority. Yet the human urge for meaningful relatedness struggles to transcend the boundaries of colour and class and build a family of affectionate relationships. Here, the lonely white landlord discovers a caring mother in his old black maid; and the workers find an honest guardian in their landlord. The agricultural post-colonial communal family of Sans Souci contrasts with the colonial communal family of Mr. Creighton's village in Lamming's *In the Castle of My Skin* where the white landlord exploits the innocent poor community ruthlessly.

Selvon's experiment with positive racial relationship in post-independent West Indies is also expressed through the family of the white estate owner Mr. Franklin and his maid Eloisa, which is part of the communal family including both the landlord and workers. Eloisa is anxious

for Mr. Franklin's health. She is sixty-five. She thinks Mr. Franklin as her responsibility, 'when the manager's wife died she took it upon herself to run all the domestic affairs, and Roger in his distress was glad for her comforting and useful presence ... She mothered him.' (p. 13) She gives him 'home' with her affection and tender care.

Community is the tenant family of Mr. Franklin. He looks after them. After the hurricane he personally meets every member of the family, provides them shelter, ' he had arranged with the shopkeeper to let them whatever they wanted at his expense.' (p. 152)

Eloisa, even though African, takes care of Sarojini after she becomes seriously ill. She does not take any objection over her relationship with Garry. She hates Prekash because he is an East Indian - a coolie. She allows him to come from back door. But she understands the need of Sarojini and helps her without any malice.

Community provides healthy family to Sarojini and Dummy, the semi-orphan children. The people provide food to Dummy as if it is their responsibility. 'Natio' with its real meaning is seen in Sans Souci inland. Timothy Brennan points out that 'natio' refers to a 'local community, domicile family, condition of belonging.'[6]

Manko is the spiritual guide of his communal family. Community turns to him at the crucial moments. He is aware of the limitations of his

obeah power. Yet his love for Sarojini as his daughter compels him to use it for her sake through he knows, 'obeah man had to practice at distanting himself from all things ... he must also know how to withdraw himself ... he must be total possession of himself'[7] Even Mr. Franklin asks his advice on the crisis of plantation in Sans Souci because of people's protest against cutting off the cocoa plants for having sugarcane plantation.

Selvon focuses on the dumb Dummy who always longs to fly like a bird, 'it had happened, ... That morning he had given God a rainbow. Now God had given him wings.' (p. 126) The boy could turn mud into the shape and semblance of everything he beholds. He represents Caribbean community. Selvon dreams of Caribbean islands without any boundries of culture, caste, colour - a rainbow of cultural mixture. He realizes it on the level of art by bringing together Garry the white and Sarojini an East Indian, and Dummy, Manko, Eloisa the Africans.

References

1. Samuel Selvon, *Those Who Eat the Cascadura*, (Toronto : TSAR, 1972, this edition 1990).

 (All quotations cited are taken from this edition).

2. Dr. Ram Kundu, "Wide Sargasso Sea : Intertext as Device for Post-Colonial Assertion", in *Commonwealth English Literature*, (ed.), M. K. Bhatnagar, (New Delhi : Altantic Publishers & Distributors, 1999), p. 42.

3. Ngugi Wa Thiong'o, *A Grain of Wheat*, (London : Heinemann, 1967).

4. Derek Walcott, *Omeros,* (New York : Farrar Straus Giroux, 1990), p. 28.

5. Renu Juneja, *Caribbean Transactions : West Indian Culture in Literature,* (London & Basingstoke : Macmillan Caribbean Ltd., 1996), p. 6.

6. Timothy Brennan, "The National Longing for Form", in *Nation and Narration,* (ed.), Homi K. Bhabha, (London : Routledge, 1990), p. 45.

7. Kenneth Ramchand, *The West Indian Novel and Its Background,* (London : Faber and Faber, 1970), p. 126.

(4) *Guerrillas* (1975)

In his novels of the 50s, 60s, and 70s, V. S. Naipaul continues to be preoccupied with the problems of sterility of Caribbean society, due to the inhuman demands of economic survival by an exploitative stratified environment. In *Mystic Masseur*, representative of his earliest sense of bitter frustration with the Caribbean situation, he finds familial relationships commercialized for money-making. *A House for Mr. Biswas*, marks his willingness to explore the possibility of overcoming that initial sense of frustration. It decodes the Caribbean struggle to create a meaningful pattern of relationships through the hero's successful attempt to build his own house. The expanding circle of experience - both colonial and post-colonial - deepens Naipaul's awareness of the Caribbean complexity. In his novel of the 70s, Guerrillas[1], the economic and the political, the black and the white, the native and the exile elements coalesce to intensify the environmental challenge. It problematizes more seriously the Caribbean struggle for meaningful survival.

Guerrillas is set in the industrial city of Trinidad. The time is post-colonial. Trinidad is politically independent but still in the clutches of white economic power-holders. The protagonist, Chinese hakwai political leader, Jimmy Ahmad, fights for economic justice. The title of the book Guerrillas directly suggests the political activity of Jimmy Ahmad. He is

a revolutionary. His political guerrilla activity is meant to fight against white imperialism.

Naipaul utilizes political setting only to foreground the crucial nature of the environmental demands on Caribbean psyche. It is projected exclusively through man-woman relationship which itself turns into a guerrilla activity for the three major characters in the novel - Jimmy, Jane and Roche. The novel probes into the problem of survival in terms of man-woman relationship on four levels, apart from the hero's experiment with communal family -

I) Black husband (exile in England) and white wife

II) Black man (ex-exile in the West Indies) and white woman

III) Black man and black boy (homosexual relationship)

IV) White man and white woman (both exiles in the West Indies)

V) The Communal family relationship

I) Black Husband (Exile in England) and White Wife : Jimmy and Carole

Jimmy is Chinese black, who works for the Black Power Movement in England. Carole, an English lady, is attracted towards him and marries him. They have two children. In that sense the family circle of Jimmy Ahmad is complete. His relatedness with Carole becomes fruitful. But his sense of fulfilment remains brief. His affairs with other English ladies

shake the faith of Carole; she also fails to understand his revolution and never attempts to support him emotionally in his political work.

Carole's English white middle-class life provides her security whereas Jimmy's racial sense gives him the fear of insecurity. Jimmy's hate for middle-class is like Malik's in V. S. Naipaul's *The Return of Eva Peron with the Killings of Trinidad*, ' Malik's resentment for English middle-class quickly turns into hatred. He begins to hate 'the people with money or connections who patronized him who were secure who held Negroes in contempt but were fascinated by him.'[2] Jimmy's racial guilt haunts him and turns him into a criminal. He is charged under the criminal act of rape and assault in England and their marriage breaks. Naipaul attempts to show the possibility of meaningful relatedness between blacks and whites through the relationship between Carole and Jimmy, although it is for a brief period.

II) Black Man (ex-exile in the West Indies) and White Woman : Jimmy and Jane

Jimmy's poilitical career as a freedom fighter after his return to the homeland makes him a hero in Trinidad. Once again, he gets the opportunity of meaningful relationship with Jane, a middle class lady from England who has arrived in Trinidad for better future. They are offered a chance to create a 'home'. For her, Jimmy is a hero, an ideal man because

she has heard the stories of his Black Power revolution in England. She is a divorcee. Her ex-politician husband was twice elder than her. He failed to satisfy her in sex. When she meets Jimmy she finds that possibility of a satisfactory relationship. Peter Roche introduces her to jimmy. He impresses her with his gentlemanly behaviour. As a Hajji (those who have done the pilgrimage of Mecca), he does not touch alchohol. Jimmy Ahmad is a muslim, mixture of African and Chinese blood. He tells her, 'I miss my children.'(p.25) She then knows that he is a desolate person. His aura of glamour also attracts her, 'Jimmy in London, with various people,......some celebrities : an actor, a politician, a television producer. They were people outside Jane's circle.'(p.24)

For Jane sex is the only means to create meaningful relationship. Her sexual advances surprise Jimmy. It is her bold attempt to be related to a man of her choice on an alien land, 'She turned to him almost with irritation, her eyes moist, as if with tears.'(p.77) Both of them lack the intensity and responsibility of love. Jimmy actually has lost his stamina to build meaningful relationship. Jane has no training to maintain such relationship. Renu Juneja comments, 'Jimmy's complicated relationship with Jane, where sexual assertion becomes a substitute for a need to diminish those who have defined you and for real power in the real world, is yet another invention of Naipaul.'[3] Basically Jane's arrival on the island is to share the privileges of the economic adventures. Yet she thinks that

her love for Jimmy will bring some kind of stability in her life. Soon she begins to know the hollowness of Jimmy, but still she has hope. She goes to meet him after the police firing on the revolutionaries, and after she knows that her lover friend, Roche who is part of the Jimmy's revolution, is going to leave him to settle in England. For her it is betrayal of Jimmy's trust. In order to comfort him she goes to Thrushcross Grange.

Jimmy, on the other hand, is a victim of racial sense of guilt of illegitimacy, insecurity and desolation. His hakwai status constantly necessitates his search for self-definition. In his writing he calls himself Heathcliff who was abandoned by the society. He fantasies on behalf of Jane in his writing about himself, "Your mother was an Indian princess, and your father the Emperor of China."(p.62) He is born in the back room of the Chinese grocery. For survival his mother has given away her body to others. This pinching truth always makes him turn to fantasy about himself. In his fantasy Jane idealizes him , 'to me he is like a prince helping these poor and indigent black people, He's the leader they are waiting for.'(p.62) In the last meeting he makes a covert reference to her death,

'Do you have nice house in London?

'I'm used to it' - - -

'Suppose it burns down while you are away?

'It's insured.'

'You'll just build another?'

'I suppose so.'(p.241)

She sees herself as the secure member of the privileged middle class. And this causes her to be brutally murdered by Jimmy and Bryant. Harold Barratt remarks, 'Jimmy's hatred for the middle class, partly explains Jimmy's brutally contemptuous killing of Jane.'[4] He murders Jane in order to overcome his recent political failure, his exposure by Meredith in the interview of Peter Roche. Roche reveals the true intentions of their pseudo-revolution. Their struggle for political and economic independence is like "fancy-dress parade."[5] Roche rightly says that he does not believe in guerrillas but in gangs. Jimmy's last attempts to rise politically in power by exploiting the death of Stephen, a young wise and clever boy from his gang, whose popularity is actually a threat to him, in police firing. But everybody knows his stunts. Failure from all sides makes Jimmy insane.

Jimmy's guerrilla activity is a camouflage of his self which is cruelly established. According to Michael Neill, 'The vision of post-imperial restlessness and disorder lies behind the broken world of Guerrillas, at once cosmopolitan and hopelessly provincial'[6] Jimmy turns himself into a political exploiter of his commune, his own people who have dedicated themselves to his revolution. He betrays his people and Jane as

Britain betrays him, 'you were my maker, then you make me feel like dirt again,..... You people sent me back here to be nothing.'(pp.228-229) The failure of Jimmy and Jane to achieve the true aim of a family /home, symbolizes Caribbean condition which is destructive even in the post-liberation period. For both Caribbean and whites economic, political and psychological insecurity exists as a reality.

III)Black Man and Black Boy (Homosexual Relationship) - Jimmy and Bryant

Jimmy's relationship with Bryant is perverted. He is homosexual. Bryant is jealous about Jane, he calls her 'a white rat.' He hates Jimmy for Jimmy's sexual relationship with Jane. To pacify his anger, Jimmy offers Jane to him in the end to be killed by him. Bryant takes his revenge in a brutal manner by using cutlass on her limbs. Renu Juneja remarks that Bryant's 'pathetic ugliness is for Jimmy, a source of self-definition as sexually attractive.'[7]

IV)White Man and White Woman (Both Exiles in the West Indies) - Roche and Jane

Jane fails to build harmonious relationship with Roche the left-wing journalist. Jane and Roche are in exile. They belong to the colonizer community. He sympathizes the Black Power Movement in England. He himself is engaged in the movement in South Africa against apartheid.

His has experience of jail and brutal treatment are nightmare for him. Jane and Roche live together like husband and wife for a long period. Their temporary relationship could have turned into permanent family but only Roche struggles to have meaningful relationship with her. In the beginning Roche appears to her as a doer, when he publishes his first book on the experiences of South Africa. But later his views 'no longer held surprise for her whose articles she no longer reads.'(p.48) She feels staleness in their relationship because, compared to Jimmy, he looks unheroic to her. For both Roche and Jane, Jimmy is a hero.

Jane and Roche oscillate between illusion and disillusion. They feel unstable as well as insecure in the alien country. They are conscious about their superiority as whites. They always cling to their middle-class security. Margaret Nightingale rightly points out that Naipaul insists on 'entirely egocentric motives of his characters.'[8] Roche is exposed by Meredith, who interviews him by showing his magnetic pull for England and his false commitment to the revolution. Fear of insecurity in land of alien races, compels Roche to make pathetic run to England even if he knows about the alleged murder of Jane. He destroys her papers and passport on which her arrival is not significantly noted. She remains non-entity.

V) The Communal Family Relationship

Jimmy establishes a commune on Thrushcross Grange as a shelter to the black orphan and poor boys. It is a kind of agricultural commune, a camouflage of the guerrilla activity. He is a man of fantasy instead of a man of thought. According to Michael Neill, 'Jimmy is the star boy of a kind of "guerrilla theatre" in essence no different from an old - style coon act.[9] His multicultural commune is run by the white Sablich's merchantile firm. Sablich's fortune comes from the trade of the black slaves. Jimmy does not mind to take that corrupt money as funds for his commune. He tells Roche, 'They've got to support me, massa. Sablich's and everybody else. I'm the only man that stands between them and revolution I'm the friend of every capitalist in the country.'(p.27)

Ridge is meant for rich people. It is different part from Thrushcross Grange. Whereas Sablich's have estate on the Ridge, Harry-de-Tunja, a Caribbean owns a beach hotel which is particularly meant for rich people, all of them are ready to free from Trinidad when revolution threatens their economic power. For Naipaul the politics of country can only be an extension of its ideas of human relationships.

Jimmy's commune never stands as communal family. Jimmy, as a head of the family, never acts as a responsible person. His Thrushcross Grange is the dumpyard of waste machinery. His boys live in filthy rooms

and sleep in shelves, which reminds of a slave ship. He is the cruel betrayer of his own people. His commercialization of commitment is clearly seen by the money he takes from the whites for his so called revolution. His duplicate policy fails to win the trust of either the whites or the blacks.

Stephen, a sincere slum boy totally commited to the cause, is Naipaul's positive image. His honesty and innocence bring the feeling of togetherness in the commune of Thrushcross Grange. Bryant admires him but Jimmy hates his sincerity. The poor boy has to make a run and for many days he remains in seclusion. It is Roche who has introduced the boy to Jimmy. When Roche starts search for Stephan, it brings him to the slum, where his mother waits for the son. Her hope is centered upon Stephen. She has lost her first son. Even in her poverty she welcomes Roche and offers him drink. Roche understands that she knows politics well. She argues, 'But is black people fault if they allow themselves to be fooled.'(p.112) She tells Roche to tell Stephen if he finds him, ' to come and look for his mother sometime.'(p.113) It is the only positive family with strong bonds presented in the novel.

Guerrillas is Naipaul's first political novel although politics is kept at the background. It depicts community's sense of commitment and hope for the future in spite of betrayal by their leaders.

Water with Berries by Lamming is another political novel which offers comparison with Naipaul's *Guerrillas*. Both are written in the 70s and are concerned with the theme of exile experience. Both rely on inter-personal familial relationships. In both, violence plays a crucial role so that the possibility of meaningful relatedness is destroyed. Both Naipaul and Lamming regard violence as an essential stage in white-black relationship in order to overcome the racial and historical guilt of skin.

References

1. V. S. Naipaul, *Guerrillas*, (England : Penguin Books, 1975).

 (All the quotations cited are taken from this editon).

2. V. S. Naipaul, *The Return of Eva Peron with the Killings of Trinidad*, (London : Andre Deutsch, 1980), p. 37.

3. Renu Juneja, *Caribbean Transactions : West Indian Culture in Literature*, (London and Bansingstoke : Macmillan Caribbean, 1996), p. 172.

4. Harold Barratt, "In Defence of Naipaul's Guerrillas," *WLWE*, Col., 28, No. 1, 1988, pp. 100-101.

5. Frantz Fenon, *'The Wretched of the Earth*, (London : Penguin Books, 1969), p. 118.

6. Michael Neill , "Guerrillas and Gangs : Frantz Fenon and V. S. Naipaul," Ariel, Vol. 13, No. 4, Octo. 1982, p. 53.

7. Renu Juneja, op., cit., p. 172.

8. Margaret Nightingale, "George Lamming and V. S. Naipaul : Thesis and Antithesis," *ACLALS Bulletin*, 5th series, No. 3, Dec. 1980, p. 45.

9. Michael Neill, op., cit., p. 25.

Conclusion

In *Crick Crack, Monkey* Merle Hodge symbolizes the universal socialogical phenomenon of the urge of the inferior low class to achieve the status of the superior higher class. She allows the two class - cultures to be mutually illuminated through introduction of a girl child's process of growth in two families. *Water with Berries* of Lamming confronts the traumatic tensions caused during the struggle for meaningful relatedness between the whites and the blacks in white society. *Those who Eat the Cascadura* is Selvon's positive, though transitory, vision of a possible future for Caribbean society in which the whites and the blacks (East Indians) will be meaningfully related in close knit bonds of familial relationships. *Guerrillas* by Naipaul, however, problematizes the possibility of white-black meaningful relatedness even in the post-liberation Caribbean environment of white economic imperialism.

CHAPTER SIX

THE NOVELS OF THE EIGHTIES

The decade of the eighties marks a definite advancement in the Caribbean novelists' stamina to explore the problem of meaningful relatedness by using individual and family relationship both as a theme and as a structural device. The novels in this group include -

1. John Hearne's

 The Sure Salvation (1981)

2. Jamaica Kincaid's

 Annie John (1983)

3. Sam Selvon's

 Moses Migrating (1983)

4. Merle Collins's

 Angel (1987)

5. V. S. Naipaul's

 The Enigma of Arrival (1987)

(1) *The Sure Salvation* (1981)

John Hearne, pseudonym John Morris, was born in 1926 at Montreal, Canada. His parents are Jamaican. He is novelist, historian, teacher, commentator and journalist. He was educated at Jamaica College, *Jamaica*:

Edinburg University. He served in Royal Air Force and was an information officer for the Government of Jamaica, Head of the Creative Arts Centre, Mona, UWI. He has been an assistant to the Prime Minister of Jamaica. He has been a visiting fellow in Commonwealth Literature, University of Leeds. He is recipient of the Rhys Memorial Prize (1956), and the Institute of Jamaica's Musgrave Medal (1964). His novels are *Voices Under the Window* (1955), *The Faces of Love* (1957), *Little Brown* (entitled : The Eye of the Storm) (1958), *A Stranger at the Gate* (1956), *The Land of the Living* (1961), *The Sure Salvation* (1981), Written with Morris Cargill under the pseduonym of John Morris, are the novels - *Fever Grass* (1969), *The Candywine Development* (1970). His work has been translated into Swedish, German, Portuguese and Russian.

The Sure Salvation[1] is the historical novel of the 80's in which Hearne undertakes the ambitious project of re-assessing the most crucial phase of Caribbean history known as 'The middle passage'. It innovates the black slaves' voyage in a slave ship of a white slave trader who has collected them from African shores and plans to sell the human cargo in Brazil. Hearne's post-colonial perspective of the traumatic phase challenges the popular historical interpretation which indentifies the roles of the exploiter and the exploited with races - the whites as typically the exploiters and the blacks as typically the exploited. The novel scans the roles of the white and the black slave traders as exploiters of the powerless black humanity,

revealing, in the process, the truth that the phenomenon of exploitation of the powerless by the power-mongers is the eternal destiny of mankind-past, present and future. The title 'Sure Salvation" ironically highlights mankind's journey towards 'sure damnation'.

The novel offers illumination on human greed and human suffering as reflected in the life of the members of the slave ship. The ship, along with its crew and the human cargo, becomes a home/family for its fortunate and unfortunate members alike. The novelist tries to grip the inner seed of lust for power through exploration of (1) the nature of relationships of individuals as members of their families and (2) the nature of relationships between two races as members of the ship's family. These relationships can be classified into three kinds -

I) White - white familial relationships

II) White - black familial relationships

III) Black - black / white familial relationships

I) White - white Familial Relasionships

These relationships especially focus on

i) Parent - child relationship

ii) Brother - sister relationship

iii) Man - woman relationship

i) Parent - child relationship : a) Hogarth and his parents -

William Hogarth is the slave trader and owner of the slave ship, 'Sure Salvation'. His mother was a saintly woman. Hogarth reminisces, 'when I was a boy ... she seemed to fill the largest room with her radiance, like flowers in a vase.' (p. 127) As a young boy Hogarth believed in human relations. His heart was not corrupted by the lust for money. He was brought up by his grandparents after the parents' death. He respects his parents and grandparents. He is a proud young man who wants to establish himself without anybody's help or influence. He wants to become a self-reliant man because 'Had my beloved parents lived, I would have accepted my grandfather's offer, nay assurance, of recommendation into the Navy. But it would have dishonoured their memories had I permitted myself to pocket so much as a guinea of his, let alone his influence.' (p. 126) He manages to find his own job in East India Company. During his second voyage his grandfather pressed him to accept his offer of job, but he refuses again. He takes from his collection only the books of great mariners' and voyagers' history. They include Hakluyt, Columbus, Tasman, Drake, Cook and many others.

b) Ned Dunn and his parents -

Ned Dunn is one of the white crew. His childhood is pathetic. Even in poverty his mother has tried to hold the family with her love and care.

She has worked hard for them, as his father was drunkand. Ned remembers how, 'There had been no work for the men, ... only for women, an' only for those as were particular neat an 'quick like mother'. (p. 109) Their poverty, according to the mother, had wasted the good man like his father whom he hated most. He is full of painful memories of his childhood : no food, no clothes, no shelter. For survival he has to work on ship from the age of nine. The ship takes him away from the family and it is lost somewhere in the crowd. He never finds his parents, although he 'looked for' em ... I looked as hard as a man could look afore I had ship out again. But it was if they'd drowned'. (p. 113) His 'hope' keeps him alive on his floating temporary home on the sea.

c) Joshua the young boy, and the ship's family -

Suffocated by the inhuman environment of the ship, the white members of the crew-including the ship owner's wife - Elizabeth - struggle to have a sense of home by their parental relationship with the young boy, Johua, one of the members of the crew. Joshua has come from British slum. His work is to take food to the crew members, and to Mr. and Mrs. Hogarth. He learns English from Eliza. She has trained him in manners. As a young boy, his biological urge for sex is natural. He inclines towards Eliza but cannot fulfil his desires in reality so fulfills them in dreams : 'in the unbidden but overwhelming urges of desire that were part memory

and part invention.' (p. 67) Her unconsious touch and by touching her things he satisfies his need of sex. He learns the tactics of survival in young age so he is always good with others. He has to pacify his bodily hunger as he has experineced starving. Only Alex tells him not to call him sir. His relationship with all crew members is amiable, 'Already he has learned his way through enough of their language to suit his needs : as a cat learns and appropriates the warmest and most comfortable corners of a new house.' (p.33) Portugese and Dunn love him and treat him like a child and take care of him.

ii) Brother - sister Relationship : Reynolds and Georgiana Reynolds

Reynolds' main business on the ship is to control the slaves with his crackling whip. He brings them on deck and gives them exercise. Such strong man has very disturbing childhood. His sister Georgiana and their governess are lesbians. When he catches them raid - handed his sister has treated him inhumanly. His family is actually trained in Christian religious practices and all of them observe the religion closely but it does not satisfy the instinctual urge of sex. He is deprived of love and affectionate relationship from childhood, because his father has got another Irish woman as his mother. Her detached behaviour frustrates him. Ironically he says, 'still I must not be ungratful to these dedicated tutors of my childhood... They taught me ... to take my pleasure whenever and however the

opportunity offers itself.' (p. 92) Neglected childhood turns psyche into psycho! Reynolds is a fractured psyche. Jerry J. Bigner comments, ' The family is one of the most powerful and pervasive influences on an individual's development, especially during infancy, childhood, and alolescence.'[2] Hogarth is commercially interested in him so he allows him to do anything because he is very good at controlling the slaves with his cat - o - nine tail-whip.

iii) Man - woman Relationship : Hogarth and Elizabeth -

Five years Hogarth has been working with Harry Llewellyn as a partner in East-India Company. His friend Oswald Oates wishes him to marry his sister Caroline but Hogarth falls in love with a beautiful, charming country girl, Elizabeth Manning. She is the daughter of Harry Llwellyn's most respected tenants. They enjoy sex. Both trust each other. There is 'much Christian sensibility in a breast' (p. 170) of Hogarth. He is determined to marry her. She is pregnant by that time. Hogarth informs of his decision to Oates who raises the question of real father of the child. When Oates asks him, 'But is the child yours?' 'It is mine, I said. "Eliza Manning has been as faithful to me these last five years as I have been to her' (p. 172). But Hogarth is tempted into the proposal of marriage with Caroline by Llewellyn who opens before him the cool calculation of mutual profits. They boost his ambition to share adventures. His ambition and false pride combine to

make him a reluctant to accept marriage with pregnant Elizabeth.

Elizabeth Manning believes in meaningful relatedness. Out of complete faith in Hogarth's love, she keeps sexual relationship with him in spite of her religious teachings. Hogarth is reluctant to reply her letter in which she pleads, ' I feel no sin or guilt for what has taken place between us these five years ...' (p. 175). Further she suggests 'marry me by proxy.' (p. 178), so that the child may be entitled to his rights. She is willing to join him wherever he says. By that time, Hogarth's moral downfall has slowly begun as he becomes the partner of vulgar trading venture of slaves. He himself has grown with Christian teaching but the magnetic pull of economic power is so strong that he slowly involves himself in corrupt practices. Still somewhere in his heart he could judge right from the wrong, he has not completely destroyed his capacity of thinking. 'I knew that I had been faithless ... to Eliza Manning and to the memory of those two who had sacrificed everything to teach me the joy of Christian love and duty.' (p. 173). His guilty conscience brings him back to her but by that time she has lost her baby in abortion. He accepts her as a wife and proves, after repentance his duty and dedication to her. He acts as a responsible man, and brings back the pride of her parents. But she accepts marriage with him on one condition, 'I will never be your wife.' (p. 186) After that Elizabeth Hogarth remains neutral. Though she accompanies him on the voyage, she is ignorant about his 'business'. After her realization, their relationship

remains barren. The lust for money has seized the possibility of family/ home.

II) White - Black Familial Relationships

There are two kinds of white - black familial relationships -

(i) Master - slave relationship

(ii) Man - woman relationship

i) Master - slave relationship : a) Alex as a child and his owner-

Alex Delfosse is the ambitious black slave trader who has encouraged the white slave trader, Hogarth, to undertake the illegal transaction of smuggling black slaves to Brazil. He works as a cook on 'Sure Salvation'. His lust for power through slave trade originates in his own childhood as a slave in the family of French slave owner, Jean Paul Delfosse.

Alex is the slave of Jean Paul Delfosse. Louis is his son, he is the slave trader. He trained Alex in his business, and Alex becomes his right hand. From the childhood Louis and Alex grow together under the guidance of Jean-Paul Delfosse. Louis 'was a bad mean boy too. The worst I ever saw...' (p. 53). He kindles the dream of power through money in Alex. 'Two of us could take and hold that country, Alex, if you were only a white man... he'd look across the Rio Grande hungering for what was on the other side. The cities, the women and the gold and the silver... Cantina,

whores...' (p. 53) Jean-Paul Delfosse gives him freedom with legal document which states, 'Alexander Delfosse is the free born Negro child of my freed and manummitted Negro,... I hereby assign property of $500 (five hundred dollars) to said Alexander Delfosse.' (p. 159)

b) The white crew and the black cargo

The tempeary family of the white crew and the black cargo prophesies the destiny of plantation slavery system in its master-slave relationship. Hogarth's immediate family becomes his ship 'Sure Salvation' with its crew members and nearly five hundred slaves at the basement of the ship. He is their surrogate father, and all of them form a group family. His ship waits for favorable wind in the Atlantic Ocean to go to the coast of Brazil. It stands still for fifteen days and Hogarth is worried about his profit. 'I cannot afford sickness,' (p. 21), he says to Bullen, and orders him, 'bring them up soon. But see all hands feed first.' (p. 24) By keeping them fit and healthy he dreams golden guineas, as a sheep is fed before sell to the butcher. He enters the date in diary May, 17, 1860. It discloses the fact that his cargo is illegal, because of 1843 Slave Emancipation Act.

Demoralization, and dehumanization of Hogarth make him indifferent to the hygenic condition of the slaves. They are cramped in the hole of the ship. The hole stinks as the door is opened by Reynolds, 'the undulating and animal moans of bewildered protest rose from the hold in

which, stacked and stowed with greatest care, lay the four hundred and seventy five bodies he had discriminately culled along the coast from the Congo to Angola for sale to Brazilian plantations.' (p. 25) All are condemned to die or permitted to live, dispassionately, according to the contribution they have made when the ledgers are being balanced. Dunn, Calder and Dolan, three British seamen, take hold of the ship, Reynolds controls the slaves with his whip and words sweetly poisoned. They have no feelings for them. They treat them like animals. Bruce King comments on the novel, 'set during the illegal slave trade of the 1860's, its themes include the horrors of the middle passage, racial prejudice, the need for tradition, the Africa to the Caribbean black, and the relationship of dispossessed blacks to their sometimes brilliant but amoral new world leaders.'[3]

Hearne has used animal imagery to explain the condition of slaves - rat, bitch, cattle, cat, hyena, litter of mongrel puppies beef, 'we drove them'. (p. 61)'docile animal lay dying'. (p. 24) 'I can keep feedin' 'em; ' There's enough left to bring 'em into the market ... they'll fatten up pretty quick...' (p. 59), 'Kennel of growling dog or the stable of an uncertain horse,' (p. 187) all that indicates the brutality of human nature.

ii) Man - woman relationship : Reynolds and the black slave girl -

The civilized code dictates the man-woman relationship of the white couple on the ship - Hogarth and his wife. On the other hand, the barbaric

instinct is let loose by the civilized whites in their sexual gratification with the black slave girls. Crew members are deprived of sex and this urge, when not fulfilled, turns into anger. It makes them saddistic. Reynolds never tries to hide his lust for sex. He selects a young girl from the second cargo and pacifies it in a sodomic manner. He teaches her to call herself 'a bitch'. The cause of his saddistic behaviour lies in his childhood.

III) Black - Black / White Familial Relationships

These relationships include -

(i) Black Alex's relationship with white Hogarth

(ii) Black Alex's relationship with the black cargo

i) Black Alex's Relationship with white Hogarth -

Black Alex and white Hogarth are mutual exploiters and victims of exploitation. Alex's plan is already ready before he meets Hogarth. he smells his greed as hyna smells the blood. He knows many languages, the two languages of white men- English and Spanish, the language of Bakongo and the Luanda, and the language of other slaves from distant regions. He is expert in persuading a person. He mesmerizes the person with his skill of business and knowledge. He works like a psychotherapist. He gathers the information about Hogarth and his ambition because in those days as Gosh explains , 'The West Indian trader was a familiar figure in English society in the 18th century and the wealth and its source were the talk of the town.'[4]

Hogarth appoints Alex as a Cook of the ship. In fact Alex is the master of the ship. He is really a free man, the master of his own will. He tells Hogarth, 'It's black men sells black men to Standish.... even though he knew he was goin' to get himself killed doin' it, there wouldn't have been no trade.' (p. 164) Alex is more ambitious than Hogarth. He sets the slaves against the crew members, imprisons Hogarth and becomes the master of the ship. The slaves take a brutal revenge by severing the heads of Dunn, Dolan and Reynolds. But the ship is caught by the patrolling guards. Eliza becomes insane. Hogarth is caught under the charges of illegal slave trade. The papers prove that he is the culprit. He scolds Alex for betrayal, but Alex answers, 'Betrayal was here to be taken ... An' you know that's how it's always been an' how it always will be...'. (p. 202)

Alex practices tremendous authority on crew members and the slaves. Calder, Dolan, Dunn hate him but they do not have courage to go against him. He controls the slaves by giving them doses of Afu through meal or water, and they never become violent. He is a tribesman and knows many herbs. Reynolds asks him, 'did you feel no sense of kinship? A twinge of guilt shall we say? Or if nothing so strange as guilt...' .(p. 57) But for Alex he has no kin and no master. His only religion is money. The men like Alex and Hogorth have their hands stained with human blood and their tongue has tasted blood; they become 'man-eaters'. Rhonda Cobham comments on the plantation slavery involving African slave labour as an evil which

'implicated the society even further in a cycle of deformed human relationships which left all parties morally and aesthetically maimed.[5]

ii) Black Alex's Relationship with the Black Cargo -

In black Alex, power and survival the two ends of the goal of existence, are brought together in conflict and mutual illumination. His ambition is to become a king of a tribe and Hogarth is the medium for achieving it . He exploits his colour to tempt the blacks, 'blackmailing' the blacks ! He is a willing black agent who is expert in catching as many slaves as the master wants. By taking control over Tadene, a strong, rebel slave woman from the black cargo of the ship, he causes mutiny on the ship through false promise of freedom to them. The anger of the slaves befalls on the crew members they turn into presecutors. They behead the white crew and hold their heads as trophy. But Alex's dream is detroyed by captain Honeyball of the patrolling ship.

The slaves are displaced from their lands, homes and families. They are deprived of human contact, but they have not lost their hope. Tadene, a clever, mentally and physically strong lady, helps the girl in the captivity of Reynolds. She tells her to eat and keep herself alive. As a tribal woman she has strong faith in her cultural beliefs - she does not want to die on an alien land because those who die, their souls wander without peace. This ruthless world of whites is unknown to her. She thinks that the white men

have no spirits. 'There could be no world without spirits; just at spirits could not exist without the world of men and women and children.'(p.137) Her sister Mtishta is seduced by a white man, and leaves her pregnant. Hence, her anger aganist white man is natural. She decides to help Alex in muntiny. Alex in the clothes of white men is her hope. 'Between the hope of chioce and no choice at all, she will gladly choose hope.'(p.142) She beheads Reynolds and plays with his head, her cruelty is a kind of catharsis.

The black girl remembers her young friend, her home, her men. Reynolds uses her as the sex object. She knows she has not done any sin. Impure body is not the stigma in African culture. On Tadene's advice she keeps herself alive and all of them wait to return to their islands. Their sincere hope rescues them all and they celebrate their freedom. Captain Honeyball provides them all clothes at the time of rescue. Promise fo home lies before them.

John Calder has no family. The vast ocean is his family, his life partner, his companion. He trusts nobody but the untreacherous, honourable sea ! He is old man now. He has trained himself to see the horrible sights but he cannot tolerate the horrible sight of the slaves on Hogarth's ship. Calder is faithful in his work. He has no wish, lives his life aimlessly. He warns all his friends to be careful, but the horrible end is inevitable, as they have all commercialised their souls for economic survival and power. Cut off from family they become ruthless, they fill the vacuume with unregretful

activities. After Alex's mutiny Calder observes the end of all, decides to commit suicide 'Like many of his generation, has refused to learn how to swim -feeling that the swift marriage of death by drowning is infinitely preferable'.(p.218)

Joseph Conrad was the first writer who brought dark side of the man in his novel *The Heart of Darkness* (1969) through white ivory trader and despot Curtz. It highlights the ugliest race for economic power by the great countries like Britain, France, America and Brazil who orphanise the humanity by destroying the core of meaningful relatedness. Hearne's *The Sure Salvation*, written in 1982, probes deeper to study the apparently conflicting roles of the whites and the blacks in the race for economic power. Bruce King rightly comments, 'Although the moneyed basis of European society results in the inhuman treatment of the lower classes and other races, slavery and greed, we are reminded, also exist in Aftrica where blacks capture, enslave and sell other blacks.'[6] Hearne problematizes the very concept of civilization by exposing the lust for power in the trans-racial perspective.

Reference

1. John Hearne, *The Sure Salvation* (London, Boston : Faber and Faber, 1981, this edition-1985).

 (All quotations cited are taken from this edition).

2. Jerry J. Bigner, *Individual and Family Development* (New Jersy : Prentice Hall, Englewood Cliffs, 1983, this edition-1994), p. 7.

3. Bruce King, "Review : John Hearne : *The Sure Salvation*, London Faber and Faber, 1981," *WLWE*, Vol. 21, No. 3, Autumn 1982, p. 656.

4. D. N. Gosh, "Representation of Slavery in English Literature," *Economical and Political Weekly*, Vol. xxxvi, No. 39, Sep. 29, Octo. 5, 2001. p. 679.

5. Rhonda Cobham, "The Background," in *West Indian Literature*, (ed). Bruce King, (London and Basingstoke : The Macmillan Press Ltd. 1979), p. 9.

6. Bruce King, op. cit., p. 657.

(2) *Annie John* (1983)

Jamaica Kincaid was born in St. John's, Antigua. Her highly praised books include the novels - *Annie John, Lucy,* and *The Autobiography of My Mother.* Her story collection is *At the Bottom of the River. A Small Place* is an essay about the island of Antigua. She is a Harvard professor. She lives with her family in Vermont.

George Lamming's *In the Castle of My Skin,* Michael Anthony's *The Year in San Fernando,* and Merle Hodge's *Crick Crack, Monkey* are childhood novels and their background is colonial. Jamaica Kincaid's *Annie John*[1] comes under this category of these novels. But it investigates the growth of Annie in post-colonial Antigua. Francis's family belongs to the poor class in *The Year in San Fernando* and the protogonist has to support his family economically by working as a servant in a white family. Tee in *Crick Crack Monkey* is spared from work through her surrogate mother is compelled to giver her in the custody of her rich aunt. Angel, in Merle Collins's *Angel* is also lucky like Lamming's 'G' and Hodge's Tee. They all belong to single-parent families, where mother is the earning member, and all are matrifocal. Annie John is the only protagonist who belongs to the lower middle class two-parent family. Her father is legally married to her mother. Her relationship with them, particularly with mother, from childhood to late adolescence is investigated under three stages, as a child completely

dependent on parents, as an adolescent and a rebel, and as a girl in her early adulthood.

The two quotations of Jamiaca Kincaid probably offer the basic framework within which Annie John can be interpreted. In one of the interviews, she opines that the mother-daughter relationship in the novel was symbolic of the colonizer - colonized relationship. She says, 'I have come to see that I've worked through the relationship with the mother and the girl to a relationship with Europe and the place I'am from.'[2] In another interview she confesses about her illegitimate status 'within the life of an English person there was always clarity... but within my life and culture was abmiguity ... The thing that I am branded with and the thing that I am denounced for, I now claim as my own. I am illegitimate, I am ambiguous.'[3]

The conflict between the white mother and the black daughter gains the political, social as well as psychological dimensions. On the social level, mother stands for the society's rigorous code of morals and on the psycholoanalytical level, she embodies super ego. The daughter who stands for racial and libidinal energy revolts against the mother to assert its own historical right to choice beyond race, skin-colour, class and culture.

The process of growth of the black girl child Annie involves the process of change in her relationship with the white mother. Their

relationship is shown to pass through three stages -

I) Black daughter's sense of unity with the white mother

II) Black daughter's rebellion against the white mother

III) Black daughter's reconciliation with the white mother

I) Black Daughter's Sense of Unity with the White Mother : Annie's relationship with her mother

The first stage of Annie's growth as a child is marked by an exceptionally strong bond of relationship between the mother and the little daughter. It represents, on the one hand, the earliest stage of colonial history at which the colonized is happy with its colonizer-cum-patron. It represents, on the other hand, the black skin in unity with the white skin because the black believes itself to be non-existent.

Annie's mother is Dominican, French, of mixed blood and therefore white in skin colour as in cultural values, and more British. Annie is Antiguan, black. Her father is a carpenter. For him, Annie, is 'Little Miss'. They have their own house. Annie is the apple of the eye of her parents. She is ten and enjoys Oedipal unity. Annie's mother is a good cook who minds their choices - lady doctor fish for Annie, angel fish for father, and kanya for herself. They take English style heavy breakfast. Dinner they all take together. Annie goes to standard English school. She has uniform, texts and extra books for extra reading. Such facilities are

never available to G and Francis. To take bath together is a kind of ritual - 'Other times it was special bath in which the barks and flowers of many different trees, together with all sorts of oils, were boiled in some large cladron.' (p. 14) Her mother is beautiful, sometimes Annie sniffs her neck, ears, hair. She thinks those are unfortunate who do not have mother. 'I spent the day following my mother around and observing the way she did everything ... How important I felt to be with my mother.' (p. 15)

Annie's mother has treasured Annie's things in a trunk such as white wool booties, baby bottles, photograph of second birthday, first note-book, first straw hat, report cards, certificates of merit and certificate of merit from Sunday school. There is story behind every object she holds in her hand 'tell me a story about myself.' (p. 21) She is engulfed in family happiness and safety. Renu Juneja comments, ' Caribbean dimensions to mothering include social structures which facilitate exceptional bondage between mothers and daughters.'[4]

Annie's father is the example of the Caribbean history and society. When he was a little boy his parents handed him over in the custody of his grandmother and sailed to South America for slaving. His grandmother took every care of him, fed him well and clothed. One day 'she had died lying next to him sometime during the night.' (p. 23) If Annie goes with her mother in the market, they hear an angry voice. She knows that it is one of the women that her father had loved and with whom he had a child

or children and 'who never forgave him for marrying my mother and having me.' (p. 17) Annie's father loves her. He has prepared a separate room for her with a special cot and shelves for his darling 'Little Miss.' He never tries to boss her.

Annie's first experience is of death, Nalda's death, a girl smaller than her. She says, 'Until then, I had not known that children died.' (p. 4). She is eager to know more about this experience. Then whenever she hears knelling sound, 'I visited the funeral parlours or the drawing rooms where the dead were laid out for viewing by the mourners.'(p.9) find out 'G' in *In the Castle of My Skin* is also exposed to the reality of Ma's death as a boy only once. But Annie becomes familiar with death. Roydon Salick comments, 'Through the series of deaths, Annie, emotionally and psychologically, draws closer to these distant figures.'[5] Annie begins to tell the fascinating stories about death to her friends starting with 'that humpbacked girl...' and raises their curiosity. Experience of deaths make her bold and strong in her childhood.

Because of family's support it is possible for Annie to grow with very little restrictions. From childhood she is notorious and has her own style of living even if she respects her parents. She has little fear of anything. She does not hesitate to steal money from mother's purse to buy sweets for her and for a neglected little girl Sonia and enjoy them by sitting

under the tree of schoolyard. Of course, she is punished when tells a lie about Mr. Earl, is their regular fisherman. Gillian Dooley comments that for Annie, 'poverty is not a problem. If anything, Annie is over-protected rather than neglected.'[6]

The Caribbean community is obessessed with the guilt of skin because of planation exploitation by the white masters. They hate white skin and yet there is the mixture of white and black skin in the race of mixed blood. Annie's early awareness of the mother's white hand becomes evident when she tries to win the favour of her mother by showing her the certificate of the best-student she got from Sunday school. She sees her parents making love. For the first time, she notes her mother's fair complexion, 'But her hand! It was white and bony, as if it had long been dead and had been left out in the elements...I could not forget her hand as it looked then.' (p. 30) It makes her so uneasy that she begins to hate her mother.

II) Black Daughter's Rebellion against the White Mother : Annie versus mother

The change in Annie's attitude to her mother from passionate love to passionate hatred signifies her growth from childhood to adolescence. In her case, the apparently normal psychological phenomenon of the adolescent child's rebelliousness against parents assumes symbolic

dimensions. The black girl's hatred for the mother's white skin reveals, on the unconscious level, the novelist's obsession with the white moral norms of legitimacy and the fact of her own illegitimate birth. She, thus, projects Caribbean psyche's inner conflict between guilt and innocence.

Annie starts answering back to her mother. If she asks her : 'Are you going to just stand there doing nothing all day?' ... it caused me to reply, "And what if I do?" and at the same time to stare at her directly in the eyes.' (p. 31) Insult the white colour is the important strategy for Annie to overcome her guilt. Now her parents' conversation does not entertain her. At Sunday afternoon walk, her father tries to hold her hand 'but I pulled myself away from him, doing in such a way that he would think I felt too big for that now.' (p. 32) She has no grudges against her father. But her strange behaviour certainly surprises them. Kay Stockholder refers to Katherine Dalsimer's view of female adolescence 'The critical eye that young adolescents turn to their parents as part of their strategy of withdrawal throws them into paroxysms of self-doubt that alternate with wildly grandiose views of their own abilities.'[7]

Annie's mother is thirty-five years younger than her father. So, naturally, she is dominant. She is victim of the colonial moral norms by which she wants to mould Annie. Her mother's training of young-lady business begins to destroy the harmony between them. She is sent off to

learn one thing and another - to learn good manners, piano lessons, how to live tidy, etc. 'I told my mother a lie - I told her the teacher had found that my manners needed no imporvement, so I needn't come anymore' (p. 28) When mother finds difficult to deal with her, she finally instructs her, 'Of course in your own house you might choose another way' (p. 29) That is the last straw which makes her detached from her mother finally. Jacques Lacan[8] talks about split subjectivity in his book *A Selection* that looking for self-definition outside of oneself, through an essentially imagined other whose defining characteristics the child does not share, leads inevitably to misrecognition as against self-recognition and self-alienation. There is Oedipal conflict between mother and daughter. The dominant mother, all powerful fulfills the role of a castrator. Annie's family ground becomes battlefield, a battle starts against her mother and against herself to caste away the sense of illegitimacy of colour. It is not abnormal.

Annie joins new school for girls. There she impresses her teachers and her classmates by her talent. She surprises them by reading an essay written on mother and her relationship with her which is a lie. 'But the real truth was that I couldn't bear to have any one see how deep in disfavor I was with my mother.' (p. 45) Her mother stands for racial super ego. Annie desires to uproot the guilt of skin from the racial memory through instinctual rebellion against super ego's system of values i.e. mother's. It starts with the experiments, first with Gweneth Joseph, a white classmate.

Annie likes her, 'At the end of the day, Gwen and I were in love, and so we walked home arm in arm together.' (p. 33) It is the sign that she reaches womanhood. Her world becomes different from her parents. Gwen presents her a lavender smelled rock covered in handkerchief which also gets the smell. 'It may have been in that moment that we fell in love ... We separated ourselves from the other girls ... Gwen and I were soon inseparable. If you saw one, you saw the other.' (p. 46) They kiss, they hug, they caress. By that time physical changes rapidly take place in Annie. The fear of menstruation makes her faint in the classroom and tears come into Gwen's eyes. 'Gwen and I vow to love each other always.' (p. 53) Kay Stockholder points out about the behaviour of adolescents, 'confused by the physical changes they perceive but unready to enter the sexual arena, they form intimate relationship with members of their own sex.'[9]

Annie's mother continues to impose her value system on her which suppresses the instinctual. In her value system to be civilized means to reject the sexual dimension of the body. Hence, Annie's rebellion is sexual which includes her efforts to be related to Gwen the white civilized girl on the one hand, and to the Red girl who is coloured uncivilized and raw, on the other. She comes across this untidy Red Girl who is very active, bold and agile. She likes her because she in uncivilized. She learns from her to climb tree and to win marbles in game. They have secret meeting places. She abandons Gwen for her because there is more thrill in the company of

the Red Girl. In spite of mother's warning not to play with that girl, she finds pleasure in flouting her instructions. She hides her marbles in the basement room, where she has already hidden those books which she is forbidden from reading. One day mother finds them. Mother and daughter stand as rivals. As Annie confesses, 'My mother and I each soon grew two faces : one for my father and rest of the world, and one for us when we found ourselves alone with each other.' (p. 87) Annie's anxiety for the forbidden areas of experience grows.

Annie's mother like G's mother is very conscious about her daughter's proper growth. She is very careful about her social norms but she does not suspect Annie seriously for her secret relationships with Gwen and the Red Girl. Soon her interest in the Red Girl reduces as she reaches the middle adolescent period. As Kay Stockholder generalizes, 'The ... middle adolesence awakens their interest in the opposite sex and loosens their ties to the friends of the same sex.'[10] Annie's childhood friend Mineu meets her she shakes hand with him but soon she understands he and his friends make fun of her at once she reduces and turns to home. But her mother misunderstands her and suspects her. As soon as Annie enters When the mother scolds her for the supposed misbehaviour with a boy, the daughter retorts, 'Well, like father like son, like mother like daughter.' (p. 102)

In schools, Annie gets colonial education which trains the students to worship England. She hates this. She exploits the extensive library of their school to read history books. Her interest is in the history of the West Indies. She comes across a large photograph of Columbus with royal dress and gold ornaments. She paints fetters around his legs. (the image and power of Queen Victoria) Annie almost blasphemously describes the image..... Victoria as 'a wrinkled-up woman wearing a crown on her head.' Craig Tapping comments, 'Annie as descendant of slaves and unlike Lamming's school - boys, is very much aware of the truth.'[11] Annie hates to read Milton's 'Paradise Lost', for Caribbeans it is already lost.

On the unconscious level, the daughter desires to destroy the mother and thinks her mohter to be anxious to destroy her. In the dream the adolescent persona argues, 'I would never have the courage with which to kill my mother, ... the chance would pass to her.' (p. 89)

III)Black Daughter's Reconciliation with the White Mother : Annie and mother

Annie's serious illness begins her growth towards maturity after the adolescent phase of wild fantasies. Over three months, she lays in bed because of fever. Even if her parents are beside her taking care' she remembers Ma Chess, her grandmother, an obeah woman, an antic link with the past. She is a rebel woman like her mother who left their ancestral

house to maintain her freedom. Telepathy brings Ma Chess to Annie and, she takes her charge, 'Ma Chess would lie next to me, curled up like a bigger comma, into which I fit.' (p. 126) Her faith in Ma Chess heals her illness. Her illness allows her 'time' for gaining psychological stamina to overcome the sense of guilt for being illegitimate. She reconciles herself with the mother difference of skin, without guilt. She becomes healthy adult.

With healthy outlook and with mature understanding, Annie decides to go for study of nursing to England. Like her grandmother and mother she also rebels for her freedom, Raydon Salick comments, 'Annie in her desire to discover and explore new experiences'[12] sets sail to Barbados, from there to England to regain her lost paradise, to make a new history. She declares, 'I have made a vow never to be fooled again... the road for me now went only in one direction : away from my home, away from my mother, away from my father, away from the everything blue sky.' (pp. 133-134) When she is able to overcome the fear of racial stigma, she is ready to accept the truth with deeper understanding. 'I could not bear to see my mother cry - which started me crying, too ... she said in a voice that racked across my skin.' "It doesn't matter what you do or where you go, I'll always be your mother and this will always be your home." (p. 147)

Annie remembers two fishermen who offer her fish at the time of her illness, Mr. Nigel and Mr. Earl. They have wonderful communion, - they share the boat, the house and even a wife. Annie wants to see such happy commune in future without any prejudice for colour or class, the most creative commune where human relatedness will matter most!

References

1. Jamaica Kincaid, *Annie John* (London : Vintage, 1983), Rpt 1997.

 (All quotations cited are taken from this edition).

2. Allan Vorda, "An Interview with Jamaica Kincaid", *Missicipi Review*, 20, 1 - 3, (1991), p. 12.

3. Kay Bonetti, 'An Interview with Jamaica Kincaid', The *Missouri Review*, 15.2, 1992, p. 129.

4. Renu Juneja, *Caribbean Transactions : West Indian Culture in Literature*, (London and Basingstoke : Macmillan, 1996), p. 35.

5. Roydon Salick, "Sex and Death in West Indian Novel of Adolescence", *Caribbean Quarterly*, Vol. 39, No. 2, June, 1993, p. 4.

6. Gillian Dooley, "Looking Back in Anger : The Transformation of Childhood Memories in Naipaul's *A House for Mr. Biswas* and Jamaica Kincaid's *Annie John*", in *The West Indian Fiction*, (ed.), R. K. Dhawan, (New Delhi : Prestige, 2000), p. 165.

7. Kay Stockholder, "Book Review : Katherine Dalsimer's Female Adolescence : Psychoanalytic Reflections on Works of Literature", *Ariel*, Vol. 8, No. 2, April, 1987, p. 105.

8. Jacques Lacan, *A Selection*, trans. Alan Sheriden (New York : Norton, 1977).

9. Kay Stockholder, op. cit., p. 105.

10. Ibid, p. 105.

11. Craig Tapping, "Children and History in Caribbean Novel : George Lamming's *In the Castle of My Skin* and Jamaica Kincaid's *Annie John*", *Kunapipi*, Vol. xi, No. 2, 1989, p. 56.

12. Roydon Salick, op. cit., p. 4.

(3) *Moses Migrating* (1983)

In the first two novels from the London trilogy, *The Lonely Londoners* (1956) and *Moses Ascending* (1965), Samuel Selvon is obsessed with the devastatingly destructive effect of struggle for survival in a white society on behalf of the colonial emigrant black community. His third novel, *Moses Migrating,*[1] written in 1983, continues his obsession with it. The novel is Selvon's post-colonial perspective of the emigrant community. The exile-psyche is re-colonized, sacrificing in the process its spiritual urge for meaningful relatedness with one's own home. Survival demands the most ridiculous compromises so that living is a farce and the individual, unfit for both worlds the white and the black -, becomes a joker, cursed to the permanent condition of homelessness. Moses condition is clarified by the novelist through three kinds of relationship -

I) Man-woman relationship

 A) Black Moses and Doris, the black girl

 B) Black Moses and Jeannie, the white married woman

II) Surrogate mother - son relationship

III) Native communal family relationship

I) Man - Woman Relationship

A) Black Moses and Doris, the black girl

Selvon introduces the only possibility of meaningful relationship -

of creating a family of his own - for Moses during his stay in the homeland, through his brief relationship wiht Doris, the young orphan girl adopted by his surrogate mother, Tanty Flora. He develops the relationship to its inevitable end of failure in order to reveal how Moses has lost the creative stamina. In losing his urge for a home, Moses discloses how he has come to regard the supremacy of biological urge - sex as a transitory fulfilment of the body. His hypocritic dream of meaningful love-relationship with Doris stands exposed because of the very fact of his lack of guilty conscience in carrying on, simultaneously, his sex adventures with the white woman, Jeannie, the notorious wife of his ex-white servant Bob - the couple accompanying him to the West Indies as tourists.

Moses himself arrives in Trinidad, the land of his childhood, as a tourist. His stay in the best hotel of Trinidad, de-Hilton, indicates his economic status. He has only one relative Tanty Flora, but no friends in Trinidad. He meets Doris, an adopted girl by Tanty who is a self-respected and self - reliant girl in that house at John John hill. He almost falls in love with her at first sight, 'Pot-pouri mixures of races that populate the island the best of the first, Doris remind me of that saying, a thing of beauty is joy forever.'(p.87) For the first time , he feels the real romantic passion of love. He even thinks of a possibility of having a stable relationship with her that can be converted into family. Doris does not believe him as he is the man from industrial city, from metropole. She keeps him away from

her because she knows his intention. He introduces himself as 'an Ambassador of Her Majesty's Service.' She understands his chauvinism and is sure that he is here today gone tomorrow. She warns Tanty as she reports later to Moses, 'I told Tanty she shouldn't worry with you and have any false hopes'(p.89) For her, Moses is fake Trinidadian, Susheila Nasta comments that 'Moses stays in the 'upside-down' world of the Trinidad Hilton - 'a tourist, in other words, in his own country.'[2] Moses provides her information that he is not married. But she retorts, 'I don't care if you married. Why I should care?'(p.90) Moses is relieved when he knows about her boy friend Francis, who is actually after Doris, but whom Doris never pays heed.

Moses goes back to de-Hilton with the thought of true love 'the wonderful sensations and delightful emotions that a decent man in the throes of true love could experience !'(p.95) He even appears to realize the falseness of physical love. Doris reponds to him even if she is not sure about the authenticity of his love. When he expresses his desire to play for Carnival, she accepts his offer to make preparations for his role. She has fondest wish which is 'a secret. Even Tanty don't know.'(p.91) Tanty then tells Moses about Doris's wish to marry a decent man and get out of Trinidad. Moses feels the new emotion of 'Love close to me, feeling as if I was seeing Tanty's Light for the first time.'(p.96) He starts dreaming a country house with hundred acres of land, where he , Tanty and Doris will live happily.

He is aware of his peasant roots. But, even in dream, he wishes to have town house. This time it seems, he is really serious. He telephones Galahad to make arrangement to sell his property in London. He even writes a love verse.

In spite of temporariness of Moses, Doris takes risk of believing him. In hearts of her heart she is of course, sure that he will return to England, but 'hope' is stronger than reality ! When Moses brings her flowers, she is really flattered, 'Nobody ever gave me flowers before, she say, she cover her face with the posy and smell the roses'(p.103) She even prepares his favourite dish calaloo with crabs, buys a bottle of Barbados rum specially for Moses. She gives him hint of marriage, 'no man ever touch me, Moses, let me tell you ! And no man going to either, unless we join together in holy matrimony !'(p.104) She shows her efficiency in making the preparation for Moses' 'mas'. Looking at life on superficial level, Moses fails to understand the feeling of wholeness, togetherness, which honest Doris is ready to offer him. Pamela C. Mordecai points out, 'preoccupation with the absence of a sense of wholeness may well be a response of the male West Indian. '[3] Moses is completely infected by the metropolitan illness of detachment. His 'existentialist dilemma'[4] does not allow him to fathom the depth of love.

There is Doris willing for relationship with Moses, but Moses' love is physical. 'I should be manly and forceful instead of hanging on her

every whim and fancy..... I should give her the old one-two-three and use some Trinidad tactics.'(p.161) For him love business is 'romantic shit'. The day before the Carnival they enjoy Jouvert, the dance to celebrate the emancipation of slavery day, 'the mas.' They feel free and in extreme joy they express their desire to marry. But, significantly, the loud noise swallows their words. Moses might have captured the moment permanently to convert that desire into permanent relationship. But Moses eludes this chance . 'I deflowerd Doris that Jouvert morning in my room at de-Hilton.'(p.166) Doris takes hopeful risk even though she knows, 'You don't love me, Moses, you only want me.'(p.166) He does not desire to take on any responsibility. Eric TabuTeau comments on Moses' notion of exoticism. 'After all, it is well known phenomenon that the feeling of novelty rapidly fades.'[5]

On realizing the truth - that her relationship with Moses can not continue, Doris suddenly becomes neutral. The situation calls for comparison with similar situation in Selvon's another novel, *Those Who Eat the Cascadura*. Doris's negative attitude contrasts with Sarojini's sense of fulfilment of meaningful relationship through sex. Sarojini does not feel helpless though she knows her pregancy. Her strong hope that Garry Johnson will return and they will have a family, sustains her stamina. On the other hand, the very relationship between Moses and Doris is barren. Tanty delivers Doris's message to Moses, "She say she would pretend it

was somebody who masquerade for the Carnival as you" (p.178) Doris dryly bids him good bye and gives him a hard slap on his face to kill mosquito which he actually deserves.

B) Black Moses and Jeannie, the white married woman

Moses has no impulse to resubmerge either in community or in any serious love business. He has been obssessed with the physical Jeannie, Bob's notorious wife, and feels sophisticated to have her because she is white. Moses charts his life within the parametres of biological need of sex and economic success. His sexual adventures on the ship and on the shores of Trinidad sea beach, his contacts with Jeannie are lustful and brief. Her promiscuity is clearly seen in her sexual relationship with Moses, Dominica, Galahad and Lennard. His insensitivity towards every relation compels him to pursue stubbornly the instinctual biological need, where no responsibility, loyalty is needed. Jeanne represents, as Mordecai points out, 'The metropolitan woman, liberated from fecundity by contraceptives released from this responsibility to community.'[6] The critic Fenwick calls such relationship a hideous reflexes of brute survival. 'Jeannie was glad to change partners'(p.160) And Moses advises her sometimes, 'You are too energetic, Jeannie. You should rest your libido sometimes.'(p.123) It is obivious that such superficial relationship cannot sustain.

Moses neglects Brenda even if she is of his own race but Brenda also knows him better. She marries Galahad before they come to Trinidad for Carnival. After that, she is never seen with other man. The relationship between Brenda and Galahad in the beginning is steady and then they form their own family and turn their love into permanent relationship. Brenda has capacity and stamina to sustain her relationship with Galahad. Her positive outlook brings her to the respected position of a wife.

II) Surrogate Mother - Son Relationship

Moses, the orphan child, is adopted by Tanty Flora, the poor woman living in the slums of Trinidad. Moses cannot have home though 'home' is there in Trinidad in the form of Tanty Flora. In the first meeting with Tanty Flora, Moses offers her money which she refuses. Tanty, who represents the West Indian community, tells him to recall the lullaby she used to sing for him in his childhood. He cannot, but she remembers every moment, of how she has raised orphan Moses. She gives him clue and he remembers, 'how she used to sit down in a old rocking chair and put me in her lap and rock me to sleep.' (p.64) Tanty is not rich in economic sense but her rootedness, her loyalty towards her community is remarkable. Moses is unwilling to prolong his first visit with her in market place because; 'out here by the Savannah I lose my identity and become prey to incidents and accidents.' (p.65)

Moses remembers his childhood days when Tanty Flora has inculcated some good morals in him. She is resourceful. She has made him capable to survive in the hostile world. He confesses, 'It was childless Tanty Flora, living alone, who took me under her wing and gave me the name Moses.'(p.61) She is riped old age. In the hut of John John hill Moses enjoyed 'rolling a hoop or bicycle wheel without the tyre, climbing mango trees and thiefing fruit in season.'(p.86) Tanty gives him mauby and his favourite dishes, and brings back his childhood days. Moses has no intention to live in Trinidad with Doris or with Tanty. He is unable to grasp the resourcefulness of his community. He always remains alien even in his own land. Tanty rightly says to him, 'You don't sound Trinidadian to me no more'(p.66) Susheila Nasta points out, 'we become aware of the impossibility for Moses of forming an organic relationship either with his own community or the white world outside.'[7] He is now perfect metropolitan man who can not breathe a fresh air of his islands.

III)Native Communal Family Relationship

In *The Lonely Londoners* and Moses *Ascending,* Selvon embeds Moses in the emigrant, communal family of London. Here, Selvon chooses device of Moses' participation in the Carnival, because as he himself explains in the preface, to the novel, the Carnival is most appropriate due to its characteristics of 'mimcry, the convolutions of irony and satire, the

ambivalences.....'[8] Moses' performance as a Queen of England for Carnival is the height of his chauvinism. To explain the cultural importance of carnival he wants to play the tune of 'rule Britannia' by making himself a joker. His idea of 'playing mas' by performing the role of 'Black Britannia' by wearing the costume which is lent by Bob and Jeannie, his white slaves turns into absurdly comic scene. Moses, the worldly black Londoner, is reduced to a buffoon by himself. John Thieme comments, 'Moses is portrayed ironically as a thorough-going Anglophile, anxious at all times to defend his adopted country against "black ingrates" and to bolster its rather tarnished image in the contemporary Caribbean.'[9] He wins first prize in masquerade.

By playing a comic role, Moses proves himself a clown in the masquerade in Carnival which is regarded as parody. As Thieme puts it, 'Moses seems both to be satirised for his misplaced British chauvinism and viewed sympathetically for his comic individualism.'[10] Moses writes for his role in Carnival, but he fails also as a writer. He migrates once again from his own islands to England. It is his third migration and final conveyed comically to mask the tragedy of the miscerable man.

References

1. Sam Selvon, *Moses Migrating,* (Washington D.C. : Three Continents Press, 1983, this edition 1992).

 (All quotations cited are taken from this edition).

2. Susheila Nasta, "Samuel Selvon : Prolific ! Popular !", (The article included in *Moses Migrating*), (Washington D. C. : Three Continents Press, 1992), p. 187.

3. Pamela C. Mordecai, "The West Indian Male Sensibility in Search of Itself : Some Comments on *Nor Any Country, The Mimic Men,* and *The Secret Ladder," WLWE,* Vol. 21, No. 3, Autumn, 1982, p. 630.

4. Ibid, p. 631.

5. Eric TabuTeau, "Love in Black and White : A Comparative Study of Samuel Selvon and Frantz Fenon," *Commonwealth* Col.16, No.2, Summer 1993, p. 91.

6. Pamela C. Mordeeai, op.cit., p. 641.

7. Susheila Nasta, op.cit., p. 186.

8. Samuel Selvon, "A Special Preface by Moses Alotta Esq.", in *Moses Migrating,* (Washington D. C. : Three Continents Press, 1992), p. xii.

9. John Thieme, "Rule Britania? Sam Selvon, *Moses Migrating,* Harlow : Longman, 1983," *The Literary Criterion,* Vol. xx, No. 1, p. 254.

10. Ibid, p.257.

(4) *Angel* (1987)

Merle Collins, a Grenadian, teaches Caribbean literature and Creative Writing at the University of Maryland. She is the author of the novel, *The Colour of Forgetting*, and the collection of short stories, *Rain Darling*. As a poet, she has published work in a number of anthologies and in her own collections, *Because the Dawn Breaks*, *Rotten Pomerack*, and *Butterfly*, an audio collection.

Angel[1], the sustained autobiographical narrativization of the personal history of the novelist herself, comes most significantly, as a powerful historicization of the crucial role of 'family' in the Caribbean society. The protagonist of the novel is not Angel but her family which embodies the history of three generations of Ma Ettie the grandmother, Doodsie the mother, and Angel the daughter. The novel evolves Doodsie's meaningful relationship with its individual members on the one hand, and to its community, on the other.

The history of Doodsie's family covers three stages of its struggle -

I) The family's struggle for bare economic survival,

II) The family's struggle to train the children,

III) and the family's participation in the newly liberated country's struggle for political stability.

They are identified with the three stages of Angel's growth - as a child, as a young girl and as an adult. They are also associated with three stages of the country's political history- the period of faith in the new government, the period of doubt against its leader, followed by the revolt against, and dismissal of the government.

I) The family's struggle for bare economic survival

During the first stage of its life-cycle, Doodsie's family encounters the economic crisis which threatens its survival. As a labouring class family living on the wages through work on cocoa fields, it is thrown into chaos when the labourers go on strike demanding increase in wages from the landowners. In anger they burn cocoa plantations. Angel is just a baby watching the fire from Doodsie's shoulder. Under such circumstances the mother has to work very hard to support her family. She runs a grocery shop and cultivates the land, which is a great support for her - 'Thank God for the little piece of family land and dis my mother you see dey. At least we could still get two grain o bluggoe an some nutmeg'(p.9), she says to cousin Maymay. Doodsie's mother has given her a spot of land, a part of the family plot. She and cousin Maymay harvest the plot of cocoa for the boss i.e. landlord for one shilling and sixpence a day. Doodsie is unmarried, living with Allan and has four children from him. Cocoa prices fall and landlords reduce the labour force. For all these reasons she has to

work hard. As strike goes on, Allan has no work and she thinks about Angel. 'Let me see her go through school properly an make something of herself. Lord, just spare me, let me see her grow up in proper family'(p.8) In all this hectic struggle for survival, she never forgets responsibility towards her mother, Ma. Ettie. Cousin Maymay takes care of their neighbour Paren Comesee, as his leg gives him trouble and he cannot walk. Everybody is ready to help him at any time. Community thinks that it is their responsibility to look after such people, old, sick, lonely. It illustrates, according to John Stewart how, 'fiction documents and stores social strategies and values that are integral to the nature of social process.'[2] At the time of crisis, their relatedness is a source of stregth.

Strike continues and Allan decides to go to Florida for work. Doodsie has to give him permission. Florida, a place in America, is very expensive to stay. He could manage to send her only a little money. His hope rests on his new born son, Simon, who from childhood is very weak and asthematic. But he wants to make him a good cricketer like himself. He writes to Martin, his friend, to look after the family in his absence. Carry over the responsibility is the unspoken bond in Grenadian community. Doodsie has to work in the house of white lady to pacify the hunger of her children. The white lady never trusts her and she often checks her bag when she leaves her house.

In Allan's absence the mother has gone through the turmoil,- children, are malnurished, she herself is not well. Doctor advises her to take milk and eat good food. She feels, ' the tears of shame I will ask him where the hell I must get the money.'(p.48) But cousin Maymay feeds the children; Mano sends her milk; aunt Thomasina manages to send her few cents or few grains of jacks or anything she likes; Paren Comesee sends a bunch of figs and assures her, 'never turn you back on family whatever happen.'(p.49) Her survival is possible only because of her faithful community - their communal family. Their network of help is unspoken. There is strong bond of love and affection between men and women. Doodsie is thankful to her community which, 'Still, is family. If family, an if wasn for them ah might of been dead this day.'(p.49)

The relationship between the family and the community, with its structure of an extended family is reciprocal. She is always ready to help others in need. At the time of hurricane the houses are washed away. Even Ma Ettie's house is completely destroyed. Doodsie brings her in her house in spite of her refusal. Her house is rather strong because it is 'wall house.' She also gives shelter to her own relatives and neighbours. She assures them and tries to provide them whatever she has. She gives instructions,

'Look, Miss Cousins, you could wrap up de three littlest ones in dis an put deem over by Angel an de oders in de corner dey, half way under de bed. Dey protected dey. Allan, move de pail a little over !'

'Dry dat little one head, she dripping still. Bad how it is,don let er ketch kol.'

'Miss Cousins, look in dat bag near de trunk in de small room. It have some more beddin.'(pp.39-40)

Doodsie is anxious about Ma Ettie. Her house where she has brought up her five children is now nowhere. Her first child was carried away to work at Panama. Her house holds the history of slave past and her twenty years' stay. She refuses to move from that place. Doodsie is worried for her. The internet of the community relationships is very powerful. Angel witnesses all that in her childhood. She gets communal lessons from her mother. As Maria Helena Lima puts it : '*Angel* points to a social model of self, a self that exists in relationship, a self that is a product of all the dicourses, that the growing child incorporates as she develops.'[3]

II) The family's struggle to train its children

The family enters the second ambitious stage of its career when its financial condition improves because Allan returns from America with money. Its urge to train the children for better future shapes the mother-daughter relationship. Doodsie is very strong mother like G's mother in *In the Castle of My Skin* who is very particular about his education and proper upbringing. She is also careful to train the girl in household work. She has two sets of rules - one for Simon because he is a boy and one for Angel. She

wakes up Angel early to sweep the house. Angel thinks it an injustice. She says, ' Simon won wake up, Mammie,' '..... Leave im Simon is man. You is little girl. You say you prayers say it an come here an help me.'(p.97) She thinks that religious training is also needed for girls. She teaches her how to protect herself particularly from the boy's naughty behaviour. She wants to make her strong like herself, a fighting woman. When a vagabond boy Tommy tries to molest her Angel shouts in such a way that he has to make a quick move. On it her mother's reaction is deadly. With a cutlass in her hand, she warns Tommy if he does it again she will cut him into pieces. Angel can protect herself and her brother on her own. When they return from the school, vagabonds block their road and start asking for Simon's slate. With one hand, she holds Simon. With another hand in her bag she roars like a tigress, 'Touch im you see how ah mash up you face'Angel pulled out her slate, pulled away the frame and held it like a huge square cutlass A hand flashed out.'(p.63) Doodsie inculcates the qualities like protest, resistance and self-respect in Angel which train her for the role as a political activist.

Angel, even as a child, understands that her father does injustice to her mother. Allan has a woman, called Geraldine, from whom he has children and there is always fight over her between Doodsie and Allan. When, on one occassion, he beats her Simon shouts at him standing between them and tells Allan to leave her alone and go out. Both of them are

startled 'by the sight of Angel in the doorway, the hammer held tightly in her hand as she stared with intense hatred at her father.'(p.90) If time comes she knows, it is her turn to protect her mother.

'Doodsie's family is under the impact of colonial culture. She invests all her interest in Angel's education, as it is the only solution to attain status in the society. Inspite of her poverty she decides to give her full scope, 'she go get de bes if even ah have to scrub floor to give er. She won be like me.'(p.101) She feels proud when the girl wins the scholarship. But schooling does adverse effect on little Angel. She feels ashamed of her unglamorous mother. Her kitchen looks shabby compared to that of English people in book. 'Angel felt resentful . . . she noticed how the girls who had long ponytails, fair skins and no cousins rolled up around their heads.laughed a lot and looked pretty and confident in the streets. - - - Angel felt sorry for herself.'(p.114) She starts hating her black skin and kinky hair. She requests her mother to straighten her hair. When she attends college in Jamaica, her friend tells her that all these things are part of her separate identity. They have a picture of smiling Christ in the drawing room. For family he is the 'Saviour.' Ngugi Wa Thiong'o comments that for a new generation 'Imperialism and colonialism became sanctified by Christian grace and all this seems to point in one direction : subservience and acceptance.'[4]

Church refuses aunt Ezra to become the godmother of Angel because she is Anglican, but aunt Ezra is determined - 'In reality Ezra would be Nen-nen, Tantie, everything. Would help see Angel through life if anything happened. No church had to tell Ezra what was her duty to Angel.'(p.19) Nen-nen or Tantie means chief godmother. The church takes objection to the name 'Angel' because angels are always white and she is black. The idea of 'black angel' is unsuitable for conditioned people. But there is difference between actual practice of the community and the theo- retical ideology of the church. The child is named 'Angel' by her family.

Angel's growth takes place on the communal and school background. She enjoys the world of fantasy by reading fictions. At the time of exam, she prays Jesus to pass her in all subjects. West Indian history bores her. She 'had failed in West Indian history.'(p.123) Lack of interest in one's own history is the result of having 'unquestionably, a feeling of inferiority, both personal and racial.'[5] According to Lamming. After the result she stops worshipping Jesus. Under the guidance of her rebel friend, Janice, Angel slowly grows with reality. She tells Angel, 'My mudder tell me take in de education but don forget what real life is all about.'(p.120) Angel admires her because she has capacity to confront danger and is ready to face the consequences. In her Latin translation book, she writes. 'Latin is a language

As dead as dead can be !

It killed the Ancient Roman

But it won't kill me !'(p.121)

She spends whole day with Janice flouting the discipline of parents and, in turn, receives the beating by belt from her father but she never gives in. The disastrous impact of colonial education on the young minds is studied by Craig Tapping[6] in the comparison between young G from In The Castle of my Skin and young Annie John. Angel is one more victim of that impact.

Angel after her high school education wants to work to help herself without bothering her parents anymore. She gets a service as a teacher in Catholic primary school. 'She guided the young ones in distinguishing, right from wrong and in the rudiments of religious knowledge.'(p.125) For one year she manages to save money, gets a small government loan and decides to go to Jamaica for university education. Mother does not stop her. She advises her, 'Take the chance ah never get Don let no chance pass you. Education is everything in dis day. Ah willin, Try you best.'(pp.124-125) She stands like a rock behind her. Doodsie signifies her community, and has capacity to recieve positive change.

University education is a great help for Angel to grow in a proper direction with complete understanding. She joins sociology classes. She gets opportunity to understand Caribbean sensitivity. The students want

to bring forth the issue at public attention of Jamaica and Jamaican government, because it is regional institution and government can not be without the support of the students. First, she wants to keep herself away from such activities. But soon, she realizes the necessity when she hears Edward's argument that "We have to live in the society and we live in a capitalist society. But we know it don benefit de majority that we're on our way to reaping benefits that the woman who came in to eat our left-overs are not likely to see.'(p.155) His plea to forget the individual benefit and think about the masses who suffer injustice, makes her aware of the losses of her grandmother and mother. She feels their burden. Students start the group called "Search" to improve their knowledge about their own culture and surrounding. Collins uses the rhetoric of Black Power of Walter Rodney and fictionalizes the 'Africa Night' of November 1968. She uses historical parallels. Soon the group of Angel is formed which includes Helen, Elizabeth, Kai, Joy Edward and a Jamaican. They begin to collect information about cultural aspects such as folk art, songs dance and dress. The proud acceptance of her black identity begins on behalf of Angel with Aaron's advice not to use iron comb to straighten the hair, ' Stop pressin it, watch it break an look bad for a while, and then your natural hard beautiful hair will come through.'(p.152) She writes to Janice 'I've just begun to grow up I believe I was just beginning to learn.'(p.166)

Angel's development to adulthood is marked by her friendship with Kai. They are at the same wavelength. Together they enjoy plays, rasta drawings, poetry reading and political discussions. But there is not intimate sex relationship between them. Collins avoids giving emphasis on body. She does not evolve their relationship in full details in the novel. It is vague and ambiguous. Next time, Angel meets him in America. Through letters they keep themselevs related.

III) The family's participation in the country's struggle for political stability

Doodsie's family, above all, participates in the country's struggle for political stability. Their urge to help the emergent nation is expressed through -

1) Regal and Angel dedicating themselves to politics,

2) the mature political consciousness of the women of the family and

3) the actual participation of women of the family in important political activities.

Doodsie is intellectually capable to assess the political leaders. She writes to Ezra her sister, in London, who works as a maid in white man's family. She comments on their political leader 'Leader' Community believes in his political coup because he is one of them, black, 'the country need a

shake up like this, even though I know the kine of person leader isThere is a lot of violence that startin up. I know we need a change but not in this way'(pp.6-7) It means she is politically aware too. She has got breathing space for survival. Her intellectual development is possible because of education. It marks surely progressive development from colonial to post-colonial period. After winning the election, Leader, who constantly emphasized the rights of men, now sits in the company of the landlords. Dooesie writes to Ezra, 'With the election he become big man in Greneda and some of these very same paymaster kind of people is senators and now when the people get squeeze by the paymaster there is no one to turn to because he Leader is in whisky company with them.'(p.52) She can articulate her thoughts, observations in a very well manner. Maria Lima comments about letters, 'The epistolary validates creole as a written language, and the letters ultimately serve to represent the unity of the Caribbean peoples in diaspora. They ultimately help to perceive them not only as an extended family, but as constituting a Caribbean community.'[7] Regal is the top man of Leader's active union, and always talks about rights of estate workers. Doodsie warns him, 'Ah hear you was part o de group dat set fire to dose people plantation. Ah not makin noise. Jus as a sister ah tellin you. Don follow dat man lead too close, you know.'(p.13) She disapproves flashiness of Leader and his grand marriage in Aruba. The women folk hate violence and instability, they want peace. But at the same

time, Doodsie suggests the need of fighting against injustice to women labourers. She points out that the women work as hard as men but still get low wages. She knows the country needs a shake up like this so she accepts the leadership of the black Leader, 'Well is to look on the bright side'(p.7) as she writes to Ezra. Even there is a big photo hung on the wall in Doodsie's house. All women participate in the rallies for justice to the labourers called by Leader. Soon Regal comes to know how corrupt the Leader is ! He arranges one programme of dance and song to raise the fund for the union but Leader snatches all the money he has collected and reminds him that people have given it on his name and calls him a joker. Heavy gold ring in the middle finger of Leader glitters. Regal is shocked by the betrayal. He feels as if 'somebody walk in over my grave.'(p.54) Still people elect him as their speaker in the parliament of Grenada and hope for the change. But Doodsie has rightly understood his 'big thief organisation' and 'his whisky company.' Then people realise to the truth that no change will come. Leader betrays them like Mr. Slime in *In the Castle of My Skin*. Angel devotes herself to political activities when she realises the necessity of revolting aganist the corrupt Leader. Her earlier sense of lack of interest in politics is now substituted by a sense of commitment towards a political cause. She joins the service of the teacher. She contests the election of teachers' union. She wants to bring change through education and, as a beginning, she thinks it essential to introduce curriculum which

will prepare students for future. The students ask her questions about what happens in U.S.A, about this revolution and that. It is really hopeful sign for Angel that they are curious.

The first change Angel brings in her house is the replacement of the photo of Leader by that of rasta boy. She asks her mother, why even if she knows that he is a fraud, do they allow that photo in the house. Doodsie answers in proverb, 'But you have to learn to swallow vinegar an pretend is honey.'(p.190) Mother tongue as Kenneth Ramchand pinpoints, is 'always the natural expression of the whole society.'[8]

In order to give justice to her community Angel joins the communist party of Chief. They form the society, named Horizon, because there is still unrest between the labourers and the land owners. The real need of change is the thought given by her family members. Her mother and aunt Ezra tell their experience of dirty treatment by the whites. A white young boy, where aunt Ezra worked slapped her calling her 'blackie'. In turn, Ezra slapped him. She tells Angel, 'you got to defend yourself. Fight back.'(p.205) Doodsie's genuine question is why they have to celebrate Queen's birthday even after independence. Chief's Horizon becomes active. Angel's brother Rupert and Carl also join the party. They oppose Leader's oppressing power and take out a rally on Union House in opposition of the present government of Grenada. All men and women participate in

it. Aunt Maise shouts slogans and they parade with song -

> "We will always let our leaders fall !
>
> When dy treat us de worst of all !"
>
> When they treat us
>
> Like shit an all !" (pp.212-213)

They sing the songs of Carnival bands which Leader had banned from the streets the year before. People cover themselves completely in black grease and paint and clatter through the streets with cans, pans, horns celebrating ironically as their African ancestors 'had celebrated emancipation, parading the blackness that gave so much fear and making sure it left its mark on anything white.'(p.212) In turn, the Rabis Gang of Leader begins to threaten the poeple and they wage a war against the Horizon group . He openly starts provoking people for violence and government has to interfere but still he continues violence. Horizon brings out his fraud after fraud and makes him leave the country. 'We slay de dragon wit we bare hands !'(p.231) The success rally is taken out again led by Melda, a woman, who leads the group chanting :

> 'Ah want to hear my African drumming
>
> Give me my African chant.'(p.231)

Angel refuses to disclose the secret activities of their revolution. But Doodsie and Carl, on behalf of community, want to know because, from their point of view, the revolution is theirs. They are aware of Chief's wrong business. According to Doodsie it is community's right to know what is going on. She demands, 'If day party ha to do wid we revolution, den we suppose to know bout it ! - An what we sayin now is leggo Chief!' (p.259) According to her, Angel should have complete faith in her community. She always suggests 'let we speak in one voice' to her. No revolution can take place in isolation. Immature understanding brings fall to their revolution. The rumour of Chief's arrest causes unrest. Then they hear the American troops come to control the revolution. under the excuse of liberating Grenada from the communist power. According to Collins it is a myth that America wants to liberate Grenada. Taking arms, Angel fights with American troops and loses her right eye in bomb blast.

Political awareness activates the women and they give full support to revolution. They manage to make history. Failure does not matter for them. As Maria Lima makes it clear, 'The words and actions of Angel's brothers help us see that it is not only from a female perspective that totalitarian structures can be recongnized.'[9]

The abundant use of Creole language in the novel by Merle Collins is a political act of asserting the status of her country as a free nation - free

also from the compulsions of using the imperialist's language for narrating the history of her family and community. A. Owen Aldridge comments, 'cultural anthropology considers the concepts of Linguistic concern the structure of language the language of sociology and investigate the basic areas of sociological inquiry,including the family, class, religion, and collective behaviour.'[10] Ma Ettie's story-telling and their every day conversation is in Creole language, it is part of building a new nation. Creole culture substitutes colonial language. It is part of community's process of emergence as a new nation and Creole language fulfils all purposes of communication. The titles of the chapters are in Creole. Doodsie uses creole proverbs and idioms and they convey the right message. For example - 'One han caan clap !', 'You never get more dan you can handle,' 'Empty crocus bag caan stan up,' 'Make sure you not livin on nobody eyelash so dat when dey wink you fall !' 'Keep an eye out for de rain if you know you have clothes outside', 'Make de most of you young days Dey won come back again.' 'Not all wag-tail is promise not to bite.' The pure creole words like 'Bon Je'(Good God), 'Chile'(child), 'chabin' (fair skinned), 'Po djab o" (poor devil), 'poupa(father), maman(mother), 'wi' (yes), give the natural flavour of the conversation. Angel comes to know the beauty of her language when she becomes a teacher. She speaks with them in creole, she tells the students, 'we learn English, but it isn't better than our own language.'(p.236) They resist, they defend; they exchange - all purposes are satisfied through creole

language. It is nativization of colonial language i.e English. Creole language becomes the weapon to defeat the pressure of colonizer. According to Miles Richardson, 'Language itself is a vocal gesture that arouses in me the attitude it arouses in you. When a vocal gesture evokes the same response in a speaker that it evokes in the person spoken to, the gesture becomes a significant symbol. In other words, it becomes a name.'[11]

The process of political liberation includes the process of social liberation as evidenced in the history of Doodsie's family. The family covers three stages of the social history of women in Grenada - the earliest stage of matrilineal family, the colonial stage of patriarchal family and the post-liberation stage of equality of status between men and women. Ma Ettie belongs to matrilineal family whereas Doodsie, her daughter, belongs to partiarchal family. Even if Doodsie and Allan earn for family, Allan holds the authority of the house. Doodsie has built the house on the piece of land given by her mother. Ma Ettie and she 'built the house on the spot with money they had both saved up. Allan went to see about the registration. He put it in his name.' (p.9) and he argues that what is hers is his too. Doodsie protests weakly. She falls prey to his emotional blackmailing.

Courage and boldness are the qualities Angel inherits from her mother. When, as a grown - up girl, she advises mother not to be very submissive, it indicates her feminist approach. But for family's sake Doodsie

tolerates Allan's nonsense though she refuses to surrender completely before his power. She maintains her individulity. Allan accepts Angel's suggestion to treat the mother as an equal in the end. Angel is successful in liberating her parents from its trap. But as a young girl, she is herself is the victim of that imperialistic ideology when she is in the convent school in 'Legion of Mary.' Under the impact of Catholic teachings as an adolescent girl, she starts believing whatever her Mother Superior tells her. She learns that living together without marriage is a mortal sin, and if Catholic marries in non-catholic church then it is also no marriage and that the person and the whole family lives in sin until there is a confession and repentance and a real marriage in a catholic church. Hence, she is anxious to see her parents officially married. They laugh. Her family observes religious practice like their community but they never surrender to it completely.

Angel comes back from America after her operation. She has already informed her mother of Kai, whom she may marry. Doodsie's strength surprises her, and her readiness to accept the possible failure of the revolution to bring change. She still hopes for the better future through staying related. She expresses the need of unity 'Let's hold together' is her motto. Angel's mother is the hub of the revolution. She gives the right direction to her daughter. Angel is also aware of her shortcomings' her fault to misjudge her community which is her real strength. With this new

awareness she plans for the next revolution on the strong backing of her mother. With the adult understanding of her community, Angel lights the candle of hope before the picture of Christ. She listens to Doodsie's example of chicken which knows instinctively how to protect themselves from hawk, 'Don run when they try to frighten you stay together an dey caan get nun !'(p.289) Suddenly it brings realization on the part of Angel that the relatedness, togetherness is the real power.

Merle Collins's *Angel* represents the process of evolution of a society, newly liberated, and emerging as a stable nation. Its feminist interpretation may marginalize the central theme where a community is undergoing pangs of self-reliance to be delivered into a new community. The picture, on the front cover, of mother and child signifies the core family unit of the Caribbean society. The network of relationships is built around it. Angel is, thus, the most vehement justification of the social institution of family which locates the human urge for meaningful survival.

References

1. Merle Collins, *Angel* (London : Seal Press, 1987, this edition 1988).

 (All quotations cited are taken from this edition).

2. John Stewart, "The Literary Work as Cultural Document : A Caribbean Case," in *Literature and Anthropology*, (ed.), Philip A. Dennis and Wendell Aycock, (Lubbock : Texas Tech University Press, 1989), p. 101.

3. Maria Helena Lima, 'Revolutionary Developments : Michelle Ciff's "No Telephone to Heaven" and Merle Collins' "Angel" ', *Ariel*, Vol. 24, No. 2, April, 1993, p. 45.

4. Ngugi Wa Thiong'o, "George Lamming's *In the Castle of My Skin*", in *Critics on Caribbean Literature*, (ed.), Edward Baugh, (London : George Allen and Unwin, 1978), pp. 48-49.

5. George Lamming, *The Pleasures of Exile*, (London, New York : Allison and Busby, 1984), p. 31.

6. Craig Tapping, "Children and History in the Caribbean Novel George Lamming's *In the Castle of My Skin* and Jamaica Kincaid's *Annie John*", *Kunapipi*, Vol. xi, No. 2, 1989.

7. Maria Helena Lima, op.cit., pp. 47-48.

8. Kenneth Ramchand, *The West Indian Novel and Its Background*, (London : Faber and Faber, 1970), p. 81.

9. Maria Helena Lima, op. cit., p. 51.

10. A. Owen Aldridge, "The Study of Man", in *Literature and Anthropology*, op.cit., p. 43.

11. Miles Richard, "Point of View in Anthropological Discourse", in *Literature and Anthropology*, op. cit., p. 35.

(5) *The Enigma of Arrival* (1987)

The exile novel's like *The Lonely Londoners, Moses Ascending, Water with Berries* and *Moses Migrating* concentrate on the crucial problem of survival of the minority black community in the majority white society mainly from the black perspective. *The Enigma of Arrival,*[1] written in 1987 by V. S. Naipaul, avails itself of the maximum potential of exile experience to comprehend the integrational nature of white and black perspectives to arrive at the truth about human condition.

Even in the process of evolution of Naipaul as an artist, *The Enigma of Arrival* marks an important stage. It is, apparently, an episodic narrative of his memories of 30 years' life in England. Notably enough, Naipaul could not write his memories earlier though he often planned to do so. As the novel proves, it symbolizes the stage at which the artist-persona has, at last, been able to integrate the fragments of his understanding of the Caribbean situation into holistic realization of the human condition.

Naipaul derives the title, 'The Enigma of Arrival' from the surrealist painting of Giorgio de Chirico. As an artist Chirico also experienced exile in many places like Munich, Florence, Rome and Paris. He was Italian from Volos in Greece. According to Walker, 'The influence of these peripatetic wanderings can be seen in the mixture of allusions evident in his early paintings : many contain references to figures from Greek mythology and

Philosophy.'[2] Chirico's painting comes as a revelation to Naipaul because it aptly conveys his deeper and mature understanding of reality, which was constant enigma for him. Chirico 'was concerned more with the psychological and philosophical implications of the intertwining of fragments of the past in the present.'[3] Correspondingly, Naipaul's novel swings between past and present, birth and death. He covers the span of nearly thirty years in the novel and arrives at mature understanding in the end.

'Family' emerges as the most significant structural device through which the novelist activates the process of artist - persona's realization of himself as the colonized, and as a human race. The persona, located in the neighbourhood of rural England, is introduced in the role of an observer. He subjectivizes the history of a number of British families residing in the vicinity so that they become a microcosm of British socio-economic history. The families are deliberately microscoped during their humble phase of economic depression which complicates their struggle for meaningful relatedness as families. The phase mirrors the Caribbean history of economic exploitation.

The choice of families in the novel is representative of different economic classes. They can be classified as follows -

I) The lowest class - it is represented through five families -

 i) The agricultural family

 ii) Dairyman's family

 iii) Gardener /laundry van driver's family

 iv) Driver's family

 v) Farm worker's family

II) The middle class - The family of the manager of the estate

III) The upper class - The landlord's family

IV) The colonized as a class

The Enigma of Arrival is the fusion of fiction and autobiography. He lives the lives of other characters on fictional level whereas his personal experiences go parallel with fiction. V. S. Naipaul personally accepts the merger of two genres.

The Enigma of Arrival is a story of a young Indian from the Crown colony of Trinidad who arrives in post-imperial England. He lives in a part of the rural England over thirty years as a writer-journlist, 'As a curious and sensitive human being he bioscopes the landscape and the minds of the people and creates a meaningful relatedness with all of them on imaginary level. His relationship begins with himself as an isolated individual, which later develops from single person family to extended family. He probes into enigmatic lives of every character he meets and builds his/her personality. His interiorization of them reveals the enigma of human history to the artist-persona.

The young writer-journalist Naipaul arrives in Wiltshire manor with biased mind and with the guilt of skin complexion. They are the days of rainy season when he arrives, the atmosphere is almost like 'a womb'. It is the enigmatic child's arrival in the new world, curious and mysterious- 'I remembered the mist, the four days of rain and mist that hid my surroundings from me.'(pp.11-12) He feels almost like a new-born child anxious to find the answers to the riddles. Without disclosing his identity he observes his environment and like a sponge his mind absorbs meticulously the details of everything. James C. Pierson comments, 'One implication is that fictional detectives are potentially useful sources of information about the various groups of people'[4]

As an outsider, writer's first need is to create relationship with 'landscape which is his immediate family. 'I was able to think of the flat wet fields with the ditches as 'water meadows' or 'wet meadows', and the low smooth hills in the background, beyond the river, a 'downs'.(p.11) The river is called Avon. He notices everything and is moved by the beauty of trees and flowers, the early sunny light, vegetation and foliage of trees. The name of the village is Waldenshaw. 'I knew that 'avon'originally meant only river, both 'walden' and 'shaw' meant wood apart from the fairytale feel of the snow and the rabbits, I thought I saw a forest.'(pp.12-13) The deer, the young pines, the cattle , the pasture all accompany him. Like an elder family member he worries about the safety of deer and rabbits

as Salisbury Plain is military area where mock warfare practices take place. They live in constant threat of death. But to his astonishment they continue to survive against all odds. 'Their survival gives him new meaning of life. His immediate family brings solace in his seclusion.

I) The Lowest class

i) Agricultural Family - Jack and His Father-in-law

Through 'Jack's Garden' Naipaul learns and comprehends the true meaning of life through decay, death and rebirth. Jack becomes the first human member of his imaginary family. His garden symbolizes the universal garden, unlike Eden where writer feels like Adam arriving from heaven to earth for the first time and trying to know the meaning of his arrival. David . P. Lichtenstein points out, 'Naipaul's foils signify his struggle to unify man and writer, to achieve both unfiltered experience and the creative, interpretative power of granting meaning.'[5]

Jack is the expert gardener. He is completely absorbed in his work. Between the ruins and scraps of the agricultural machinery he grows his garden. He grows seasonal flowers. The narrator-persona finds the 'man in tune with the seasons and his landscape - .'(p.33) He has noticed his pointed grey beard, sees him from distance. He is in his late forties. Jack has his own world of plants, flowers soil and decay. He cultivates his own secret piece of land with complete zeal. Renu Juneja states, 'We see Naipaul now

making this landscape his own through intimate knowledge.'[6] Whenever he sees Naipaul he greets him with a waving hand, the only communication between them, but it is enough to understand his mood. Jack is solidly rooted in his earth, has created his own life. Jack is not a permanent fixture, nor is he a crumbling relic of some past time. In the face of ruin, surrounded by evidence of decay and death, Jack is able to recognize the death motif and make it work positively for him. 'All around him was ruin; But he had sensed that life and man were the true mysteries - - -something like religion.'(p.87) He has created his own life, his own world, almost his own continent. The world he enjoys and uses, is too precious for him. Jack teaches new meaning of life to the writer. Creativity of Jack and nature are linked with his own creativity.

The narrator meets Jack's father-in-law,old with absurd bend as though his back has been created to carry the loads. To feed cheecks and work in the garden is his routine. The artist-persona associates the old man with the decay of the garden. The decay of the leaves and plants creates the healthy manure for new saplings' healthy growth.

Day before Jack's death, he enjoys the Christmas Eve with his friends 'to have final sweetness of life as he knew it That final trip to the pub served no cause except that of life, yet he made it appear an act of heroism, poetical.'(p.48) He welcomes death as inevitable as he welcomes seasons, the change. Roseanne Brunton remarks, 'Jack's garden symbolizes the

successful dimension of the death motif.'[7] Writer-persona, who is afraid

of the decay and death, now understands the reality of death, the enigma of

death. Life continues in spite of that reality. Jack's wife soon gets married

to another man. That does not surprise him.

ii) Agricultural Family - Dairyman and His Children

Writer persona's family on imaginary level extends with the arrival

of dairyman's family. The members, with their dry and impassionate

behaviour, always remain detached from others. They feel happy to torture

their horse who is blind in one eye. His sight is so pathetic that writer wishes

his death. To his great relief, the horse dies and family also moves for good.

But Bray, the taxi driver, tells him the secret of Peter, one of the cruel sons of

the dairyman, that the child was vey good at birds. Behind cruelty there is

soft heart too. Writer knows that, reality is always different, to probe into

its core is essential, otherwise misinterpretation is inevitable.

iii) Gardener/laundry Van Driver's Family - Pitton and his cottage

Pitton, once in military, always wears camouflaged dress. He

maintains his dignity through it so that even Tom, writer's friend, thinks

him as a landlord. He is also a good gardener. There is a system in his work.

He brings everything into order with his hard labour, the agricultural

cottage, the garden shed,the manor grounds. 'He needed the other idea

that he had, the country-gentleman idea.'(p.224) Because of his

temperament, he has no friends. Writer soon becomes his friend. Without any invitation writer goes to his house before Christmas with a bottle of whisky to strengthen the friendship. The inside show of the house reveals his real status, his poor struggle to show himself as an economically stable man. 'I discovered now that he was hurt by his poverty, ashamed of it.'(p.227) Within one look the writer understands his whole secret life. He is soon relieved from his work. Then writer finds him more friendly. His economic survival continues. He becomes laundry van driver. Writer understands that like him white people are vulnerable too. Pitton cannot accept death. His energy is wasted in formality, design and dignity. Brunton rightly points out, 'but he fails to keep back the encroaching disintegratioon. Unlike Jack he does not recognize the virtue in the attempt itself.'[8]

iv) Driver's Family - Bray, His Wife and the Stranger Lady

Bray is another human species, the car-hire man, who loves his freedom. He is a rough contry man, a perfect driver and expects the same from his employers. He owns his own land and a house. He has queer way of behaviour but loves birds, 'His talk about birds and their habits seemed to come from his childhood.'(p.39) His compassion for a stranger lady brings his personal relationship into quandary. His love for that lady comes to an end after wife's threatening. He loves his freedom, because of his childhood

exploitation as a servant. Mrs. Bray is very dedicated to her husband. She answers in cheerful little voice the telephone calls of Bray when he is out and makes the booking for him. She has full knowledge of Bray's second woman who has inculcated the seed of religion in Bray. The religious fancies of Bray, according to Mrs. Bray, will surely ruin their life, because he is more inclined to charity. She decides to inform about his relationship to the union of taxi drivers. She is sure that they will seize his licence, but in reality she does not want any harm to come to Bray. The stranger woman goes back ot her home. Their brief relationship changes Bray. Her depature brings relief to Mrs.Bray.

v) Farm Worker's Family - Leslie and Brenda

Writer observes the changes around him. The effect of industrial revolution brings the change even in Wiltshire manor. Everything is replaced - first the agricultural instruments, then machine replaces man. This rapid change affects personal life of Brenda and Leslie. She is modern lady who threatens the sexuality of men. Leslie is particular about washing his hair every morning because he does not want to sleep on it when they are wet. 'This news about the washing of the hair suggested a lonelier and more desperate man' (p.73) Brenda is too much for him. When he fails to satisfy her she runs away with Michael Allen, a central heating contractor, to Italy, but soon realizes her mistake. She leaves message for Leslie with

Mrs. Philips but the woman delibarately delivers it after four days, just to have her sense of thrill. After her return, she provokes him and Leslie murders her. According to Christine Crowle, 'The drama of Brenda's adultery has a great deal to do with her husband's sexual insecurity.'[9] There is another side of Brenda's behaviour. She is conditioned by her mother to hate poverty. Economic instability in her family brings frustration and despair. It shows to the writer-persona how the struggle for economic survival is universal and does not allow to form meaningful relationships.

II) Middle Class : The Family of the Manager of the Estate - Mr. and Mrs. Philips

Mr. and Mrs. Philips are compelled to praise their whimsical landlord for economic survival. They are obsessed with insecurity of their job. Mr. Philips is the manager of the estate, very shrewd in maintaining his masterly distance from the ordinary men. This attitude is clearly seen when he calls Pitton 'Fred' in authoritative tone. Mrs. Philips is interested in gossip, the habit of higher middle-class. She likes sensation. She keeps herself informed about the private life of others. Particularly she is interested in their conflicts. Philipses always try to maintain their social status and their distinctness. Behind the mask there is always the threat of instability. Stephen Casmier generalizes the problem in his statement, 'This fear of extinction, of invisibility, is also the driving force behindthe

European and metropolitan centre.'[10] Mr. Philips dies suddenly of heart attack and Mrs. Philips has to leave th place. Before she leaves, she reveals her secret to the writer, 'I thought I'd let you know before the gossip reaches you, Stan and I agreed on that. Who ever remained should marry again.'(p.304) The first time writer understands the strain in the relationship of husband and wife. Writer informs himself that exile is inevitable in everybody's life.

III) The Upper Class : The Landlord and His Distant Relative, Alan

Landlord strategically maintains his imperial glory. He delibarately remains a secluded and mysterious man, anxious to enjoy his past authority. Writer has glimpses of him, and finds him old and suffering from accadia. For writer, it is the pathetic sight of past glory. The relationship between exploiter-exploited, colonizer-colonized, oppressor, oppressed is dissolved when he sees his landlord. He sympatzes with him. The landlord sends poems written on Shiva and Krishna to him. They are actually trash. Landlords old age signifies the decaying order of the empire. Renu Juneja comments, 'for all his syhmpathy for landlord's feelings, Naipaul is vigilant of the oppostion, of all that separates the landlord and the tenant. The empire links them but it also lies between them.'[11] His special love for ivy, the parasitical plant which kills the trees, surprises the writer. The man sends Pitton to bring flowers from the market impatient of waiting for those

flowers which Pitton grows in the garden. Writer does not dare to comment on the landlors's poetry or fiction, because it enables him, as Fawzia Mustafa discloses, 'to heavily invest his own parable with something resembling self-parody.'[12] Landlord's hollow imperial authority is vainly active in ordering the servant not to remove the ivy because it looks beautiful.

Alan is the distant relative of the landlord as hollow as the old man. His pompous behaviour and living style indicate his hollowness. He has no talent for writing but tries to show it by writing reviews. His false pride about himself turns him into a drunkard who soon dies. His death brings relief to the landlord and Mr. and Mrs. Philips. For writer 'one could never touch the true person.'(p.264) Alan never adds 'mister' while calling Mr. Philips, and calls him sometimes as 'Stan' only. He maintains the gap of the status between them. Writer observes how colonizer is colonized himself in Alan.

IV) The Colonized as a Class : The Writer - Persona's Familial Past

The way, the writer- persona identifies himself with different families clarifies how he establishes his relationship with his family on the personal level as well as with his history and his race. The writer-persona does it by linking himself with past events to cope with present reality. He joins the alien present with the lived past. In the chapter 'The Journey' he experiences once again the enigma of the middle passage. The journey

becomes for him the substitute for the mature social experience - the deepening knowledge of the society, which his background and the nature of his life had denied him. It is Naipaul's second arrival. He has the glimpses of GalaNight on the ship where men and women enjoy freely. A black man as he notes, refuses to share the compartment with him. Journey back to England is important for him in order 'to find myself in tune with a landscape in a way that I had never been in Trinidad or India (both sources different kinds of pain).'(p.157) As a writer the journey is essential for knowledge, about himself. 'I defined myself the worlds I contained within myself, the worlds I lived in...... ' (p.135) As Renu Juneja interprets, 'He, too, claims to achieve a new palteau of insight To explicate the trope of arrival the narrator is no longer a shipwrecked colonial.'[13]

Some of the incidents link Naipaul to the past. The hills of Salisbury remind him of Himalaya, Jack's geese fulfils his childhood desire to see them in reality. Pitton's struggle to hide his poverty reminds him of his poverty during childhood, 'when remote, richer branches came to visit us, how strong the instinct with us was to boast to show off to pretend that we were richer - we didn't boast with people who were as poor as ourselves.'(p.227) He remembers the abuse of the colour, race ,status through the childhood abuse of Bray 'I lived easily the different ideas of authority presented by our Hindu family and then, above that, the racial-colonial system of our agricultural colony.'(p.221) It reminds of the flogging

of the children as a ritual in Tulsi family in *A House for Mr. Biswas.*

Landlord's love for ivy and his imperial cruel attitude remind him of the plantation slavery. Sugarcane like ivy destroys natural wealth and the respect of human being as a human being. He wants to send his landlord as an indentured labourer on the false promise of return and the ownership of the land- 'Sugar-cane covered the land. Sugar - cane the old slave crop sugar-cane explained the poor Indian style houses and roughly thached huts...... .'(p.203) Jack's personal garden reminds him of the plot where his father grows vegetables and other crops. The sweet sugar cane squeezes all the sweetness of the life. As Helen Hayward points out, 'Naipaul turns to the consideration of his own position as an observer, his personal odyssey, and how he has arrived at the point of which the work begins'[14] He feels each generation goes from the world of sanctity. Men need history, it helps them to have an idea of who they are.

In the last chapter 'The Ceremony of Farewell,'the writer-persona returns to Trinidad for the funeral of his sister Sati. At the time of ceremony, he finds that educated son and the husband of Sati believe in rebirth. They ask the pundit, "will she come back?" Sati's husband asked, 'will we be together again?' The pundit said, "But you wouldn't know it is her."(p.314) He is astonished to see their faith in old rites. Their wish gives sanctity to the occasion. He returns to England with new vision, the complete

understanding of life. 'It showed me if and man as the mystery, the true religion of men, the grief and the glory. And that was when faced with real death, and with the new wonder about men.'(p.318) His final arrival after the enigma is visionary. He has encountered the deaths of those whom he has valued. As Shashi Kamra puts it, ' It is nature's laws of dying and rejuvenation, as the seasons change, that awaken in him the existential understanding.'[15] He knows now 'self' is cultural too. He links himself with culture with deeper understanding.

The experiences empower the writer-persona to respond positively. His urge to be related expands his members of the family, it becomes universal, global family. Now he truly arrives 'home.' It is the fulfilment of meaningful relatedness. He goes beyond everything petty. He is ready to accept his own past, ready to link himself with racial past. It begins from the loss of 'home' as a race to discovery of 'home' as a human being. 'Home' is network of relationships spacial and temporal. His urge to define himself is fulfilled. With new insight, he understands that home is a state of mind, a sense of being at home with past, present and future. Naipaul, in his other novels, concentrates on the individual struggle. In *The Enigma of Arrival*, his approach is holistic, collective.

References

1. V. S. Naipaul, *The Enigma of Arrival* (London : Penguin Books, 1987).

 (All the quotations cited are taken from this edition).

2. W. John Walker, "Unsettling the Sign : V. S. Naipaul's *The Enigma of Arrival*", *The Journal of Commonwealth Literature*, Vol. xxxii, No. 2, 1997, p. 71.

3. Elizabeth Cowling and Jennifer Mundy, *On Classic Ground : Picasso, Le'ger, de Chirico and the New Classicism 1910-1930*, (London : Tate Gallery, 1990), p. 71.

4. James C. Pierson, "Mystery Literature and Ethnography : Fictional Detectives as Anthropologist," in *Literature and Anthropology*, (eds.), Philip A. Dennis and Wendell Aycock, (Lubbock, Texas : Texas Tech Uni. Press, 1989), p. 16.

5. David P. Lichtenstein, "Naipaul's Foils : Part Two of the Double and the Centre ," *Internet* : http/165.107.211.206/past/Caribbean/themes/double 2 html., 2001.

6. Renu Juneja, *Caribbean Transactions : West Indian Culture in Literature*, (London and Basingstoke : Maemillan Caribbean, 1996), p. 159.

7. Roseanne Brunton, "The Death Motif in V. S. Naipaul's The Enigma of Arrival : The Fusion of Autobiography and Novel as the Enigma of Life-and -Death," *WLWE*, Vol., 29, No. 2, Autumn, 1989, p. 77.

8. Ibid, p. 78.

9. Christine Crowle, "V. S. Naipaul, *The Enigma of Arrival* and the Unbearable Body," *New Literature Review*, 30, Winter, 1995, p. 109.

10. Stephen Casmier, "Black Narcissus : Representation, Reproduction, Repetition and Seeing Yourself in V. S. Naipaul's *A House for Mr. Biswas* and *The Enigma of Arrival*,' *Commonwealth*, Vol. 18, No. 1, Autumn, 1995, p. 93.

11. Renu Juneja, op.cit., p. 160.

12. Fawzia Mustafa, *V. S Naipaul*, (Great Britain : Cambridge Uni. Press, 1995), p. 173.

13. Renu Juneja, op.cit., p. 157.

14. Shashi Kamra, *The Novels of V. S. Naipaul*, (New Delhi : Prestige, 1990), p. 171.

15. Helen Hayward, "Tradition, Innovation, and the Representation of England in V. S. Naipaul's *The Enigma of Arrival*," *The Journal of Commonwealth Literature*, Vol. xxxii, No. 2, 1997, p. 56.

Conclusion

The Sure Salvation by John Hearne reassesses the traumatic phase of slave past of the Caribbean history centred in the transfer of the black slaves in a slave ship by the white slave traders from their own country to an alien land. The ship changes into a temporary family which discloses the cross-racial tensions of their relationship. In *Annie John*, Jamaica Kincaid centrestages mother-daughter relationship to experiment with the crucial challenge of meaningful relatedness between the whites and the blacks from the racial, historical, and psychological perspectives. *Moses Migrating* of Samuel Selvon delineates the farcical existence of the black community under the magnetic influence of the white culture, unable to form a meaningful relationship and hence suffering from a sense of homelessness. Merle Collins's *Angel* is a powerful historization of the role of "family" in the newly liberated country's political history, as well as, in the individual's history of growth. In *The Enigma of Arrival*, Naipaul exploits the maximum potential of "family" as a source of establishing meaningful relationship with his own past - a relationship based on the knowledge that both the colonizer and the colonized are subject to nature's law of decay, death and birth of new life.

CHAPTER SEVEN

CONCLUSIONS

The efforts to comprehend the Caribbean phenomenon in and outside literature have been, mainly, identity-oriented. However, identity-oriented approach appears to have proved inadequate in scanning the enigmatic nature of the particular phenomenon - probably due to the definition of the concept of 'identity' based on the experience of ethnocentric, homogeneous and stable societies. It emphasizes difference rather than sameness or togetherness. In the Caribbean context, the struggle for identity is , in essence, a struggle for meaningful relatedness, or the sameness with others as human beings, within a society compelled by history into racial and cultural hybridization on the one hand, and social, economic and political stratification, on the other.

The racial history of dispossession of ancestral homes, and a denial of family life for plantation slave, and , later, for indentured labourers offers special significance to the institution of family in Caribbean social history. Hence, the study of individual and family relationship as explored in the Caribbean novels of the four decades (1950s to 1980s) contributes valuably to the comprehension of the Caribbean phenomenon.

The study of individual and family relationship in the Caribbean Novel needs definition of two important contexts, the psychological and

sociological in general, and the specific Caribbean sociological context in particular. According to the psychologists, 'family' is one of the most pervasive influences on an individual's development from childhood to early adulthood. Sociologists find 'marriage' as the foundation of family in a stable society. Sociologist, Jerry Bigner, thinks that family evokes love, care, physical and psychological nurturance and, protects an individual from the hostile world. The different types of families include - neuclear, extended, one - parent family, blended family etc.

The exceptional nature of the Caribbean political and social history foregrounds the need of understanding 'family' in the Caribbean sociological context. The long period of slavery, introduced by European sugarcane field owners in the West Indies, has influenced the Caribbean family pattern. African labourers were exported to the West Indies through slave trade. Marriage or family unit was not allowed to them as plantation slaves. Fathers remained shadowy figures. Thus, emphasis was given upon mother and child relationship. After the 1834 Emancipation Act, indentured labour system was introduced by the plantation owners. In spite of the European cultural norms of marriage and legitimacy the plantation slave system and indentured labour system resulted in racial hybridity and essentialised the flexibility of the family pattern. Illegitimate children are, hence no stigma in Caribbean society.

The novels of the fifties focus on the economic, social and psychological consequences of colonization through the strategic treatment of individual and family relationship. The novels in this group include Edgar Mittelholzer's *A Morning at the Office* (1950), George Lamming's *In the Castle of My Skin* (1953), Roger Mais's *Brother Man* (1954), Samuel Selvon's *The Lonely Londoners* (1956), and V. S. Naipaul's *The Mystic Masseur* (1957).

Mittelholzer's *A Morning* narrates the routine of the office in Port of Spain, Trinidad, one brief morning between four minutes to seven and lunch time. The office is a workplace family in itself, and becomes with its colonial, urban, educated middle class mileu, a microcosm of the West Indian society. Entrenched in body's affiliated meanings - body as skin and body's need for survival in economic terms - the individuals in Mittelholzer's novel are hectically engaged in the strategies of superiority - inferiority as defence mechanism.

Mr. Murrain, the Englishman is the head. His work place family includes in its members - the black office boy and the hero Horace Xavier, apart from other male-female members, the mulattos, the blacks, the East Indian and the members of the mixed blood. They clash and compromise, indulge in the antagonism, and celebrate the victory as perpetrators of humiliations while being humiliated themselves by others. The racial heterogeneity and the stratification of the family background generates

racial, and economic tensions for individuals in the office. However, in spite of them, the body's urge for sexual contact and love relationship offers the only opportunity to overcome the man - made barriers. Mittleholzer offers a hopeful future of integrated cultures through his ideal lovers Bisnauth, an East Indian girl, and Arthur.

Lamming's *In the Castle* focuses on the mother and son relationship. The setting is rural Barbados, the colony of the Britishers. This novel is a daring experiment in autobiographical and childhood fiction where the story of G's - the hero's - growth from childhood to early adulthood is historically recreated to visualize the colonial society's evolution from self-ignorance to self-knowledge. The history of G's growth accentuates the relation between G and his mother while the history of the village focuses the communal family relationship between the white landlord and the rural community.

The variety of signified circles of meaning emanate from mother-son relation in the novel. In the absence of family support, G's mother is both wage earner and nurturer. The economic dimension dominates mother's attitude to her son. As a colonial mother she is anxious to educate her son as education appears to be the only means to asertain his stable future. She works hard to pay for his tution and enables him to win the scholarship, thus providing him the opportunity of further education. The

rare opportunity of high school education, however, introduces him to the superior world but alienates him from his own people. The mother's limited knowledge cannot provide him political insight which is provided by G's friend, Trumper and his godfather Pa, the oldest figure of the village. G is a helpless witness to the tragedy of displacement of his people from their own land due to the conspiracy of the white landowner Mr. Creighton and the black elite Mr. Slime, who betrays his own people. The mother succeeds in developing G into a mature adult who is now anxious to define his enviornment and his role in it. He is armed with the creative stamina to experiment with an alternative definition of "my people" which may include both whites and blacks - the humanity free from exploiter -exploited relationship.

Roger Mais's *Brother Man* projects the conflict between body's urge and mind's urge through familial relationships within colonial urban slum community. The characters like Girlie and Papacita, Cordelia and her husband, Jasmina and Shine try to seek fulfilment through body. John Power alias Brother Man is a spiritual man and has unusual healing power which wins him respect as a spiritual father of the community. His firm belief in spritual life results in his lack of response to Minette, the prostitute, he resques. The murder of a white couple by a fake Rastaman ignites the community against him. Their violent attack awakens awareness of the body in Brother Man. He realizes cathartically the vital need of Minette;

responds to her as a lover and thus becomes a normal human being. He understands how there should be a proper reconciliation of the spiritual and the sexual urges both being complementary and not mutually exclusive.

Samuel Selvon's *The Lonely Londoners* is the first of his trilogy of London or exile novels. It narrates the tragic story of the black exiled minority's struggle for survival in a white society of the so-called Mother country for the colonials. They try to get the feeling of relatedness through sex to overcome the humiliation as blacks. Some of their sex relationships are nominal, some meaningful yet transitory. The exiled black youths try to form a communal family with the senior countryman Moses as their friend, philosopher and guide. Their search for surrogate family relationship is satisfied by Moses. His economic help, his psychological support and his room brings solace to the helpless exiles. Moses' room becomes the 'home' for all. Weekly gathering takes place as a ritual and confessions are given to him . It is the first stage of Moses as an exile. Selvon investigates the corruption and degeneration of Caribbean psyche because of oppressive alien enviornment through further evolution of Moses in the next two novels Moses Asecending and Moses Migrating.

V. S. Naipaul's *The Mystic Masseur* has colonial, rural-urban setting. It is the story of an East Indian community which is represented by Ganesh and Leela. According to Naipaul, Caribbean situation does not allow any

dignity. Naipaul graphs the career of Ganesh from bare economic survival to achievement of economic and political power. In the beginning, Ganesh's struggle for economic survival as a teacher and as a massager proves failure. His marriage with the daughter of Ramlogan, the shopkeeper, is exploited by him for economic purpose. He manages to get from his father-in-law a house and a handsome amount. Leela, his educated wife, contributes to her husband's first commercial success as a mystic masseur. He, then, exploits his image for political power. He is finally successful in being the member of the British parliament - changing his name to Mr. G. R. Muir, Esq. M.B.E. He is thus the victim of imperialist western culture and becomes a mimic man by completely sacrificing his own identity. In spite of strong Indian family background, Ganesh and Leela treat family only as a money - making machine. Ganesh and Ramlogan relationship repeats the colonizer -colonized pattern. The family sacrifies opportunity for meaningful relatedness for their excessive greed of money.

The novels, representing the sixties decade, differ in their deeper exploration of individual and family relationship. They include V. S. Naipaul's *A House for Mr.Biswas* (1961), Wilson Harris's *The Eye of the Scarecrow* (1965), Michael Anthony's *The Year in San Fernando* (1965), Samuel Selvon's *Moses Ascending* (1965), and Jean Rhys's *Wide Sargasso Sea* (1966).

Naipaul's A House is an epic narrative. The autobiographical novel covers the protagonist Mr. Mohun Biswas's struggle to conserve his individuality and to relate himself meaningfully with his family members. Naipaul portrays his career from birth to death. Here, Naipaul experiments with the possibility, however small, of struggling for meaning on behalf of the society compelled into strategies for economic sturvival. It is projected in the novel through three roles of Biswas - 1) as a son in his parents' family, 2) as a son-in-law in his mother-in- law's joint family, and 3) as a father in his own familial house. He faces harsh treatment from his own relatives after the death of his father. Poverty forces him, his mother, his sister and his brothers to disperse to different relatives for survival. His education, as an East Indian Brahmin and his skill as a sign painter, bring him into the feudal system of Tulsi family. He is trapped into marrying Shama, by the rich lady, Mrs. Tulsi, her mother. Undemocratic system of Tulsi joint family gives animal status to its members. The work and food are provided according to hierarchical and economic status in Hanuman House. Mrs. Tulsi, her sons Owad and Shekhar, and her brother-in-law Seth, hold the highest authority in the family. In spite of their pride as Hindus, children take English education. The family observes Christmas and Easter.

Mr. Biswas rebels aganist the system. The promise of separate house and business is postponed by Mrs. Tulsi and Mr. Seth . His rebellion as a poor, jobless dependent son-in-law of the family consists of absurd verbal

and physical methods of insulting the top family members. He is at last, offered a separate house and shop at Chase. He attempts to build his house twice in vain, but he never gives up. He remains a visiting father for his own children in Hanuman House. His wife, Shama, who is trained in Tulsi feudal system always humiliates him for his poor status and his dependency on Tulsi family. He is, however, successful in getting an independent job in Sentinel news paper as a reporter. He is able to build his own house at Sikkim Street. His wife and four children come to live with him. He gives the sense of dignity and independence to Shama. He dies peacefully in his own house. His house symbolizes 'home' as a meaningfully related unit of the members of the family. It stands for self-respect, independence and significant identity of Mohum Biswas. By that time, Tulsi family structure collapses due to the quarrels for property among the members.

Mr.Biswas's life-long struggle to gain dignity as the son-in-law of Mrs.Tulsi family allegorizes the colonized society's struggle against the powers of exploitation. The novelist foregrounds to Mr.Biswas's positive struggle to relate himself meaningfully against the negative background of Tulsi family. His marginal success in building the house reveals Naipaul's belief in the possibility of future for Caribbean society.

Wilson Harris's visionary novel, *The Eye of the Scarecrow*, is a concretization of his metaphysical vision. 'Scarecrow' stands for actual,

dead or static reality, and the 'eye' signifies the capacity to grasp inner reality. Harris tries to overcome the obsession with the past, relating it on the inner level, to the past of other nations so that the particular past is universalized. He chooses diary writing for the method of narration which enables him to bring past, present and future on the same plateau. Geographical and historical realities authenticate the inner drama. The novel swings between two realities - the outer and the inner -represented by, apparently, two independent persons - the Narrator and his so - called childhood friend, L -. L - stands for scientific, dead approach to reality; the Narrator for the spiritual, living approach to it.

In the first part of the novel 'The Visionary Company', Harris offers the framework of nature for visionary interpretation. The historical facts are reorganized through the image of 'family'. His grandfather signifies plantation slavery, the Narrator's father, colonial past and the Narrator stands for the present. The second part 'Genesis', gives Biblical reference to the origin of birth - it is an inner journey in search of the origin of human race. If the first part, emphasizes the separateness of the identities of L - and the Narrator, the second part opens a way to their sameness. They are revealed as brothers, the father of L - being the lover of the Narrator's mother. In this part, L - undertakes the expedition to find out the lost city in the bed of a Demerara river, for his scientific project of excavation for gold. On the metaphysical level, it is the search for inner truth. At the end of the

second part, the novelist significantly introduces Hebra, the prostitute, who is supposed to guide the two friends towards the lost city.

The third part of the novel, 'The Raven's Head' projects the most crucial phase of the inner journey. It is the name of the lost city. The search for the real city or the authentic inner reality is difficult because of the existence of another legendary city - the outer inauthetic reality. The Narrator and L - cannot reach the inner truth unless they get the most important knowledge of the sexual reality. Both rape Hebra. The woman's roles as a mother, a wife, a beloved merge into her basic identity as sexual being. L - and the Narrator, as sex partners of Hebra, share the act of creation - merging the male into the female. L - accepts the limitedness of his traditional or scientific mode of thinking. L - kills Hebra, before that they rape her, death-singifying the liberation from the traditional interpretation of the role of the female as whore. In the end, four dimensional reality is presented by the writer as a city with four gates. 'Hebra's Gate' notes biological reality. 'Suspension Bridge' stands for the capacity to go from actual to the inner vision. 'Sorrow Hill' indicates suffering as a part of the process of understanding reality on universal level, and 'Raven's Head,' which is another image of 'scarecrow', signifies ageless truth about spirit. Family relationships are narrowed down in the final stage to single male-female relationship which is again narrowed down to single principle of Creation, the ultimate universal reality the 'Womb' of the mother.

The setting of Michael Anthony's *The Year in San Fernando* is colonial-partly rural and partly urban. The writer recreaters his own one year experience as servant -companion of an English landlady in Port of Spain, through the child, Francis. The novel moves between two kinds of families representing two cultures - one the rural, working class and black, and another, the urban upper class and white. Francis and the other children enjoy childhood under the kind care of Ma as inhabitants of Mayaro village. Their close familial bonds are a great solace and source of strength for the members to bear the pangs of poverty. Mr. Chandles who works in forest office in Mayaro, offers opportunity to Ma to send her son, Francis, as a servant companion for his mother, Mrs. Chandles, at San Fernando. The mother accepts Mr. Chandles' proposal to ease the economic problem and to exploit the opportunity for her son's education. It becomes difficult for Francis to adjust with the new atmosphere and the big house of Mrs. Chandles. He establishes relationship with nature and the surrounding, and then successfully makes friends with the angry, disciplined, old Mrs. Chandles.

The narrativization of Francis's experiences in Mrs. Chandles' house, facilitates comparison between mother-son relationship in two cultures. Mr. Chandles' relationship with his mother is based purely on economic self-interest. Francis senses the hollowness of their relationship and finds his own culture superior. His mother is salt of the earth who

supports her family with a smilling face in spite of hard work. The death of Mrs. Chandles is accepted by Francis as her release from the family's tragedy. It marks his growth towards adolescence.

The traumatic experience of humiliation as a black in the white society of London compels Moses to search for an alternative strategy for survival as an exile in Samuel Selvon's *Moses Ascending*. He now struggles to establish his economic identity to join a possible status of equality with the whites. Even if he is black, he purchases a dilapidated house at Shepherd's Bush. He appoints Bob, a white man, as his servant to allot the rooms on rent, prepare food, and look after household work. The illusory power relationship of the black master with the white servant changes into disillusionment on realization of Bob's betrayal in sheltering illegal emigrants in the house by charging extra money from them. But economic interest unites the two. Moses' moral degradation begins. For economic power, Moses allows illegal emigrants himself. I Ie avoids contact with his own people - his communal family - Brenda and Galahad, who work for Black Movement. They entrap him as a rich man into the membership. Further, his sexual adventure with Bob's wife, Jeannie, brings him from his top penthouse to the basement inverting the illusory black master - white servant relationship. Moses ascends economically but descends morally. In his fanatic struggle to be like the whites, Moses is comically reduced to a non-entity incapable to be meaningfully related either

to the blacks or the whites.

In Jean Rhys's *Wide Sargasso Sea*, the traumatic condition of uprootedness of white ex-plantation owners community finds its most apt expression in the individual's relationship with the family. The novel narrates the tragedy of a creole white girl, Antoinette, covering her life from childhood to her premature death. The child suffers from a sense of homelessness in her own family because of her lonely, widow mother's (Anette's) preoccupation with her own problem of economic and social survival in black majority community, and because of her anxiety for her invalid son. Antoinette's search for home on the unconscious level is compensated by the discovery of a surrogate mother in the form of their black maid servant, Christophine. The mother's marriage with a perfect English white patriarch, Mr. Mason, offers a temporary respite for the mother and daughter only to be ended in their house being burnt by the black community, and death of the brother, on account of Mason's humiliating treatment to the blacks. The shock sends the mother into insanity, and, later into a victim of black sex appetite.

The daughter, a burden for the stepfather, is dismissed in marriage to an English Rochester - an exile in the West Indies in search of economic security. He is easily blackmailed by Mr. Mason into marriage in exchange of a large amount of money. Antoinette's marriage offers her illusory home. But her stepbrother's revengeful disclosure of the family history of madness

to Rochester results in Rochester's distrust and insecurity with the wife. The girl's helpless efforts to be meaningfully related to her husband through the obeah treatment of her surrogate black mother end disastrously in her insanity. Rochester refuses the advice of Christophine to settle some amount for the girl to enable her to live by herself. He prefers crookedly to carry the insane wife with him back to England to dump her in Thornfield Hill. Antoinette, the victim of patriarchal and racial revenge, alienated from her home and the homeland beyond the 'wide Surgasso Sea', at last, burns Rochester's house in the unconscious desire for liberation from the physical and psychic prison, and commits suicide.

Jean Rhys transforms in the novel, Charlott Bronte's *Jane Ayre*, into a metaphor for Caribbean situation. Antoinette represents ex-colonizer Caribbean psyche exploited by the white master, who himself suffers from insecurity. Rhys affirms, through the relationship between Antoinette and Christophine, her faith in the creative future for the racially stratified Caribbean society, with the whites and the blacks overcoming the historical guilt of skin and being integrated into positive human relationships. The feminists interpret the insane Antoinette's act of burning Rochester's house as a successful revolt against the patriarchal power. However, the act appears to be, more significantly, an attempt to possess - on the level of dream - the home for which she yearned throughout her life.

The novels of the seventies provide valuable means for assessing cross -racial and cross-cultural possibilities for meaningful relatedness in the form of individual and family relationship. They include Merle Hodge's *Crick Crack, Monkey* (1970), George Lamming's *Water with Berries* (1971), Samuel Selvon's *Those Who Eat the Cascadura* (1972), and V. S. Naipaul's *Guerrillas* (1975).

Merle Hodge's *Crick Crack, Monkey* reveals the growth of the protagonist, Tee, in rural and urban Trinidad. She is exposed to peasant rural family of Tantie with other adopted children, and urban upper middle-class family of Aunt Beatrice. The novelist floodlights the living content of the peasant culture by scanning the negative impact of the dead content of the metropolitan culture on the girl during the process of her growth from childhood to early adulthood. In spite of Tantie's anger against Beatrice's hypocritic superiority complex, she accepts her proposal of taking Tee (and, her brother) into her family for training her to be 'a lady'.

The novel foregrounds the vivacity of Tee's childhood home with its informal, public, collective and intensely passionate participation of family experience by its members as contrasted with the formality, privacy, coolness and sophistication of the members of Aunt Beatrice's family. The process of Tee's growth is the process of her gradual alienation from her authentic culture which is also a process of acceptance of the so-called

superior culture. Aunt Beatrice's systematic training of the little girl in the middle-class Europeanized value system victimizes the girl to its infulence to such an extent that she comes to question the validity of her own. Merle Hodge indicates the possibility of Tee's return, as an adult, back to her culture, assimilating the positive aspects of both, through the very manner in which the adult persona re-assesses its exposure to two cultures in the novel. The girl-protaganist's relationship with two families - Tantie's and Beatrice's - validates the conflict between the human urge for meaningful relatedness and the compulsions of economic survival. The novel is a valuable illustration of the sociological phenomenon of the struggle of the lower class to achieve the status of the upper class.

George Lamming's *Water with Berries* offers the post-colonial perspective of exile experience on a deeper level than his earlier exile novel, *The Emigrants*. Here is a multiple hero, specified in three emigrant artists from post-independent San Cristobal island with its new-colonial leaders. The cross-racial struggle to enter meaningful relationships includes the surrogate mother-son relationship between the white landlady, Old Dowager, and her black tenant, Teeton, the painter and the secret worker for the black revolutionary group. It also includes the intense love-relationship between the black musician Roger, and his white American wife Nicole. The landlady is herself the victim of patriarchal husband, finding escape in the love-relationship with her brother-in-law Ferdinand,

which leads to the birth of their daughter Myra. The daughter is , however, forced away from the mother by the husband who is a plantation owner in San Cristobal. His stay ends with his murder by the revolting black workers and the most barbarous rape of the girl by the gang. The Old Dowager, struggling to compensate her loss of the child by the love for Teeton, smuggles him to the small island to avoid his arrest for the possible charge of Nicole's murder in his room. Unfortunately, Ferdinand suspects her love for the black man so that she has to kill her lover. But Teeton is compelled to kill the old lady in order to liberate himself from the trap of illusory love. Roger, the musician, cannot appreciate Nicole's pregancy because of his racial obsession of the guilt for colour, fearing the child to be illegitimate and white, in spite of her honesty, love and readiness to abort for his sake. He causes her death and burns the hotel where he stays - the acts of violence serving as a cathartic release for his skin-obsession. Derek, the actor, humiliated by he ordinary role of a corpse, revolts by burning the theatre to seek release.

For Lamming, the present generation of blacks and whites must exorcise the ghost of the ancestral past with its prejudice against skin before they can build meaningful future. It is suggested by him through the title 'Water with Berries' which refers to the ceremony of souls which binds the living and dead. The novel illustrates how the ruthless racial and economic compulsions of survival change the sacred urge for relationships of three black artists into an unfortunate yet historical need for psychological release

through acts of destruction of those very relationships.

Samuel Selvon's *Those Who Eat the Cascadura* has the post-colonial agricultural setting of a cocoa field of an estate-owner on San Souci island. The novel narrates the story of a short - lived yet intense love relationship between the exceptionally beautiful cocoa field worker - East Indian girl, Sarojini, the estate owner Mr. Franklin's and the visiting British jounalist friend, Garry Johnson. It centralizes the relationships between Sarojini and her field worker- father Ramdeen; between the girl and her white lover;and between the black, white and East Indian members of the village.

Sarojini grows almost as an orphan due to her drunkard father's lack of interest in her. In spite of her marriage settled in childhood with Prekash for money by the father, the young girl persistently postpones it in search of a possible man who would respond to her urge for meaningful relationship. As an illegitimate daughter of Mr. Franklin and her mother, she is herself the symbol of her mother's urge for such relationship.

Garry Johnson stays with Mr.Franklin for his interest in Caribbean legends. The passionate love-relationship between him and Sarojini, though destined not to last long, gains idylic dimensions in the company of Nature. When the hurricane endangers Sarojini's life, Garry himself risks death in order to save his beloved. She regards her pregancy as a valuable memorial of their love although Garry goes back to England. Of course, the

superstitious poor girl vainly struggles to, tempt him to return to the island by feeding him, as a legend dictates the fish named 'Cascadura.'

Selvon structures the narrative to reveal his faith in the Caribbean capacity to overcome the racial guilt originating in ancestral history. The village itself is a strongly bonded family with the landlord less as an exploiter and more as a guardian for the mixed workers community. His old black maid, Eloisa, is more of a surrogate mother to the lonely white man. The black obeah man, Manko, is Sarojini's surrogate father. He guides, comforts, warns and supports Sarojini in her affair with the white man and uses his obeah for their sake though he doubts its usefulness in her lover's case. Even Eloisa loves Sarojini while Sarojini becomes surrogate sister for the poor dumb boy in the villge.

In V. S. Naipaul's *Guerrillas*, the economic and the political, the black and the white, the native and exile elements coalesce to disclose his awareness of the colonial and post-colonial Caribbean situation. The political setting of the novel is only a framework to project the inter - racial man woman relationship which itself becomes a guerrilla activity for the obsessed Caribbean psyche. The novel explores into the problem of survival of a black Chinese-Moslem hero Jimmy Ahmad, the leader of black revolutionary group opposed to the white economic imperialists. The sterility of post-colonial Caribbean environment is gradually exposed through the evolution of his relationship with his divorced British wife

Carole and two children, with the girl-friend of his white sympathizer, Jane, and with the homosextual black slum boy, Bryant. He creates Thrushcross Grange for his guerrilla activities. His commune collects orphan or poor boys from slums. They live in fithy conditions. His pseudo revolution reveals him as a blackmailer of the rich industrialists like Sablich.

Jane's attraction for Jimmy, the ex-exile of Britain, originates in her position as a white middle-class exile in the West Indies in search of economic security, and as a young woman with her romantic attraction for Jimmy as a political hero who contrasts with her prosaic white friend, Peter Roche. Jimmy's sense of defeat due to divorce, on the other hand, compels him to seek ancestral revenge against white skin through his sexual relationship with Jane. His sense of insecurity with her creates the need of self-assertion for him through hemosextual relationship with Bryant. Jimmy is compelled, through Bryant, to kill Jane who symbolizes his guilty conscioence the murder exposing Jimmy's inability to face the reality about himself. The novel exposes even the hypocritic liberal mindedness of Peter Roche towards the blacks who he is compelled to plan return back to England, as an escape.

The novels of the eighties mark a definite advancememt of the Caribbean novelists' capacity to explore the problem of meaningful relatedness. They display greater stamina on behalf of the novelists in

treating individual and family relationship both as a theme and as a structral device. This group includes John Hearne's *The Sure Salvation* (1981), Jamaica Kincaid's *Annie John* (1983), Sam Selvon's *Moses Migrating* (1983), Merle Collins's *Angel* (1987), and V. S. Naipaul's *The Enigma of Arrival* (1987).

In *The Sure Salvation*, John Hearne recreates the historical voyage of the blacks as slaves brought to the Caribbean islands by the European slave traders. His post colonial perspective of the trauma of 'the middle passage' problematizes the traditional allocation of roles - the whites as the exploiters and the blacks as the exploited. The novel narrates how both the white and black slave traders exploit the powerless black community for their greed of money and power. It highlights the truth of exploitation of the powerless by the power-mongers as the eternal destiny of mankind. The title of the novel, 'The Sure Salvation', ironically pinpoints mankind's destiny of 'sure damnation' in the face of human greed.

The history and relationship of members of the slave ship illuminates the nature of human greed and human suffering. The ship, along with its trading crew and the human cargo becomes a temporary home/ family for all. The novelist significantly portrays the tragic voyage on the background of the relationship of the members with their own families. Hogarth, the owner of the ship, has a saintly mother; Dunn's father is a drunkard and mother, a hard labourer fighting against poverty. Reynolds suffers from

sense of injustice by his lesbian sister; black Alex is himself a slave child from the family of the white owner, Delfosse, who frees him legally but from whom the boy inherits the skill of managing the slave trade for highest profit. The exploiters are themselves victims of loneliness. Hogarth's wife, Elizateth, rejects to be his bed-partner in spite of their earlier love because he did not respond positively to her need during pregancy before marriage. Reynold turns into a sex maniac. Hogarth's wife helplessly seeks fulfilment of her motherhood by being surrogate mother to the ship-boy, Joshua. They treat the black slaves most barbarously. The slaves are cramped in the hole of the ship, stacked and stowed there; naked, chained, hungry and stinking like abominable animals.

Alex, along with the support of the slaves, attacks the white crew members and becomes the master of the ship, betraying both Hogarth and the slaves. The slaves, particularly Tadene and the black young girl, take historical revenge against white crew members by severing their heads. The ship is , however, caught for the illegal slave trade by the patrolling ship and Hogarth and Alex are arrested. Slaves are freed on one island casually. In the process of brutal exploitation of the slaves, the traders themselves are condemned to violence, death and displacement. The novelist offers a critique on the civilized man's journey back to barbarism through the ruthless race for power on the ship.

Jamaica Kincaid's *Annie John* depicts the process of the black girl-child Annie's growth from childhood to early adulthood as a visualization of the process of evolution of mother-daughter relationship, on the psychoanalytical level. The first stage of the black child's growth as a member of lower middle class, post-colonial family with her Dominican French white mother reveals symbiotic unity between the mother and daughter. On the one hand, in encodes the earliest stage of the colonizer - colonized relationship and , on the other, the earliest stage of unchallenged acceptance of the white skin and negation of the black skin, on the psychoanalytical level. The daughter's growth towards adolescence finds the girl as a rebel against the conservative white moral codes represented by the mother. In the school, she is sexually attracted, first, towards a white girl and then towards a native Red girl. It discloses the black persona's need to be meaningfully related to both black and white skin/ cultures. The adolescent girl's passionate hatred for the mother suggests the novelist's obsession with the white moral norms of legitimacy due to her own illegitimate birth. Annie's prolonged allegorical illness closes the phase of rebellion, followed by the adult understanding of meaningful relatedness with the mother . There is reconciliation between the mother and the daughter. She accepts the job of a nurse in England. Mother assures the adult daughter that her home/family would always wait for her coming. Ma Chase, Annie's grandmother, represents African obean culture and past, her white mother,

colonialism, and Annie, the modern times.

Selvon's third novel from London trilogy, *Moses Migrating*, continues his preoccupation with the black emigrant community's struggle for survival in a white society. It enacts the process of exile psyche's re-colonization. The ex-exiled Moses is unable to avail himself of the opportunity for meaningful relatedness with his own home. As a self-defined Englishman he, 'migrates' to Trinidad to meet his surrogate mother Tanty Flora, who has reared orphan Moses at John John hill. But he prefers to stay in de-Hilton hotel to protect his elite status. The beautiful young Doris, another adopted girl by Tanty, offers for him, the possibility of settling with a home. But the girl's awareness of the hollowness and hypocrisy of the young man prevents her from responding to him. He fails to comprehend her urge. She hopefully makes the preparations for his Carnival performance, where he is going to act as Rule Britannia Queen. Before the Carnival, he deflowers Doris who responds out of belief in his transformation. However, she realizes her mistake immediately. The sex adventures of Moses as the morally degraded man with Bob's wife, Jeannie, in the ship, and in Port of Spain, are hopelessly ridiculous because Jeannie is like a prostitute, who freely entertains a variety of sex indulgers like Dominica, Galahad and Lennard the journalist. They have lost the sense of responsibility and total commitment for love, and turn themselves into sex objects. Moses illustrates comically how survival in an alien, oppressive

environment demands most absurd compromises so that the individual is left homeless in his own land.

Merle Collins's *Angel* is set in post-colonial, rural Grenada. It epitomizes the crucial role of 'family' in the Caribbean society through the history of the heroine - Angel's family with its three generations. The history unfolds on the background of the country's political history. The struggle of Angel's mother's - Doodsie's family for bare economic survival forms the background of Angel's childhood. As a family of cocoa field labourers, it faces the problem of bare survival because of the strike of the labourers against the white landlords. Angel's father, Allan, is compelled to migrate to America in search of work, while her mother struggles hopelessly to feed her little children. The family survives because of the valuable support by the grandmother, on the one hand, and by the communal family, on the other.

The family enters the second stage of its life-cycle with the return of Allan and improvement in its economic resources. The black mother's urge to educate the children strengthens mother-daughter relationship, in particular. Trained in European patriarchal system, the mother follows discriminatory norms for her daughter, Angel, and son, Simon. However, Angel significantly reveals an instinctive urge to protest against the father's exploitation of the mother. At school, the girl is victim of the

disastrous impact of colonial education. But, at the University of Jamaica, she learns courage to accept her own black identity, cleansing herself of the negative impact of Christianity and European norms of living. As an adult, she develops her sense of responsibility towards the society, and emerges as a political activist.

Doodsie's family, in its adult stage, participates in the newly - liberated country's struggle for political stability. Not only Angel and her brother, Rupert, dedicate themselves to political activities but even the women, including Doodsie, take part in strikes and protest against the corrupt Leader and Chief - a sign of their mature political consciousness. It is the mother with her early realization of Leader's corruption in spite of his popularity, who guides Angel on the right path. She awakens the frustrated girl to the need of complete faith in the capacity of the people/ the community to build their future in spite of failures of their political leaders to offer stable future for the country. The novel may, thus, be regarded as Merle Collins's gospel of faith in the power of the people meaningfully related as members of their families and their close-knit communal family.

The Enigma of Arrival marks an important stage in the evolution of V. S. Naipaul's vision as a Caribbean artist. It is an episodic narrative of his experiences of 30 years as an exile in England. The novel evidences the writer-persona's arrival at the holistic understanding of the enigma of

Caribbean situation as being a part of the human condition shared by both the colonizers and the colonized. 'Family' provides a valuable device for Naipaul to relate the British history to the Caribbean past.

The writer- persona is located deliberately in the neighbourhood of rural England. He fictionalizes the history of a number of British families so as to mirror the British socio-economic history. The choice of families from the lowest, the middle and the upper classes during their phases of decay or change facilitates parallelism between the British and the colonized. The lowest class includes the agricultural families of Jack the farm gardener, Pitton the gardener, Bray the driver, and Leslie the farm worker. The family of the estate manager, Mr. Philips, belongs to the middle class, the landlord, with his estate in ruins, stands for the upper class.

The writer-persona links himself with his own familial past as well as with his racial past through realization of decay, death and change shaping the fictional histories of the British families. It brings the cathartic comprehension of the unity between the colonizer and the colonized as parts of human race, bound equally by the laws of decay, death and change on the metaphysical level. It signifies to write persona's experience of arrival 'home' as the achievement of the sense of reconciliation with one's own past. The 'enigma' of arrival is, thus, the metaphysical experience of illumination.

The relationship between individual and family, as explored in the novels of the four decades above, emerges as a complex process of dynamic reaction in response to a variety of discriminatory forces in mutual conflict. These forces - racial, social, economic, historical, regional and emigrant - can be displayed digrammatically.

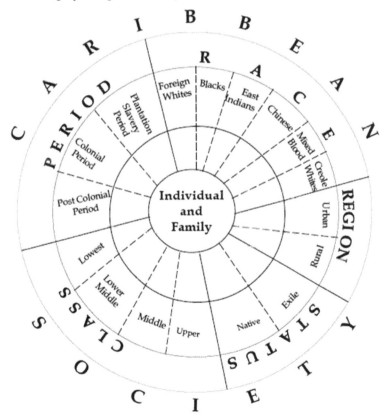

The novelists avail themselves of a large variety of roles of an individual in the Caribbean family. The corresponding roles of man and woman in Caribbean family are presented diagrammatically below -

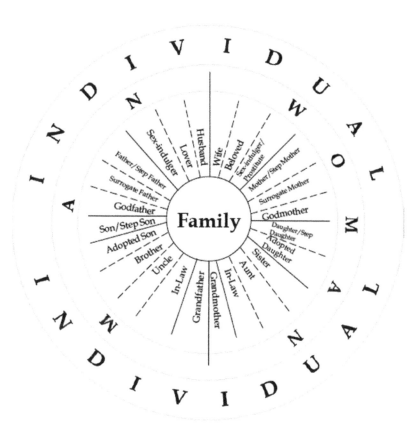

The novels, on the whole, facilitate insight into the tensions of man - woman relationship -racial and cross-racial. The exploitative socio-economic environment appears to forbid stamina for individuals to enter into sustained relationship in the form of a family. The cross-racial man - woman relationship is often bogged in nominal sex-relationship as in *The Lonely Londoners, A Morning,* and *Moses Migrating.* It breaks under social and psychological tensions before it could shape as a positive experience as in the cases of the emigrant Moses and rural Doris in *Moses Migrating,* black Jimmy Ahmad and white Jane in *Guerrillas,* Brenda and Michael Allen in *The Enigma,* And L -'s mother and Anthrop's engineer twin brother in *The Eye.*

The instinctual choice of a partner from another race necessitates greater stamina on behalf of an individual to liberate himself from the racial memory of humiliation and guilt. Yet the novels celebrate the courage of the Caribbean persona to enter such relationship as illustrated by the idylic though short - lived love-relationship between a white jounalist visitor Garry, and an East Indian rural girl Sarojini, in *Those Who Eat;* by the strong relationship between Arthur-a writer and an East Indian lady clerk Miss Bisnauth, in *A Morning;* by love of Minette, the prostitute and Brother Man, the spiritual leader in *Brother Man.*

The tensions of cross-racial man-woman relationship, most often problematize the very survival of the individual, psychologically or socially.

As a result, the relationship - of love or marriage -crumbles into chaos or tragedy as in the cases of black Roger murdering his white American wife Nicole in *Water With*; the white Rochester turning into the colonizer for his creole white wife Antoinette, in *Wide Sargasso*, or as in the humiliating divorce to black Jimmy Ahmad by his British wife in *Guerrillas*. The idyllic love-relationship proves too idealistic to survive in the discriminatory enviroment so that the white journalist goes back to his country leaving the beloved, in *Those Who*.

The 'mother' instinct within Caribbean female persona plays a vital role in individual and family relationship as decoded by Caribbean novels. Historically, she has sustained the possibilities for meaningful relatedness in the form of a family through her vital role as a nurturer and earner for the children. The novels emphasize this role of the mother. The illiterate, poor working class mother labouring to educate her child is the archytype of Motherhood in *In the Castle, The Year, Crick Crack and Angel*.

The novels flash the trailer of meaningful relatedness as achieved by the maternal or paternal instinct across races and cultures. It is found in the white cocoafield owner, Mr. Franklin and his surrogate mother the old black maid - Eloisa in *Those Who*, in the black Teeton and his surrogate white mother - the Old Dowager in *Water With,* in the ex-emancipation plantation owner's lonely daughter and her surrogate mother-the black nurse, Chrisophine in *Wide Sargasso*, in black Alex, the slave boy and his

surrogate father-the white slave owner, Mr. Delfosse, in *The Sure Salvation*, in the black oheah man, Manko, acting as a surrogate father towards the East Indian girl, Sarojini, in *Those Who*.

The illuminative quality of the Caribbean novels is most evident in their capacity to utilize the image of 'family' for its thematic as well as structural potential. Thematically 'family' is the cathartic battleground for individuals to overcome the racial, political, and economic tensions. Black adolescent Annie's relationship with her white mother and with the white and Red girl friends, is a replay on the psychological level, of the drama of conflict between the claims of the native and the white cultures on the Caribbean persona. *A House for Mr. Biswas* embodies the struggle to sustain the urge for meaningful relatedness within the economically exploitative feudal environment. *Angel* centralizes the key role of the family as a vital link between the individual and society - sharing the process of children's growth as political activists accompanied by the process of family's active political awareness of the possibility towards the country's future. The Sure Salvation encapsulates the horror of human greed for money and power - equally shared by the blacks and the whites, through human relationships between blacks and whites in the temporary family of the slave ship.

'Family' emerges as a structrual device in *In the Castle, The Enigma*, and *The Eye*. The stages of colonial history of a society changing from passive

acceptance of the colonizer to active awareness of his betrayal is narrativized through the history of the child hero in *In the Castle*. *The Enigma* celebrates the possibility of faith in meaningful relatedness between the colonizer and the colonized as equal subjects of law of decay, death and change. The relation is achieved through the exile persona's imaginative recreation of relationships within white families in economically transitional phases. *The Eye* concretizes the metaphysical vision of mankind with its different histories in different places, as sharing one origin - the Womb of the mother.

The Caribbean novel, thus, internalizes as well as externalizes the tensions of the colonial past, and the post - colonial present through the caleidoscopic treatment of individual and family relationship. It transforms 'family' into a creative arena for the Caribbean individual to create opportunity for meaningful relatedness within the exploitative barren environment with its precipitative centrifugal forces isolating human beings from one another in groups and factions - the environment which is in itself, a microcosm of the world as a whole.

BIBLIOGRAPHY

I Primary Sources

1. Anthony, Michael. *The Year in San Fernando*. London : Heinemann in Association with Andre Deutsch, 1965.

2. Collins, Merle. *Angel*. London : Seal Press, 1987, this edition, 1988.

3. Harris, Wilson. *The Eye of the Scarecrow*. London : Faber and Faber, 1965, this edition, 1974.

4. Hearne, John. *The Sure Salvation*. London : Boston : Faber and Faber, 1981, this edition, 1985.

5. Hodge, Merle. *Crick Crack, Monkey*. London : Andrew Deutsch, 1970.

6. Kincaid, Jamaica. *Annie John*. London : Vintage, 1983, this edition, 1997.

7. Lamming, George. *In the Castle of My Skin*. England : Longman Drumbeat, 1953.

8. Lamming, George. *Water with Berries*. London : Longman Caribbean, 1971, this edition, 1973.

9. Mais, Roger, Brother Man. London : Jonathan Cape, 1954.

10. Mittelholzer, Edgar. *A Morning at the Office*. London : Heinemann, 1950.

11. Naipaul, V. S. *The Mystic Masseur*. England : Penguin Books, 1957.

12. _____. *A House for Mr. Biswas*. New Delhi : Penguin Books India Ltd., 1961.

13. _____. *Guerrillas*. England : Penguin Books, 1975.

14. _____. *The Enigma of Arrival*. London : Penguin Books, 1987.

15. Rhys, Jean. *Wide Sargasso Sea*. New York and London : W. W. Norton and Co. INC., 1966, this edition, 1982.

16. Selvon, Semuel. *The Lonely Londoners*. London : Longman Caribbean, 1956, this edition, 1972.

17. _____. *Moses Ascending*. London : Davis Poynter, 1965.

18. _____. *Those Who Eat the Cascadura*. Toronto : TSAR, 1972, this edition, 1990.

19. _____. *Moses Migrating*. Washington D. C. : Three Continents Press, 1983, this edition, 1992.

II Secondary Sources :

A Books

1. Abrahams, Roger D. *Deep Down in the Jungle*. Chicago : Adline Publishing Co., 1970.

2. Baugh, Edward (ed.). *Critics on Caribbean Literature*. London : Boston, Sydney : George Allan & Unwin, 1978.

3. Barthold, Bonnie J. *Black Time : Fiction of Africa, the Caribbean and the United States*. London : Yale Uni. Press, 1940.

4. Beaumont, Gustave De. *Mark of Slavery in the United States. Stadford Calif*: Stadford Uni. Press, 1958.

5. Benson, Eugene and L. W. Conolly (eds.). *Encyclopedia of Post-colonial Literatures in English*. London & New York : Clays Ltd. St. Ives Publication, 1994.

6. Bhatnagar, M. K. (ed.). *Commonwealth English Literature*. New Delhi: Atlantic Publishers and Distributors, 1999.

7. Bhabha, Homi K. *Nation and Narration*. London : Routledge, 1990.

8. Bigner, Jerry J. *Individual and Family Development*. New Jersey : Prentice Hall, Englewood Cliffs. 1983, this edition 1994.

9. Blamires, Methuen A. *A Guide to Twentieth Century Literature in English*. London & New York : Methuen & Co. Ltd., 1983.

10. Bush, Barbara. *Slave Women in Caribbean Society : 1650 - 1838*. Kingston, London : Heinemann Publishers, (Caribbean, Bloomington and Indianapolis, 1990.

11. Cameron, Norman. *Personality Development and Psychology*. Bombay: Vakils, Feffer and Simons Pvt. Ltd., 1969.

12. *Chamber's Encyclopaedia : New Revised Edition.* London : International Learning Systems Corporation Ltd., 1973.

13. *Compton's Pictured Encyclopaedia and Fact Index.* Chicago : F. E. Compton & Co., 1956.

14. Comitas, Lambros and David Lowenthal (eds.). *Work and Family Patterns : West Indian Perspectives,* Garden City, NY : Anchor Press / Doubleday, 1973.

15. Conrad, Joseph. *Heart of Darkness.* London : Toronto, New York : Bantan Books, 1910, this edition, 1969.

16. Cooks, M. G. (ed.). *Modern Black Novelists.* New Jersey : Prentic Hall, 1971.

17. Cowling, Elizabeth and Munday, Jennifer. *On Classic Ground Picasso, Leger, de Chirico and New Classicism.* London : Tate Gallary, 1990.

18. Cudjoe, Selwyn R. (ed.). *Caribbean Women Writers : Essays from the First International Conference.* Wellesley, USA : Calcalou Publications, 1990.

19. Das, Bijoy Kumar. *Aspects of Commonwealth Literature.* New Delhi: Creative Books, 1995.

20. Davidson, Basil. *Black Mother.* England : Penguin Books, 1961.

21. Davidson, Kathy N. and E. M. Broner (eds.). *The Lost Tradition.* New York : Frederick Ungar Pub. Co., 1980.

22. Dennis, Philip. A. and Wendell, Aycock (eds.). *Literature and Anthropology*. Lubbock, Texas : Texas Tech Uni. Press, 1989.

23. Dhawan, R. K. (ed.). *Commonwealth Fiction*. New Delhi : Classical Publishing Co., 1988.

24. _____. *The West Indian Fiction*. New Delhi : Prestige, 2000.

25. _____. L. S. R. Krishna Sastry (eds.). *Commonwealth Writing : A Study in Expatriate Experiences*. New Delhi : Prestige, 1994.

26. Duvall, E. *Marriage and Family Development*. 5th edition, Philadelphia: Lippincott, 1977.

27. *Encyclopaedia of Commonwealth Literature*. New Delhi : Cosmo Publication, India, 1988.

28. Fenon, Frantz. *Black Skin White Masks*, Trans. Charles Lam Markmnn. 1952, rpt. New York : Grove Press, 1971.

29. Fenon, Frantz. *The Wretched of the Earth*. Trans. Constance Farrington, 1961, rpt. England : Penguin Books, 1967.

30. Ganatilka, Susantha. *Crippled Minds : Exploration into Colonial Culture*. Bombay : Vikas, 1982.

31. Gilkes, Michael. *The West Indian Novel*. Boston : Twayne Publishers, 1981.

32. _____. (ed.). *The Literate Imagination : Essays on the Novels of Wilson Harris*. London and Basingstoke : Macmillan Caribbean, 1989.

33. Gorden, Eva J. *Human Development*. Bombay : D. B. Taraporwala Sons & Co. Ltd., 1970.

34. Griffith, Gareth. *A Double Exile : African and West Indian Writing Between Two cultures*. London : Marion Boyars, 1978.

35. Hall, Stuart and Paul Du Gay (eds.). *Questions of Cultural Identity*. London : Sage Publications, 1996.

All novels of Harris Wilson are published by (London : Faber and Faber).

36. Harris, Wilson. *Palace of the Peacock*. (1960)

37. Harris, Wilson. *The Far Journey of Oudin*. (1961)

38. _____. *The Secret Ladder*. (1963)

39. _____. *Tumatumari*. (1968)

40. _____. *Ascent of Omai* (1970)

41. _____. *Carnival*. (1985)

42. _____. *Tradition and the Writer and Society : Critical Essays*. London, Port of Spain : New Bacon Publication, 1967.

43. Herdeck, Donald E. (ed.). *Caribbean Writers : A Bio-Bibliographical - Critical Encyclopaedia*. Washington D. C. : Three Continents Press INC., 1979.

44. Hughes, Petre. *V. S. Naipaul*. London & New York : Routledge, 1988.

45. James, Trevor. *English Literature from the Third World*. Beirut : Longman, York Press, 1986.

46. James, Louis (ed.). *The Inlands in Between*. London : Oxford Uni. Press, 1968.

47. Jones, Eldred Durosimi. *African Literature Today : 14 Insiders and Outsiders*. London : Ibadan, Nairobi, New York : Heinemann and Africana Publishing Co., 1984.

48. Joshi, Chandra B. *V. S. Naipaul : The Voice of Exile*. New Delhi : Sterling Publishers Pvt. Ltd., 1994.

49. Juneja, Renu. *Caribbean Transactions : West Indian Culture in Literature*. London & Baingstoke : Macmillan Education Ltd., 1996.

50. Kamra, Shashi. *The Novels of V. S. Naipaul*. New Delhi : Prestige, 1990.

51. Keur, Dorothy L. and Vera, Rubin (eds.). *Cultural Assimilation in a Multicultural Society, Social and Cultural Pluralism in the Caribbean: Annals of the New York Academy of Sciences*. Millwood NY : Kraus, 1978.

52. King, Bruce. *West Indian Literature*. London and Basingstoke : The Macmillan Press Ltd. & Co., 1979.

53. Lamming, George. *The Pleasures of Exile*. London Allison & Busby, 1984.

54. _____. *The Emigrants*. London and New York : Allison & Busby, 1954.

55. _____. *Of Age and Innocence*. London and New York : Allison and Busby, 1958.

56. Lamming, George. *Natives of My Person*. London : Longman Caribbean, 1972.

57. Leslie, Gerald R. *The Family in Social Context*. London, New York, Toronto : Oxford Uni. Press, 1976.

58. Marcus, Herbert. *Studies in the Ideology of Advanced Industrial Society*. London : Routledge and Kegan Paul, 1964.

59. Martinson, Floyd Mansfield. *Family in Society*. New York : Dodd Mead & Co., 1972.

60. Mintz, Sidney W. (ed.). *Slavery, Colonialism, and Race*. New York : Norton, 1974.

61. Mustafa, Fawzia. *V. S. Naipaul*. Cambridge : Cambridge Uni. Press, 1995.

62. Murdock, G. P. *Social Structure*. New York : Macmillan, 1949.

63. Narasimhaiah, C. D. *Essays in Commonwealth Literature*. Delhi : Pencraft International, 1995.

64. _____. (ed.). *Commonwealth Literature : Problems Repose*. Madras, Bombay, Calcutta, Delhi : Macmillan India Ltd., 1981.

65. Naipaul, V. S. *The Mimic Men*. London : Andre Deutsch, 1967.

66. _____. *The Middle Passage*. London : Andre Deutsch, 1962.

67. _____. *Mr. Stone and the Knights Companion*. London : Andre Deutsch, 1969.

68. _____. *The Return of Eva Peron with the Killings in Trinidad*. London : Andre Deutsch, 1980.

69. Nettlefield, Rex M. Caribbean Cultural Identity : *The Case of Jamaica: An Essay in Cultural Dynamics*. Jamaica : Institute of Jamaica, 1978.

70. Pandit. M. L. *New Commonwealth Writing : A Critical Response*. New Delhi : Prestige, 1996.

71. Paquet, Sandra Pauchet. *The Novels of George Lamming*. London : Heinemann, 1982.

72. Ramaswamy, S. *Commentaries on Commonwealth Fiction*. New Delhi: Prestige, 1994.

73. _____. *Essays on Commonwealth Literature*. Bangalore : M. C. C. Publications, 1988.

74. Ramadevi, N. *The Novels of V. S. Naipaul : Quest for Order and Identity*. New Delhi : Prestige, 1996.

75. Ramchand, Kenneth. *The West Indian Novel and Its Background*. London : Faber and Faber, 1970.

76. Rajan, P. K., K. M. George, et. el., (eds.). *Commonwealth Literature : Themes and Techniques.* Delhi : Ajanta, 1993.

77. Schaffer, Kay. *Women and the Bush : Forces of Desire in the Australian Cultural Tradition.* Cambridge : Cambridge Uni. Press, 1988.

78. Sellogman, Edwin R. A. (ed.). *Encyclopaedia of the Social Sciences.* New York : The Macmillan Co. MCML. XIII, 1934, Rpt. 1935, 1963.

79. Sherlock, Philip. *West Indian Folk Tales.* London : Oxford Uni. Press. 1966, Rpt. 1986.

80. Simmons, Gloria M., Hutchinson Helene D., et. el. *Black Culture : Reading and Writing in Black.* New York, Chicago, San Francisco, Atlanta, Dellas, Montreal, Toronto : Holt Rinchart and Winston, INC. 1972.

81. Singh, Manjit Inder. (Thesis) *V. S. Naipaul and George Lamming : Two Approaches to the Problem of Alienation and Identity.* Patiyala: The Punjab Uni. 1985.

82. Smith, Rowland (ed.). *Exile and Tradition : Studies in African and Caribbean Literature.* New York : African Pub. Co., Dalhousie Uni. Press, 1976.

83. Sussman, M. and S. Steinmetz (eds.). *Handbook of Marriage and the Family.* New York : Plenum, 1987.

84. Tufte, Virginia and Barbara, Myeschoff(eds.). *Changing Images of the Family.* New Haven : Yale Uni. Press, 1979.

85. Thiong'o, Ngugi. Wa. *Homecoming : Essays on African and Caribbean Literature, Culture and Politics.* New York, Westport : Lawrence Hill and Co., 1972.

86. _____. *A Grain of Wheat.* London : Heinemann, 1967.

87. Uma, Alladi. *Woman and Her Family : Indian and Afro-American - A Literary Perspective.* New Delhi : Sterling Publishers Pvt. Ltd., 1989.

88. Walcott, Derek. *Omeros.* New York : Farrar Straus Giroux, 1990.

89. Walker, Alice. *In Search of Our Mothers' Gardens.* New York : Harcourt Brace Javanovich, 1983.

90. Walsh, William (ed.). *Readings in Commonwealth Literature.* Oxford: Oxford Uni. Press, 1973.

91. White, Richard. *Inventing Australia : Images and Identity 1688 - 1980.* Sydney : Allen and Unwin, 1981.

92. Williams, Eric. *The Approach to Independence.* Port of Spain, 1960.

93. Zinn, Maxine Baca and Eitzen, Stanley D. *Diversities in families.* New York : Harper collins college Publisgers, 1996.

III B Journals and Other Sources

1. Antrobus, Peggy. "Crisis, Challenge and Experiences of Caribbean Women". *Caribbean Quarterly*, Vol. 35, Nos. 1 & 2, March/June, 1989.

2. Argyle, Barry. 'Commentary on V. S. Naipaul's "A House for Mr. Biswas" 1. - A West Indian Epic.' *Caribbean Quarterly*, Vol. 16, No.4, Dec., 1970.

3. Balutensky, Katheleen. ' "We are All Activists". Interview with Merle Hodge.' *Callalo*, 12.4, Fall, 1989.

4. Barratt, Harold. " In Defence of Naipaul's *Guerrillas*". *WLWE*, Vol. 28, No. 1, 1988.

5. Braithwaite, L. E. "Roots". *Bim*, Vol. x, No. 37, July-Dec., 1963.

6. Brathwaite, Edward. "West Indian Prose Fiction in the Sixties : A Survey". *Caribbean Quarterly*, Vol. 16, No. 4, Dec., 1970.

7. Brunton, Roseanne. "The Death Motif in V. S. Naipaul's *The Engima of Arrival* : The Fusion of Autobiography and Novel as the Engima of Life - and - Death". *WLWE*, Vol. 29, No. 2, Autumn, 1989.

8. Casmier, Stephen. "Black Narcissus : Representation, Reproduction, Repetition and Seeing Yourself in V. S. Naipaul's *A House for Mr. Biswas* and *The Engima of Arrival*". *Commonwealth*, Vol. 18, No. 1, Autumn, 1995.

9. Cottor, Michael. "Identity and Compulsion : George Lamming's *Natives of My Person*". *New Literature Review*, 1977.

10. Crowle, Christine. "V. S. Naipaul, *The Engima of Arrival* and the Unbearable Body". *New Literature Review*, 30, Winter, 1995.

11. Cudjoe, Selwyn R. "Revolutionary Struggle and The Novel". *Caribbean Quarterly*, Vol. 25, No. 4, Dec., 1979.

12. Cumper, Gloria. "Review : Mirror Mirror Identity : Race and Protest in Jamaica". *Caribbean Quarterly,* Vol. 17, No,s., 3 & 4, Sept.-Dec., 1971.

13. Dawes, Kwame S. N. 'Voilence and Patriarchy : Male Domination in Roger Mais's "Brother Man",' *Ariel*, Vol. 25, No. 3, July, 1994.

14. Deosaran, Ramesh, "Some Issues in Multiculturalism : The Case of Trinidad & Tobago in the Post-Colonial Era". *Caribbean Quarterly*, Vol. 33, Nos. 1 & 2, March-June, 1987.

15. Donnelly, Mary E. ' Mother Country, Father Country : "In the Castle of My Skin" and Oedipal Structures of Colonialism.' *Ariel*, Vol. 26, No. 4, Octo., 1995.

16. Down, Lorna. 'Singing Her Own Song : Women and Selfhood in Zee Edgell's "Beka Lamb".' *Ariel*, Vol. 18, No. 4, Octo., 1987.

17. Drayton, Arthur D. "The European Factor in West Indian Literature". *The Literary Half-yearly*, 1970.

18. Durix, Jean-Pierre. 'Paradoxes of Creation : Wilson Harris's "The Secret Ladder".' *Ariel*, Vol. 15, No. 2, April, 1984.

19. _____."Review : Sandra E. Drake : Wilson Harris and the Modern Tradition : A New Architecture of the World". *Commonwealth*, Vol. 10, No. 1, Autumn, 1987.

20. _____. "Ripples in the Water : An Examination of *The Eye of the Scarecrow*". WLWE, Vol. 22, No. 1, Spring, 1983.

21. Elder, J. D. "The Male / Female Conflict in Calypso". *Caribbean Quarterly*, Vol. 14, No. 3, Sep., 1968.

22. Emery, Mary Lou. "The Politics of Form : Jean Rhys's Social Vision in *Voyage in the Dark* and *Wide Sargasso Sea*". *Twentyeth Century Literature*, Vol. 28, No. 4, Winter, 1982.

23. Espinet, Ramabai. "The Invisible Woman in West Indian Fiction". *WLWE*, Vol. 29, No. 2, Autumn, 1989.

24. Evans, Jennifer. "Women of 'The Way' : Two Thousand Seasons, Female Images and Black Identity". *ACLALS Bulletin*, Sixth series, No. 1, November, 1982.

25. Fabre, Michel. "Moses and the Queen's English : Dialect and Narrative Voice in Samuel Selvon's London Novels". *WLWE*, Vol., 21, No. 2, Summer, 1982.

26. _____. "Interview with Wilson Harris". *WLWE* Vol. 22, No. 1, Spring, 1983.

27. Forsythe, Dennis. "West Indian Culture Through the Prism of Rastafarianism". *Caribbean Quarterly*, Vol. 26, No. 4, Dec., 1980.

28. Gikandi, Simon. 'Narration in the Post-Colonial Moment : Merle Hodge's "Crick Crack, Monkey".' *Ariel*, Vol. 20, No. 4, October, 1989.

29. Gordon, Shirley. "Review : The Rebel Woman in the British West Indies during Slavery by Lucille Mathurin Mair". **Caribbean Quarterly**, Vol. 22, Nos. 2 & 3, June-September, 1976.

30. Hagley, Carol R. "Ageing in the Fiction of Jean Rhys". *WLWE*, Vol. 28, No. 1, Spring, 1988.

31. Hayward, Helen. "Tradition, Innovation, and the Representation of England in V. S. Naipaul's *The Engima of Arrival*". **The Journal of Commonwealth Literature**, Vol. xxxii, No. 2, 1997.

32. Henriques, Fernando. "West Indian Family Organisation". reprinted in *Caribbean Quarterly*, Vol. 2, No. 1, n.d.

33. _____. "Introduction to the West Indies". *The Journal of Commonwealth Literature*, No. 4, Dec., 1967.

34. Henry, Paget. "Rex Nettleford African and Afro-Caribbean Philosophy". *Caribbean Quarterly*, Vol. 43, No. 2, June, 1997.

35. Healy, J. J. 'Wilson Harris at Work : The Texas Manuscripts with Special Reference to the Mayakovskey Resonance in "Ascent to Omai".' *Ariel*, Vol. 15, No. 4, October, 1984.

36. Hearne, John. "The Fugitive in the Forest : A Study of Four Novels by Wilson Harris". *The Journal of Commonwealth Literature*, no. 4, December, 1967.

37. Howard, WM. J. "Edgar Mittelholzer's Tragic Vision". *Caribbean Quarterly*, Vol. 16, No. 4, Dec. 1970.

38. James, Louis. (Compl.) "The West Indies : Introduction". *The Journal of Commonwealth Literature*, Vol. vii, No. 2, Dec. 1972.

39. _____. "How Many Islands Are There in Jean Rhys's Wide Sargasso Sea?" *Kunapipi*, Vol. xvi, No. 2, 1994.

40. _____. "Structure and Vision in the Novels of Wilson Harris". *WLWE*, Vol. 22, No. 1, Spring, 1983.

41. J. P. D. "Review : John Thieme : The Web of Tradition : Uses of Allusion in V. S. Naipaul's Fiction". *Commonwealth*, Vol. 10, No. 2, Spring. 1988.

42. Jha, J. C. "The Hindu Sacraments (Rites De Passage) In Trinidad and Tobago". *Caribbean Quarterly*, Vol. 22, No. 1, March, 1976.

43. Kirpal, Vineypalkaur. 'Fiction of the "Third World" in English".' *ACLALS Bulletin*, 6th series, No. 1, Nov. 1982.

44. King, Bruce. "Review : John Hearne, *The Sure Salvation*, London : Faber and Faber, 1981". *WLWE*, Vol. 21, No. 3, Autumn, 1982.

45. Kom, Ambroise, "*In the Castle of My Skin* : George Lamming and the Colonial Caribbean". *WLWE*, Vol. 18, No. 2, November, 1979.

46. Larsen, Jesse. "Review : *Crick Crack Monkey*". *Internet : Amazon.com*, 2001.

47. Layne, Anthony. "Race, Class and Development in Barbados". *Caribbean Quarterly*, Vol. 25, Nos. 1 & 2, March-June, 1979.

48. Lichtentein, David P. "Naipaul's Foils : Part two of The Double and the Centre". *Internet* : http"//65.107.211.206/post/caribbean/themes/double2.html, 2001.

49. Lima, Maria Helena. "Revolutionary Developments : Michelle Cliff's "No Telephone to Heaven" and Merle Collins's "Angel"." *Ariel*, Vol. 24, No. 2, April, 1993.

50. Lewis, Rupert. "Nettleford's Critique of the Black Elite". *Caribbean Quarterly*, Vol. 43, No. 2, June 1977.

51. Londsdale, Thorunn. "The Female Child in the Fiction of Jean Rhys". *Commonwealth*, Vol. 15, No. 1, Autumn, 1992.

52. Loe, Thomas, "Pattern of the Zombie in Jean Rhys's *Wild Sargasso Sea*". *WLWE*, Vol. 31, No. 1, Spring, 1991.

53. Luengo, Anthony. "Growing up in San Fernando : Change and Growth in Michael Anthony's *The Year in San Fernando*". *Ariel*.Vol. 6, No. 2, April, 1975.

54. Lyn, Diana. "The Concept of The Mulatto in Some Works of Derek Walcott". *Caribbean Quarterly*, Vol. 26, Nos. 1 & 2, March-June, 1980.

55. McDonald, Avis G. "Within the Orbit of Power : Reading Allegory in George Lamming's *Natives of My Person*". *The Journal of Commonwealth Literature*, Vol. xxii, No. 1, 1987.

56. MacDonald, Bruce F. "Symbolic Action in Three of V. S. Naipaul's Novels". *The Journal of Commonwealth Literature*, Vol. ix, No. 3, April, 1975.

57. Mordecai, Pamela C. "The West Indian Male Sensibility in Search of Itself : Some Comments on Nor Any Country, The Mimic Men and *The Secret Ladder*". *WLWE*, Vol. 21, No. 3, Autumn, 1982.

58. Moss, John G. "William Blake and Wilson Harris : The Objective Vision". *The Journal of Commonwealth Literature*, Vol. ix, No. 3, April. 1975.

59. Nandan, Satendra. "A Study in Context : V. S. Naipaul's *A House for Mr. Biswas*". *New Literature Review*, 1977.

60. Nazareth, Peter. "Interview with Sam Selvon". *World Literature in English*, Vol. 28, No. 2, 1974.

61. Nettelford, Rex. "Caribbean Crisis and Challenges to Year 2000". *Caribbean Quarterly*, Vol. 35, Nos. 1 & 2, March / June, 1989.

62. Neill, Michael. "Guerrillas and Gangs : Frantz Fenon and V. S. Naipaul". *Ariel*, Vol. 13, No. 4, Octo., 1982.

63. Nighitingale, Margaret, "George Lamming and V. S. Naipaul : Thesis and Antithesis". *ACLALS Bulletin*, 5th series, No. 3, Dec. 1980.

64. Ogundipe, Leslie. "Recreating Ourselves All Over the World : Interview with Paule Marshall". *Matau*, 3.6, 1983.

65. Olaussen, Maria. 'Jean Rhys's Construction of Blackness as Escape from White Feminity in "Wide Sargasso Sea".' *Ariel*, Vol. 24, No. 2, April, 1993.

66. O' Rand. A. M. and Krecker, M. L. "Concepts of the Life Cycle, Their History, Meanings and Use in the Social Sciences". *Annual Review of Sociology*, 16, 1990.

67. Raiskin, Judith. "Jean Rhys : Creole Writing and Strategies of Reading". *Ariel*, Vol.22, No. 4, Octo. 1991.

68. Ramesar, Marianne D. "The Impact of the Indian Immigrants on Colonial Trinidad Society". *Caribbean Quarterly*, Vol. 22, No. 1, March, 1976.

69. Ramchand K. "Song of Innocence, and Song of Experience : Samuel Selvon's *The Lonely Londoners* as a Literary Work". *WLWE*, Vol. 21, No. 3, Autumn, 1982.

70. Ramraj, Victor J. "West Indies". *Kunapipi*, Vol. vii, No. 1, 1985.

71. Ramraj, Victor J. (Compl.). "The West Indies (1981 - 1984)". *The Journal of Commonwealth Literature*, Vol. xx, No. 2, 1985.

72. Robinson, Jeff. "Mother and Child in Three Novels of George Lamming". *Release*, 6, 1979.

73. Rohlehr, Gordon. "The Problem of the Problem of Form : The Idea of an Aesthetic Continuum and Aesthetic Code-switching in West Indian Literature". *Caribbean Quarterly*, Vol. 31, No. 1, March, 1985.

74. Rooke, Patricia T. "Evangelical Missionaries, Apprentices, and Freedmen : The Psycho-sociological Shifts of Racial Attitudes in the British West Indies". *Caribbean Quarterly*, Vol. 25, Nos. 1 & 2, March/ June, 1979.

75. Salick, Roydon. "Sex and Death in the West Indian Novel of Adolescence". *Caribbean Quarterly*, Vol. 39, No. 2, June, 1993.

76. Sevry, Jean. "*A House for Mr. Biswas* : Comblen de romans?" *Commonwealth*, Vol. 10, No. 1, Antumn, 1987.

77. Slemon, Stephen. "Interview with Wilson Harris". *Ariel*, vol. 19. no. 3, July, 1988.

78. Smilowitz, Erika. "Childlike Women and Paternal Men : Colonialism in Jean Rhys's Fiction". **Ariel**, Vol. 17, No. 4, October, 1986.

79. Sunitha, K. T. "The Theme of Childhood in *In the Castle of My Skin and Swami and Friends*". *WLWE*, Vol. 27, No. 2, Autumn, 1987.

80. Stockholder, Kay. "Review : Katherine Dalsimer : Female Adolescence: Psychoanalytic Reflections on Works of Literature, New Haven : Yale Up, 1986". *Ariel*, Vol. 18, No. 2, April, 1987.

81. Tapping, Craig." Children and History in the Caribbean Novel: George Lamming's *In the Castle of My Skin* and Jamaica Kincaid's *Annie John"*. *Kunapipi,Vol.* xi, No. *2,*1989.

82. TabuTeau, Eric. "Love in Black and White : A Comparative Study of Samuel Selvon and Frantz Fenon". *Commonwealth,* Vol. 16, No. 2, Summer/1993. :

83. Thorpe, Michael. "Wilson Harris : Writing Against the Grain", *Ariel,* Volr.25, No. 3, July, 1.994. \

84. Thomas, Clara. "Commonwealth Albums: Family Resemblance in Derek Walcott's *Another Life* and Margaret Laurence's *The Diviners"*. *WLWE,* Vol. 21, No. 2, Summer, 1982.

85. Thieme, John. "Rule Brittania? Sam Selvon, *Moses Migrating,* Harlow: "Longman, 1983". *The Literary Criterion,* Vol. xx, No. 1,1985.

86. Tsomondo, Thorell, "Metaphor, Metonymy and Houses : Figures of Construction in *A House for Mr, Biswas"*. *WLWE,* Vol. 29, No. 2, Autumn, 1989.

87. Walker, John W. "Upsettling the Sign : V. S. Naipaul's *The Engima of Arrival"*. *The Journal of Commonwealth Literature.* Vol. xxxii, No. 2,1997.

88. Warner, Maureen. "2. - Cultural Confrontation, Disintegration and Syncretism in."A House for Mr. Biswas". *Caribbean. Quarterly,* Vol. 16, No. 4, Dec., 1970.

89. Walsh, William. *"V. S.* Naipaul : Mr. Biswas". *The Literary Criterion,* VoLx, Summer, 1972.

90. West, David S. "Lamming's Poetic Language *in In the Castle of My Skin". The Literary Half Yearly, 1* 973.

91. Walcott, Derek, "Antilles : Fragments of Epic Memory". *The New Republic,* Dec. 1992.

92. Yeh, Diana, "Ethnicities on the Move : British - Chinese Art - Indentity, Subjectivity, Politics and Beyond". C Q. *Critical Quarterly,* Vol. 42, No. 2, Summer, 2000. 4

CPSIA information can be obtained
at www.ICGtesting.com
Printed in the USA
BVHW080241110119
537596BV00001B/20/P